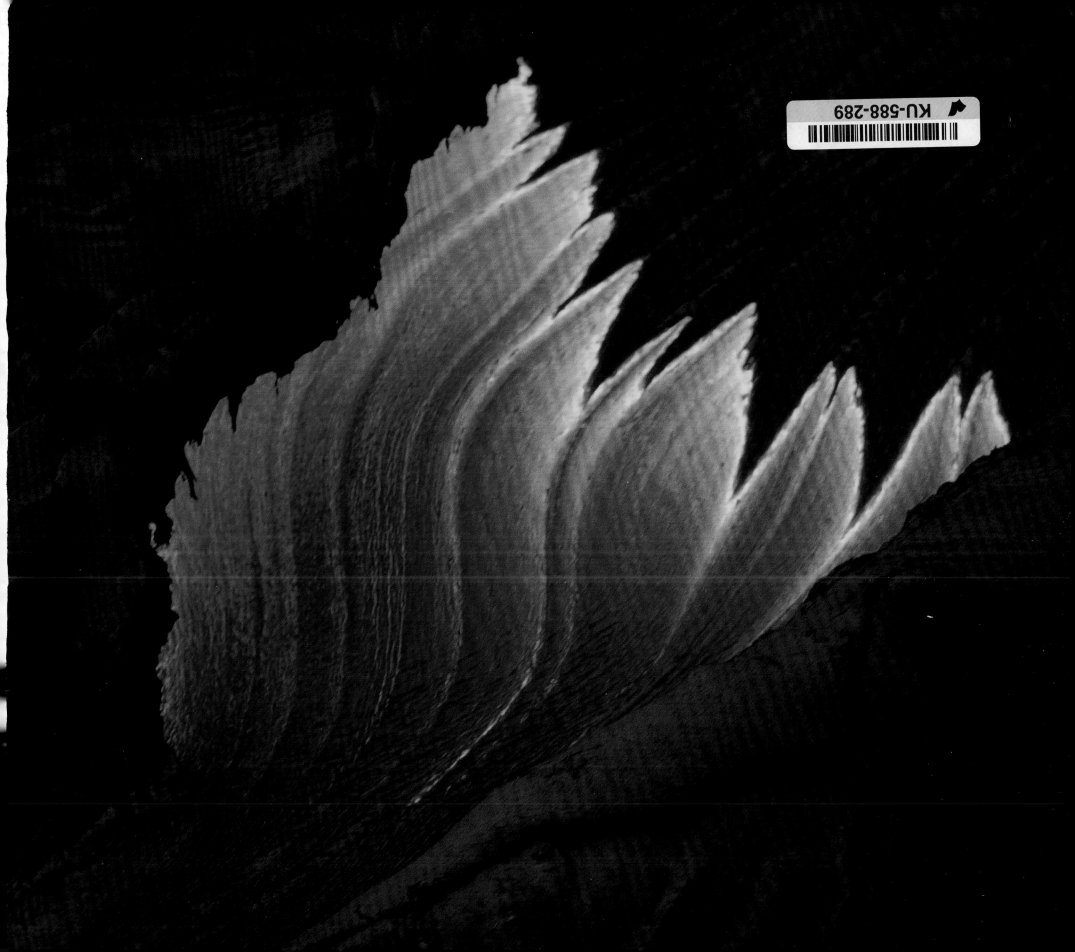

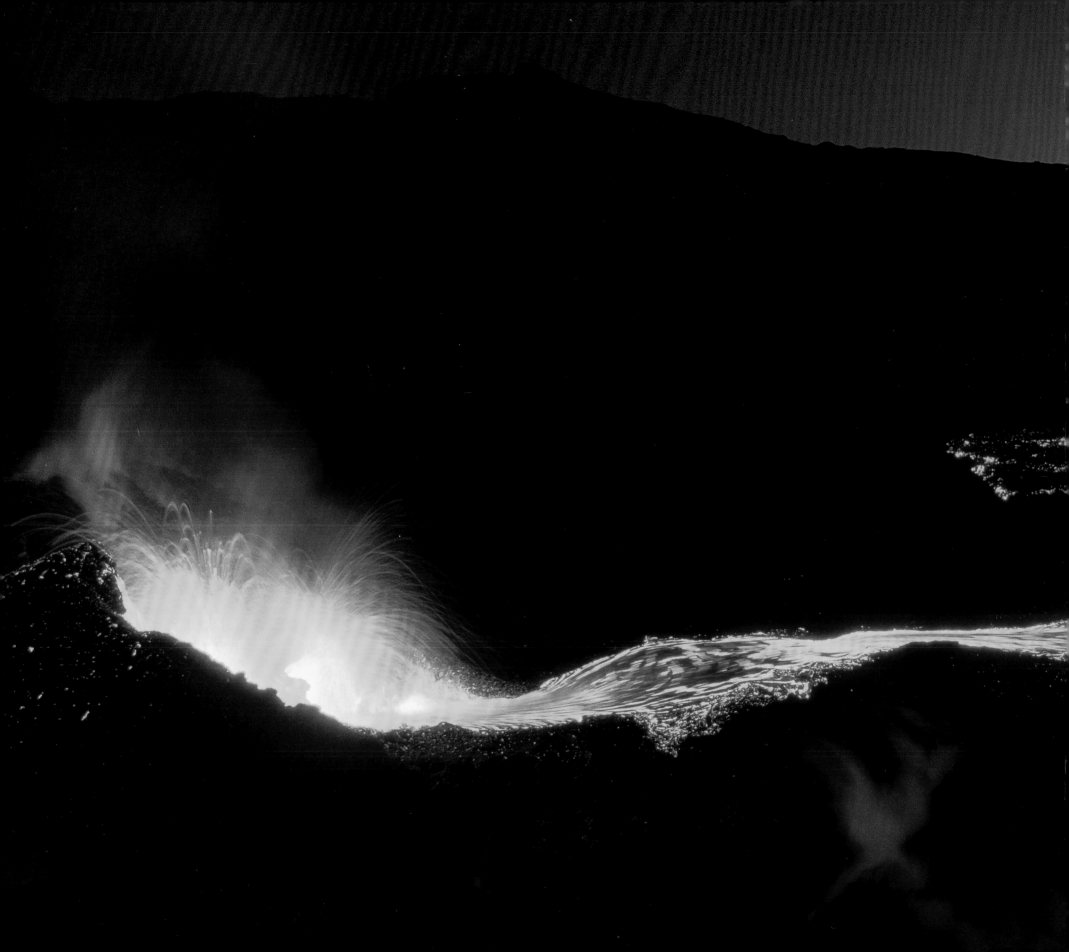

the red volcanoes

FACE TO FACE WITH THE MOUNTAINS OF FIRE

Photographs by

G. Brad Lewis and
Paul-Edouard Bernard de Lajartre

Introduction by
John P. Lockwood and Alain Gerente

with 126 colour photographs

Thames & Hudson

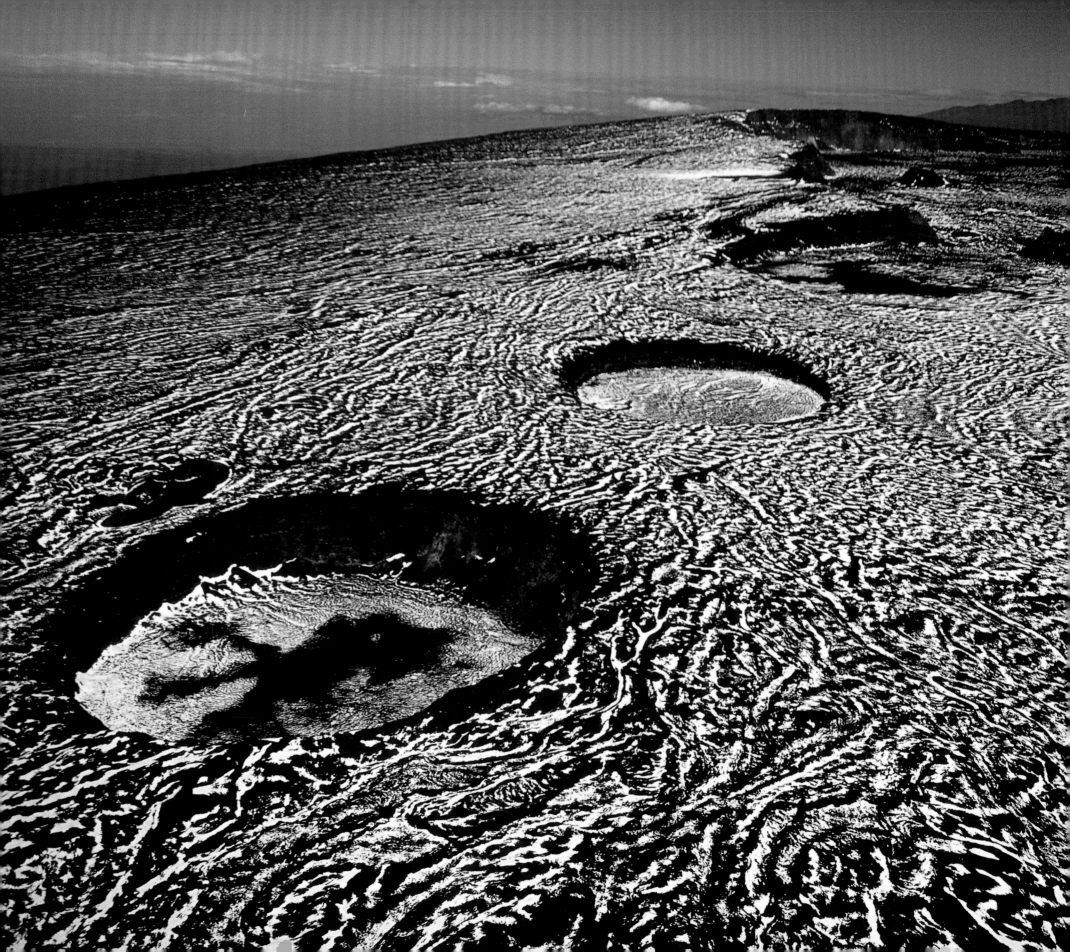

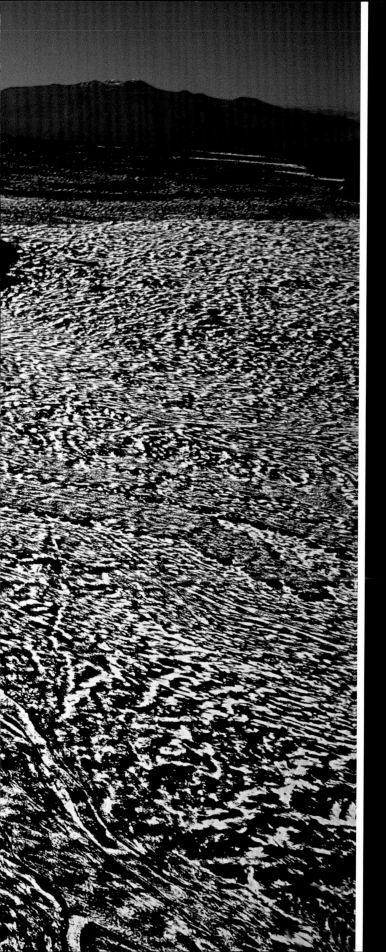

foreword

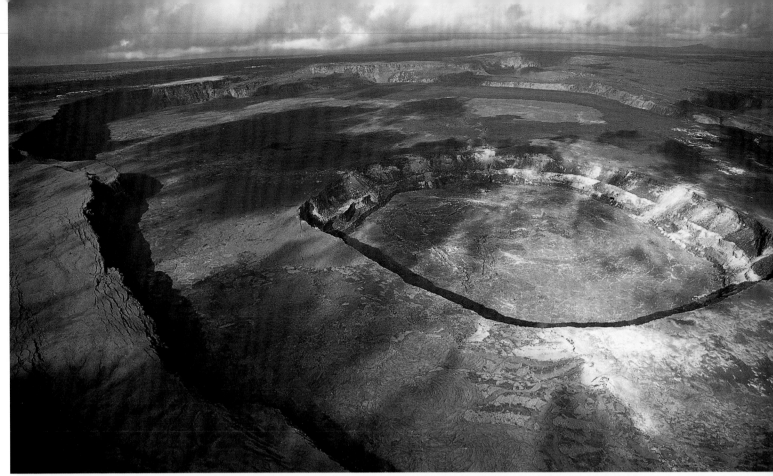

The late volcanologist, Bob Decker, always described Piton de La Fournaise (Réunion) and Kilauea (Hawaii) as sister volcanoes because "each is active and erupts almost every year with fluid fountains and flows." They have something else in common—both volcanoes are located over and supplied with magma by a mantle hotspot. Kilauea has physically closer sister volcanoes that are fed by the same hotspot—Mauna Loa, Hualalai, and Loihi. We can consider Piton de La Fournaise as a *hanai* (adopted) sister, genealogically linked to a different hotspot. They both have spirited personalities.

It is, therefore, fitting that two world-class photographers of different nationalities, G. Brad Lewis and Paul-Edouard Bernard de Lajartre, have combined their talents with their love of these two *hanai* sisters to produce this incredible book. Even though I have seen many aspects of Kilauea volcanic activity, Brad's photos always show me something new, something deeper, and something more spiritual than I can see with my more analytical eye. It *is* magic.

Internationally recognized volcanologist Jack Lockwood provides an introduction based on his extensive work with Hawaiian volcanoes and the native people that live on them; he is at home in all parts of the volcanic world. Jack is a rare scientist who can weave geologic facts and cultural and mythological insights. Alain Gerente introduces the *hanai* sister Piton de La Fournaise. Alain's knowledge comes through experience and intimacy with this volcano while filming *video incroyable*. Both Jack and Brad have become linked, become one with Kilauea as Alain and Paul-Edouard have with Piton de La Fournaise and they share their magic with you in this book. Enjoy our world.

Jim Kauahikaua
Scientist-in-Charge, USGS Hawaiian Volcano Observatory

This book is more than just a tribute to the beauty of Piton de La Fournaise and Kilauea. The magnificent photographs are irresistible: they revive memories for all those who have been lucky enough to witness the eruption of these two magical volcanoes. The authors show us the relationship that is created over time between a volcano and the people who live around it, in both Hawaii and Réunion: a feeling of fear, but also of eternal fascination and wonder. Living close to the volcano, the people of Réunion have come to value its frequent awakenings, as demonstrated by the number of curious visitors who gather by the most accessible lava flows whenever the news spreads: "*Volcan i pêt!*" (Volcano's erupted!).

Closely watched, these giants put on a dazzling display: their amazing, ever-changing spectacle is impossible to resist. So is the talent of these artists and the power of their images: tirelessly and passionately, Alain Gerente and Paul-Edouard B. de Lajartre take us between dream and reality into the breathtaking world that is the heart of Piton de La Fournaise. With the same passion, Jack Lockwood and G. Brad Lewis show us the splendors of their beloved Kilauea, long famed for its legendary beauty. All have a close bond with these two volcanoes, waiting patiently for the smallest of events, venturing where none of us would dare, day and night, guided by the glowing lava, wading through the mist or trudging under the scorching heat of these regions. Perhaps they are a little crazy. And maybe we are not crazy enough.

Like its faraway cousin Kilauea, Piton de La Fournaise is a treasure trove, and one that is still untapped. Inside the caldera known as the Enclos lie some of the most extraordinary sights that it is possible to see, a direct link with the genesis of the Earth.

I hope that the photographs in this book allow the world to understand what a great asset La Fournaise is to Réunion. Its frequent eruptions are moments to tell the rest of the world about, and to share with visitors passing by. The people of Réunion love their volcano. The pathways that lead to further discoveries are just waiting to be followed. This book is part of that journey.

Gora Patel
General Director, RFO SAT TV

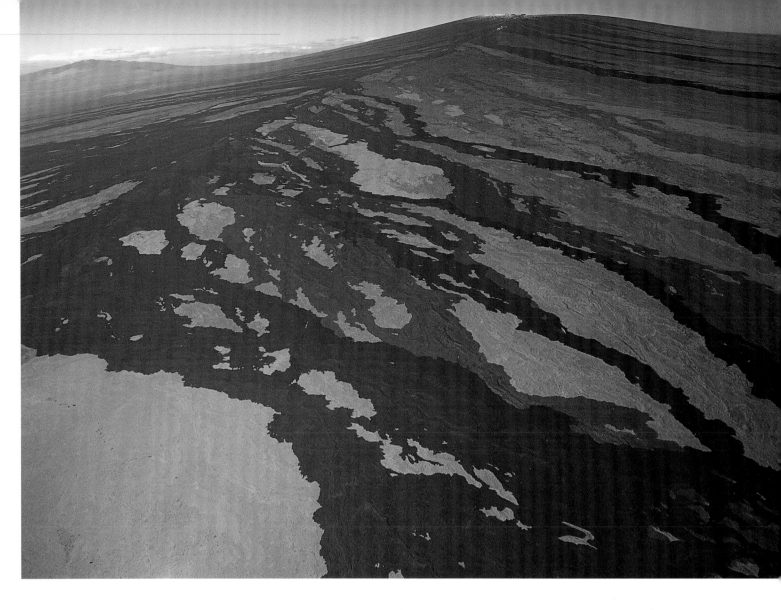

introduction

Volcanic eruptions offer a spectacular glimpse into the internal dynamics of the Earth. Active volcanoes are mainly located on the boundaries of the tectonic plates that form the surface of our planet. As these plates move, the nature, temperature and viscosity of the rising magma changes, and the resulting volcanic activity can vary from dangerous explosions to calm lava flows. Some volcanoes are not linked with plate boundaries. These are called hotspots, a phenomenon discovered in the sixties.

Explosive volcanoes, such as those of the Pacific Ocean's famous "Ring of Fire," are a threat to the environment and to nearby populations. In contrast, effusive volcanoes can have a positive effect on the economy of a region, as is the case in Hawaii, where the beautiful eruptions of Kilauea and Haleakala receive more than one million visitors every year.

Effusive volcanoes can be easily watched from a safe place, and this book focuses on two of the most active and accessible: Kilauea in Hawaii, and Piton de La Fournaise in Réunion, a small island in the Indian Ocean.

Kilauea

by John P. Lockwood

The volcanoes of Hawaii form the most isolated islands on Earth, lying almost 5,000 kilometers from any continental landmass. There are eight principal Hawaiian islands, but these are only part of a chain of volcanoes that extends more than 6,000 kilometers across the north-central Pacific, from the tropical waters of Hawaii to the cold sub-Arctic waters of the Aleutians and Kamchatka. Although mostly now cold and submerged deep beneath the sea, each was born of fire, and each was once the locus of fire, brimstone, and violent explosions as their lava flows met the sea. As their fires waned and stable land was created to harbor life, each was populated by forests and unique animals and plants that we can now only imagine. These ancestral Hawaiian islands lived, died, and were eventually submerged beneath the sea, and continued to move northwestward with their mobile Pacific Plate host toward their eventual burial site beneath Kamchatka. The beauty of these long-gone islands could only have been appreciated by passing seabirds, and their successor islands waited for the 19th-century American author Mark Twain to describe them as "the loveliest fleet of islands that lies anchored in any sea."

It is unknown when the first ancestral Hawaiian islands rose from beneath the sea, but it must have been more than 75 million years ago, when the mammalian ancestors of we humans were insignificant little rodent-like creatures, scavenging in the forests, fearful of being trampled by grazing dinosaurs. When the first humans evolved from apelike ancestors in Africa more than two million years ago, the islands of Hawaii had not yet emerged from beneath the sea, and likely had not yet even begun to grow from the seafloor.

Imagine what it must have been like to witness the birth of the present Hawaii Island! That first volcano appeared on the floor of the Pacific Ocean perhaps a million years ago—far to the east of the then-active volcanic island we now call Maui. Nothing was visible in the cold, pitch-dark world on the muddy floor of the Pacific on that day of creation—about 4,000 meters below the world of light and air above. Perhaps the deep-sea creatures felt some strange vibrations of the seafloor as a dike of magma rose toward the surface from a magmatic crucible (the celebrated Hawaiian "hotspot") far below? A long crack probably appeared in the muddy seafloor—but only a few blind fishes may have been witness to Hawaii's birth pangs. The first lava emerging from that crack may have caused some minor submarine fire fountains, but the pressure of the overlying ocean was too great to allow the explosive expansion of steam. The real fireworks began a few hundred thousand years later, as the growing volcano finally reached the ocean surface and saw daylight for the first time. That first volcano to breach the sea's surface announced its emergence with massive steam explosions, and became the volcano Hawaiians much later named Kohala—now an extinct volcano on the north end of Hawaii Island. Soon other volcanoes grew from the seafloor and joined together to form the present island of Hawaii—first Mauna Kea, then Hualalai, then Mauna Loa—and finally, perhaps 50,000 years ago, Kilauea rose explosively from the sea on the eastern flank of Mauna Loa. Kilauea was almost continuously active as she grew larger, and uncountable thousands of spectacular eruptions occurred, unseen by human eyes.

As Kilauea was growing higher, and forests were covering more and more of her surface, early humans had begun to migrate across Southeast Asia and began to explore the vast Pacific Ocean. These Polynesian seafarers were the greatest ocean navigators the world had known. About 1,500 years ago, long before Christopher Columbus had sailed his ships across the Atlantic Ocean, Polynesian explorers from the Marquesas Islands sailed their small canoes almost 4,000 kilometers across open ocean to become the first humans to discover the beauty of Hawaii.

What was the first view of Hawaii for these first Polynesian voyagers? They had probably known that they were approaching land because of the changing ocean currents and birdlife—but was the first visual sign of Hawaii a red glow in the night sky long before land itself was in sight? Did an eruption from Kilauea or Mauna Loa provide a beacon that guided the first explorers to this new land? The volcanic fires of this new land were a novel phenomenon to these first Hawaiians, since the volcanoes of the Marquesas had long been cold. They must have viewed volcanic activity with great awe, and there was an obvious need to understand and to name a new god that could explain and rule these fires—a goddess they called Pele. During over a thousand years of isolation, the Hawaiian people lived harmoniously with their new land and new volcano goddess as their population expanded and they exploited land and sea. The Hawaiians knew that the Earth, the forests, the wildlife, and the people themselves had been created by powerful gods. They taught that Pele—the Fire Goddess—had brought her magic fires down the island chain to Hawaii Island long before, to claim a new home and a magmatic hearth beneath the volcano they named Kilauea. The Hawaiian language is beautifully poetic, and place names reflect the nature of the area named. The underlying meaning of the word Kilauea (*Ki-lau-ea*) refers to the rising leaves of the ti plant, and conveys an image of fumes, or perhaps lava fountains, rising above the volcano's summit.

Pele was a highly changeable, capricious goddess, and she could take many forms—usually a beautiful, charming, playful woman who could tempt and love the other gods, but sometimes a wrathful old hag that could defend her fires with violence and spite. There are many tales of Pele and her control of Kilauea's fires, and many prehistoric (i.e. pre-European) eruptions are well described by oral legends and chants that explain the events very well—

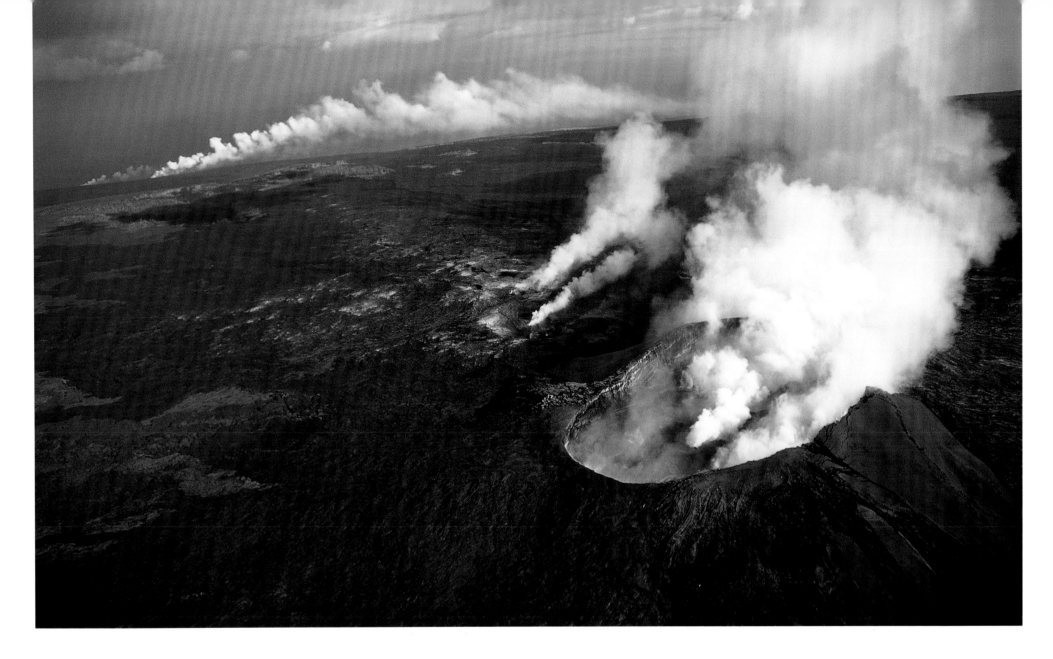

in terms of conflicts between powerful gods. The Hawaiian explanations are very logical, and show that Hawaiians understood basic concepts of volcanism very well. Their chants tell of Pele's migrations underground from her home in Kilauea's summit crater to eruptive sites down rift zones, and also explain the variable ages of Hawaiian volcanoes (which become older farther west from Kilauea) in terms of Pele's migration with her fires eastward down the Hawaiian island chain.

Europeans began crossing the vast Pacific only about five hundred years ago, but were unaware for hundreds of years that the Hawaiian Islands existed, as their ships sailed far off Hawaii. It was only a little more than two hundred years ago when James Cook accidentally "discovered" Hawaii in 1778, over a thousand years after the real discovery by Polynesian sailors.

By the mid-19th century scientists began coming to Hawaii, chiefly to describe the active volcanoes and the incredible variety of Hawaiian plants and birds. Cameras had not yet been invented, so artists accompanied the scientists to sketch both the volcanoes and wildlife. Soon artists began to descend on Hawaii, producing paintings and sketches of volcanic activity to sell abroad. Portrayals of Kilauea eruptions (often made from sketches by far-away engravers who never saw Hawaii) were published widely and fed the interest in Hawaiian volcanism.

Photographers began to appear on the Hawaiian scene in the late 19th century, but found that black-and-white panchromatic film could not capture volcanic activity very well (red lava looked grey), so their photos were tinted with red ink to simulate lava! The long exposure times required by early gelatin plate photography showed moving lava as a blur.

Early films were also slow in speed, so most photographs for the next eighty years or so were taken of stationary people and scenery. The advent of color photography around the Second World War changed that: photographers at last had a means to capture the beauty of Hawaiian eruptions with color film. But these early photographers mainly focused on the spectacular nature of Hawaiian eruptive activity—high lava fountains or massive torrents of lava. Few photographers turned their attention to the more subtle, but intensely beautiful details of flowing lava or of the amazing moments when lava reached the sea or began to freeze into stone.

G. Brad Lewis and Paul-Edouard B. de Lajartre are artists, not merely photographers, and seek to reveal the artistic qualities of Kilauea and Piton de La Fournaise's creations through the medium of film, which is why their photographs are so unique and beautiful. Many of their photographs do indeed capture spectacular aspects of Hawaiian volcanism, but each needs to be looked at as a work of art—art created by Pele, but captured by the artistic awareness and technical capabilities of the photographers. Many of these photos will invariably be viewed at first with awe—but after that, one needs to look beyond the merely spectacular to appreciate the "beauty that lies beyond."

The molten lava captured in these photographs originated far below Kilauea's surface, about 60 to 80 kilometers down, within the celebrated "hotspot" beneath Hawaii Island. It is not really known if the hotspot is much hotter than the surrounding rock, but what is known is that something causes the dense rocks below Hawaii to partially melt—to "sweat a little," and to generate small amounts of basalt magma along the edges of mineral grains. This nascent magma is less dense than the surrounding rocks, and begins to rise upward—at first along mineral boundaries and then along narrow fractures in the rocks. We know about these processes because rising magma commonly brings fragments of these host rocks to the surface as inclusions called "xenoliths" (foreign rocks). These have been studied extensively by geologists, who have documented how this basalt magma is formed and how it migrates upward. This newborn basalt magma continues to rise upward along numerous passageways, and may rest a little in various storage chambers. Eventually this magma accumulates in a large storage area directly beneath Kilauea's summit—a "magma chamber" about three kilometers below the surface. This chamber is not a continuous void—it's probably more like a sponge, a sponge that inflates and deflates depending on the balance between incoming magma from below, and outgoing magma. That outflowing magma may intrude elsewhere into Kilauea's flanks, or may ascend to the surface and at last be accessible for Hawaiians to worship, for scientists to study, for visitors to admire, and for skilled photographers to document.

When Pele brings her fires to the surface, her lavas remain molten for only a short time, and will soon freeze solid unless stored for a while beneath thick, insulating crusts. Red, molten lava can only be seen for a brief moment in time, since cooling will cover that lava with thin black crusts in a few minutes. How fortunate we are that persistent and talented photographers like Brad and Paul-Edouard have been present to document those magic moments before crimson lava changes forevermore into black, lifeless stone!

At the moments when these photographs were taken, molten lava had come to Kilauea's surface but had not yet frozen, and was in contact with a continuous hundred-kilometer-long subterranean conduit of fire that led deep into the Earth. The fiery fluids you see in these photographs were connected to surface eruptive vents, which in turn were connected to a magma-filled fissure that led back along Kilauea's East Rift Zone to the vast magma chamber beneath Kilauea's summit. From there, a continuous fracture system led downward, beneath the Earth's crust, to the nether world far below, where Pele's lavas were incubated. This is worth consideration as you view these photographs—you are looking at the open end of an "artery of fire" that extends 60 to 80 kilometers below the world of sunshine, forests, and photographers!

We humans are fascinated by volcanic activity, and no wonder, because volcanoes are literally within our bones. The entire Earth we live on was molten in its early history, and all of the elements that form our planet were originally forged in cosmic furnaces. All of the minerals in the Earth's soils are ultimately derived from volcanic rocks (albeit recycled through many different forms of rock), so that the food we eat and thus our bodies themselves are recycling molecules and atoms that once knew volcanic fire.

Perhaps this explains the human fascination with volcanoes, and perhaps one should view these beautiful photographs from Brad and Paul-Edouard as more than just portrayals of the present. These photographs are also windows through which we might contemplate the volcanic past from which we all came, as well as windows into a fiery future that astronomers predict awaits the entire solar system and the atoms of our own bodies in a few more billion years....

Piton de La Fournaise

by Alain Gerente

Arising from an ancient volcano that appeared at the dawn of humanity, at a latitude of 21° south and a longitude of 55° east, the island of Réunion stands between sky and sea under the trade winds, framed by the ultramarine and turquoise shades of the Indian Ocean.

1977: Chronicle of an Eruption

It happens during a violent thunderstorm the evening of April 8, 1977, such a long time ago now. On that Friday, Piton de La Fournaise awakes. Torrential rains fall uninterrupted in the east of the island, preventing access to the volcano site.

Along the east coast, in the village of Bois Blanc, Good Friday is traditionally celebrated with family—and under waterspouts! It is 7 p.m. and dark when the residents begin to notice, despite the poor visibility, that the low-level clouds over the ocean—some 400 meters above sea level—have turned a fiery red. An incredible event is occurring and danger is close; the alert is given promptly. For the first time since 1800, an eruptive fissure has opened above a residential area, somewhere in the vast rainforest that covers the slopes of the volcano, outside the Enclos, a horseshoe-shaped caldera where eruptions usually take place. My friends and I arrive as fast as we can to film and photograph this unusual eruption.

It is now 11 p.m., and nine hundred inhabitants have been evacuated with the army's assistance and moved to the village of Piton Sainte-Rose. In the flooding ravine of Bois-Blanc, the temperature rises quickly. Less than a kilometer away, the front of the running lava runs into the ravine, with water evaporating into scalding steam that spreads through the village. Under the reddening sky, it seems like the end of the world has come. But finally slowed by the flood then cooled, the threatening flow fortunately never reaches the village.

The following morning, to our great surprise, a new lava flow emerges from the layer of clouds and runs down the slopes, crossing the Route des Radiers and moving into the sugar-cane plantations above Piton Sainte-Rose. We watch it closely. Huge explosions shoot flames over 20 meters into the air and start fires, making our journey even more difficult. This phenomenon is caused by hydrocarbons in the ground evaporating with the heat to form methane and other combustible gases.

Then the main flow enters the Lacroix ravine, which passes through the village of Piton Sainte-Rose. This time the emergency action plan kicks in, leading to the immediate evacuation of some 1,500 people from Piton Sainte-Rose to Bois-Blanc. Nothing can stop the lava flow from entering Piton Sainte-Rose, burning a dozen buildings on its way. When it reaches the ocean, just a little before dawn on Easter Sunday, a long plume of red steam rises into the sky. It can even be seen from the island of Mauritius, almost 200 kilometers away. The scene is apocalyptic!

Exhausted by sleepless nights spent hunting the most impressive images of our lives, we dive into the sea near the eruption, into water warmed by lava, and find crabs and shrimps that, unable to escape from the fury of La Fournaise, have been boiled alive. The poor creatures provide a royal banquet for us that day!

But only a few days later, the brief respite is over. Another alert is issued: a new large and very fluid lava flow is once again heading toward Piton Sainte-Rose. Cameras in our hands, we are prepared this time. The lava spreads rapidly through the village, destroying houses and buildings. Birds fall around us, suffocated by gases. A side flow breaks through a local bank's fence but stops in front of the building, then surrounds the police station, which holds out, and runs around the church before entering the nave, where we have retreated urgently with equipment and luggage. All around us, the stained-glass windows shatter from the heat. The front of the lava moves a few meters forward. We move back. But suddenly it stops dead. After miraculously escaping destruction on April 13, 1977, an unforgettable day for Réunion, the church of Piton Sainte-Rose is renamed "Notre Dame des Laves"—Our Lady of the Lava.

However La Fournaise does not give up. The following day, a new fissure opens up at an altitude of 500 meters, producing an amazingly fluid lava flow which reaches the ocean in less than five minutes at a speed of 80 kilometers per hour—fortunately without causing any damage this time. The magnificent show lasts a few more days, then the volcano suddenly ceases activity on April 16. Over 100 million cubic meters of lava destroy hundreds of hectares of cultivated land. Many families lose everything they own.

The eruption of Piton Sainte-Rose is a call to action, and the authorities decide to establish a volcano observatory on the island. The Observatoire Volcanologique du Piton de La Fournaise officially opens three years later in 1980.

The Magic of Volcanoes

Since time immemorial, mankind has been fascinated by volcanoes. Of all natural phenomena, no other sets our imaginations on fire like a volcanic eruption, perhaps because the sight of it takes us right back to the creation of the world. Volcanoes lie at the origin of the continents, the oceans, the atmosphere of the Earth, and maybe even at the beginning of life itself.

According to ancient tales, volcanic activity has always brought fear as well as mystical enchantment and deep admiration to human minds. To discover that the Earth had the ability to crack and spread burning lava, raining down ash and melting rock, transforming everything, was immensely powerful. From ancient times to the present day, right across

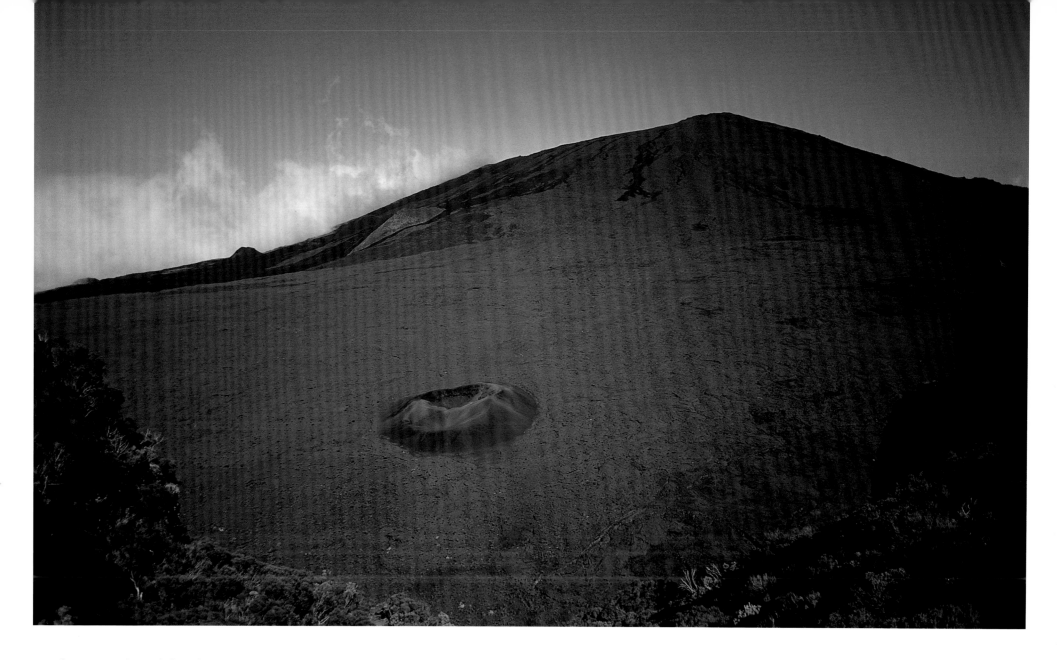

our planet, many legends have been born at the foot of an active volcano. These myths have in common the universal theme of the mystery of life, in which humans feel dwarfed by this phenomenon of nature. In Persian mythology, its name is "Qaf," which means the sacred mountain, mother of all volcanoes. It has roots so deep that they reach the core of the Earth. And through them, God brings volcanoes to life.

Piton de La Fournaise on the island of Réunion is no exception. Exceptional in many ways, it is, like Kilauea in Hawaii, one of the most active volcanoes on Earth. It has erupted over two hundred times since humans first arrived on the island in 1646. In the early 19th century, Bory de Saint-Vincent, a famous French explorer and scientist, included an outstanding description of it in his work *Voyage to the Four Principal Islands of the African Seas*, published in Paris in 1804, capturing his memorable encounter with the "burning mountain" and the "country consumed by underground fires." He wrote: "Beneath our feet, two gigantic columns of igneous matter gush side by side from an elliptical abyss with tumultuous colliding waves launched over 40 meters high, bright as glowing blood, despite the glare of the sun untempered by clouds. A continuous sound like a huge waterfall accompanies this majestic scene that fills one's soul with terror and admiration…. The most magical description, the most exact painting can only give a mediocre idea of the majestic effects produced by the amazing contrast of light and shade during a volcanic eruption."

Nowadays, thanks to new technology, images have replaced words. But the fascination for volcanoes remains. Some of us, driven by an intense call from within, dedicate our lives to studying, filming, and photographing eruptions. For me, it has become the very essence of my life. My good friends Maurice and Katia Krafft, famous volcanologists, shared this

passion and paid for it with their lives in June 1991, during a deadly eruption on Mount Unzen in Japan, very different from the eruptions of Piton de La Fournaise and Kilauea.

There are some 1,500 active or potentially active volcanoes in the world. Some of them, in the category of stratovolcanoes like Mount Unzen in Japan, Mount St. Helens in the United States, or Krakatoa in Indonesia, are extremely dangerous. Others like Piton de La Fournaise and Kilauea belong to the category of shield volcanoes, and calmly produce the magnificent fountains and spectacular flows of lava that you will be able to enjoy in this book. Created by long and fluid lava flows, their slopes are gradual. They are also appropriately referred to by the evocative name of "red volcanoes."

To Maurice and Katia, Piton de La Fournaise and Kilauea were the most beautiful volcanoes on Earth, and they dedicated several works to La Fournaise. In one of them, entitled *In the Devil's Lair*, Katia compared herself to a matador in the arena facing a "roaring beast… shaking, belching and stretching with all the violence of its mass." "The intense heat burns my face," she wrote, "but I remain still, fascinated by the blazing celebration that the volcano offers."

For centuries, indifferent to mankind, the numerous eruptions of Piton de La Fournaise have provided an incredible show, a prodigious feast with an amazing variety. For me, it has no comparison except its faraway Hawaiian cousin, rivaling its beauty in another hemisphere, surrounded by the Pacific Ocean. This book and its images testify to the splendor of these two volcanoes, forgotten by the media because they usually spare human lives. A sublime vision of beauty by photographers Paul-Edouard B. de Lajartre for Piton de La Fournaise and G. Brad Lewis for Kilauea, this work is an hymn, a poem, a dance, a mystic and universal journey.

In order to penetrate this inner world and understand the history of my beloved Piton de La Fournaise, we have to go back more than two million years, when a volcano emerged in the heart of the Indian Ocean and gave birth to the island of Réunion, a spectacular event witnessed by no one but perhaps a few sea birds. Réunion was just a bare rock at first, far from continental land masses but close to its elder sister Mauritius, formed by the same volcano 8 million years earlier. Eruption after eruption slowly shaped its landscape. This young volcano's first manifestation was long cracks opening with fountains of lava, sometimes reaching hundreds of meters high. Cones were formed and basaltic lava spread for miles around, solidifying when it came into contact with seawater and extending the island. After these constructive stages came the destructive ones; hurricanes and tropical storms with violent rains rage every year in this part of the globe during the southern hemisphere's summer (November through March). This has created a chaotic relief with countless ridges as sharp as blades, with torrents and cascades running down from basin to basin, into huge abysses, sometimes forcing their way in between gigantic walls of rock. On this intense island, the hot and humid environment favored the gradual growth of luxurious plant life, where the rainforest reigns, covered with gigantic mosses and wild orchids as abundant as coral in the sea. Giant ferns mingle with ancient, wind-blown tamarind trees.

Although located on the sea route to the East Indies, this unusual island remained uninhabited for a long time. This was probably due to the frequent eruptions of its volcano, which kept away the many merchant ships that sailed by at the time of the spice and perfume trade between Europe, Africa, and Asia. Réunion appeared for the first time on sea maps in 1502, under the Arab name of Dina Morgabin, then was renamed Santa Apollonia by the Portuguese. In 1613, an English ship, the *Pearl*, stopped over and baptized it Pearl Island. Pigs and poultry were unloaded and the island became a supply port for European ships sailing to India. It was later named Mascarin, as one of the Mascarene Islands, after the Portuguese sailor Pedro Mascarenhas. In 1646, twelve French mutineers from Fort Dauphin, on the French bastion of Madagascar, 900 kilometers away, were exiled on the island as a punishment. They were rescued three years later in excellent physical condition, demonstrating that the island was very favorable to life despite the active volcano. The new government of Madagascar therefore decided to take possession of the territory and rechristened it Île Bourbon, after the French king Louis XIV and his Bourbon dynasty.

In the years that followed, East India Company ships dropped Europeans, Malagasies, and Indians on the island. Later, between 1718 and 1848, African slaves were brought to work in the fields, to develop the trade in coffee, spices, and perfume. The island was renamed several times due to the many upheavals of French history until 1848, when slavery was abolished. It was then given its present name of Réunion, symbolizing the coming together of a population from many different origins. In the years that followed, more people came to this welcoming land from India and China, creating a striking multi-ethnic culture that unites European, African, and Asian traditions.

A symbol of diversity, this unique island is also a land of natural contrasts. From the pounding waves to the mountain peaks, the ultramarine blues of the Indian Ocean contrast with the rich greens of the forests, which then fade gradually into the intense reds of the high rocky ridges above.

An extinct volcano 3,000 meters high, Piton des Neiges dominates the island. The La Fournaise massif was born on its slopes 500,000 years ago. Réunion is still expanding toward the southeast, the region ruled by Piton de La Fournaise, which reaches a height of 2,632 meters and is crowned by two craters: Bory and Dolomieu. Its frequent eruptions emit

lava flows of many different types, marking the landscape with a multitude of craters. Remains of the past, each crater has a name and has its own story to tell, forming part of the wider history of La Fournaise.

Most eruptions begin inside the summit craters then move toward lower regions. But it is a long way to the ocean, which explains why in Réunion, unlike in Hawaii, eruptions that reach the sea are rare. If we go back in time, the number of eruptions reaching the ocean averages between five and ten per century. However, since the start of the 21st century, there has been a notable increase in this type of volcanic activity, with more or less explosive encounters between water and fire resulting in the formation of tall columns of white

steam, full of hydrochloric acid. At night, these magnificent plumes of smoke take on a glowing red tone, bright enough to be seen from Mauritius. In an atmosphere that recalls the creation of the world, when the lava reaches the sea, it meets the oncoming waves with an unbelievable noise of whistling steam, roaring backwash, and creaking of the blazing hot rocks as they fall into boiling water. It is then that La Fournaise offers the incredible sight of new land being born: the youngest beach in the world.

I am fortunate enough to live in Réunion, and my first ascent to the summit craters was in 1967. Today I can no longer count my number of visits there. When an eruption is occur-

ring, the expeditions often require the setting-up of a base camp for several days, which generally means hours of walking on chaotic ground carrying heavy equipment. We have to be prepared for everything, because weather conditions at this high altitude can be a nightmare and the nights are freezing.

The island has a saying: "You have to deserve the volcano." From the years I have spent filming and observing the many "shows" of Piton de La Fournaise, I know that they are never the same: they are always surprising and amazingly varied. Each eruption is a new journey, a tiny link in the neverending chain of the volcano's history. After being at my side through many expeditions to the eruption sites for over ten years, Paul-Edouard now shows the world for the first time a selection of the most captivating moments of this part of its history. A passionate photographer, he does not hesitate in the face of danger and takes us into the heart of this amazing volcano with his unforgettable images of magical eruptions and lava of all kinds: smooth, ropy, or in sheets like elephant skin; bubbly scoria that sometimes forms plates or marbles; lava fountains thrown up into the air by the expansion of gases; volcanic bombs, fragments of liquid or viscous lava that are thrown out, spin through the air and fall to the ground in an infinite variety of shapes before slowly cooling. When a crust forms on its surface, the lava crumples, slowly tears apart and drifts with the stream underneath. Sometimes melted basalt solidifies into thin strands of glass that are carried away by the wind; these are known as "Pele's hair," after the Polynesian goddess of volcanoes. These different types of lava often combine and create spectacular displays that change color from dawn to sunset. At night, sumptuous droplets of fire splash into the dark sky. The show is neverending, constantly renewed. It hypnotizes and seduces us. It stirs us and invites us to contemplation.

This exceptional, magical volcano is still a mystery, even to the scientists who dedicate their lives to it. If you can, come to visit. Who knows—maybe your life will change forever....

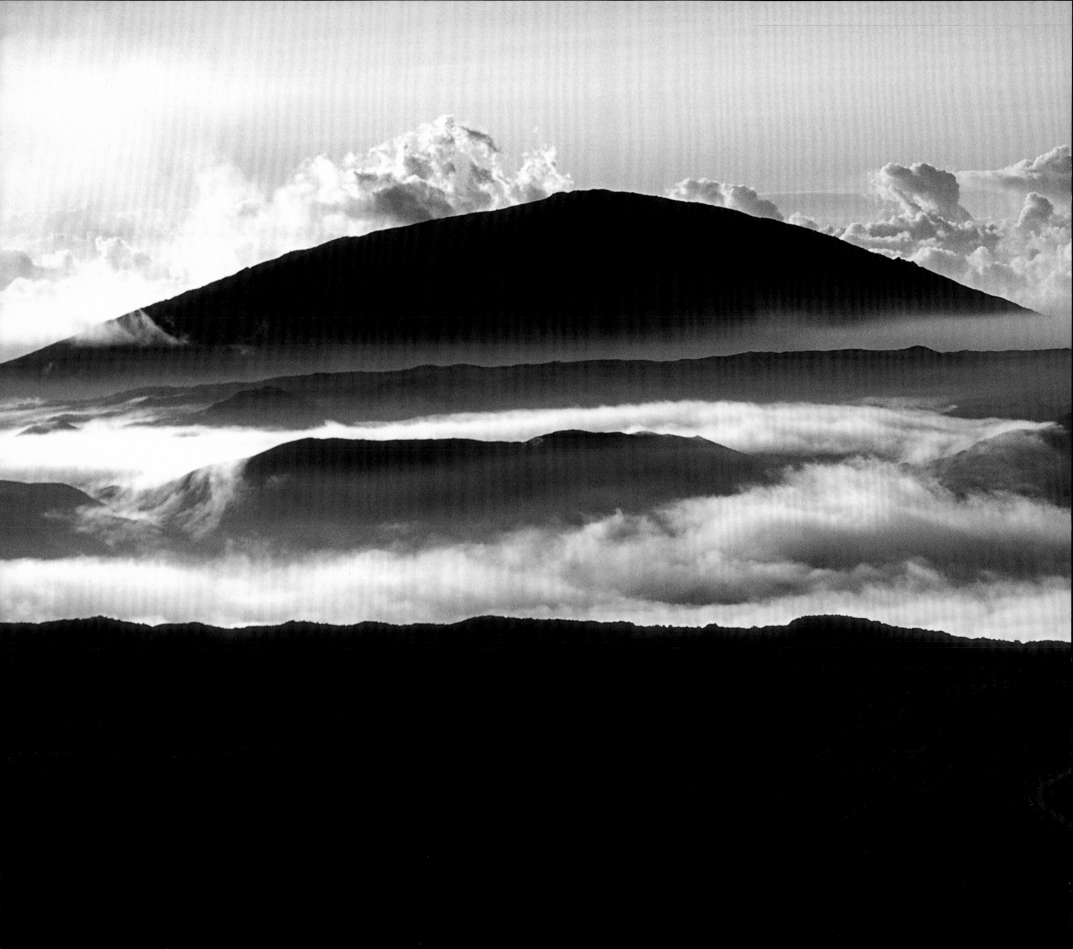

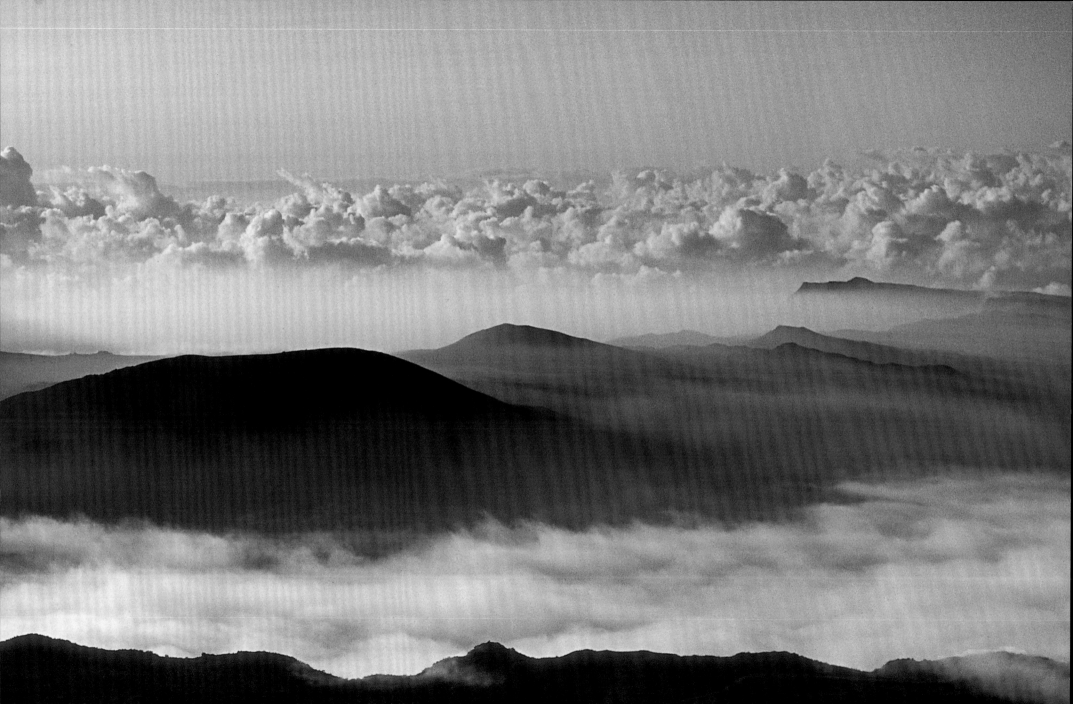

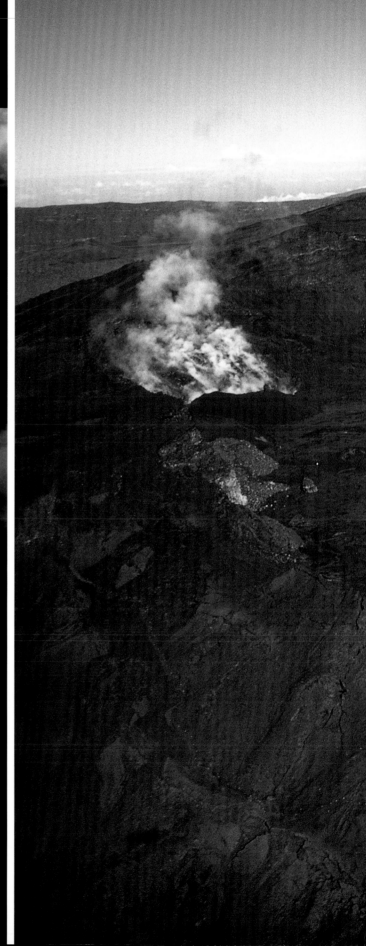

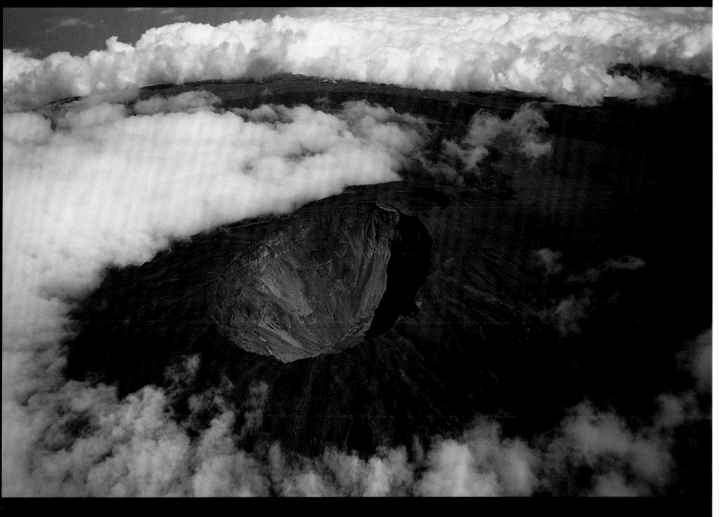

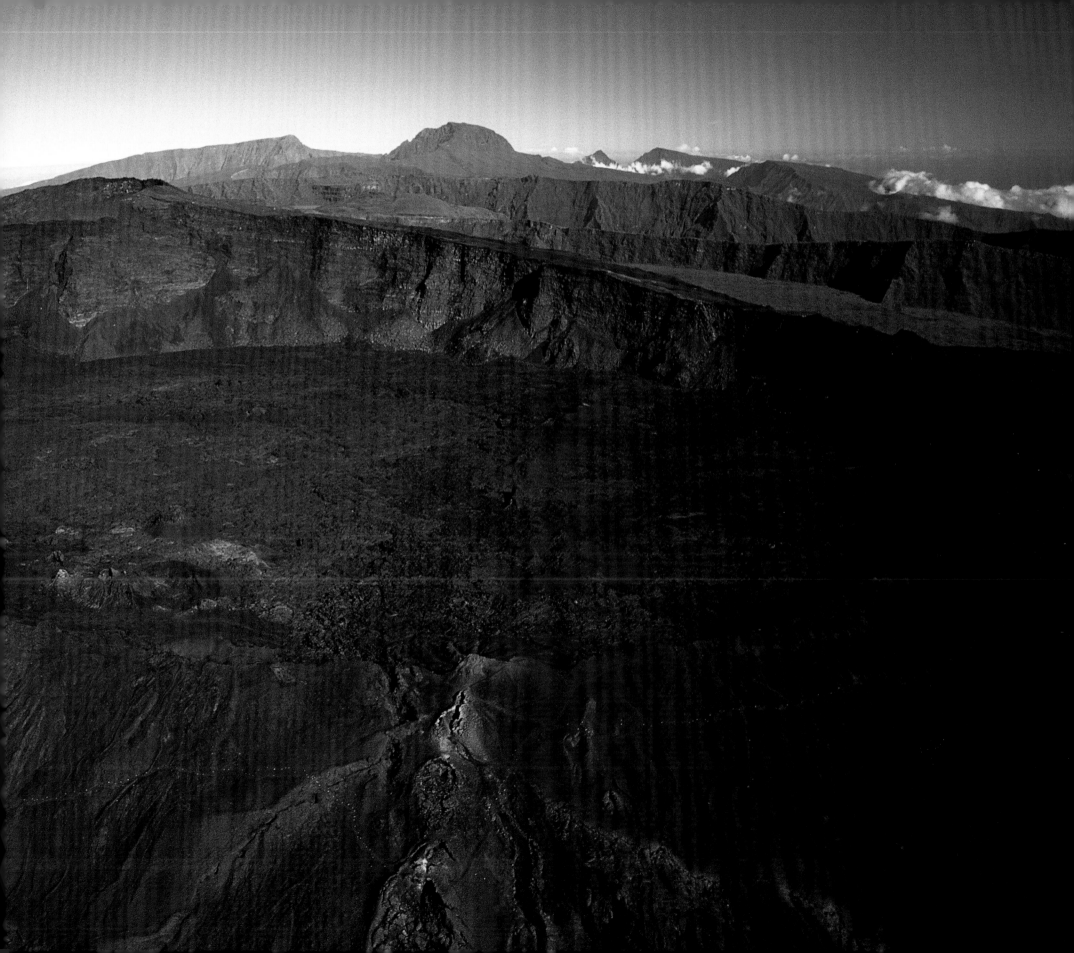

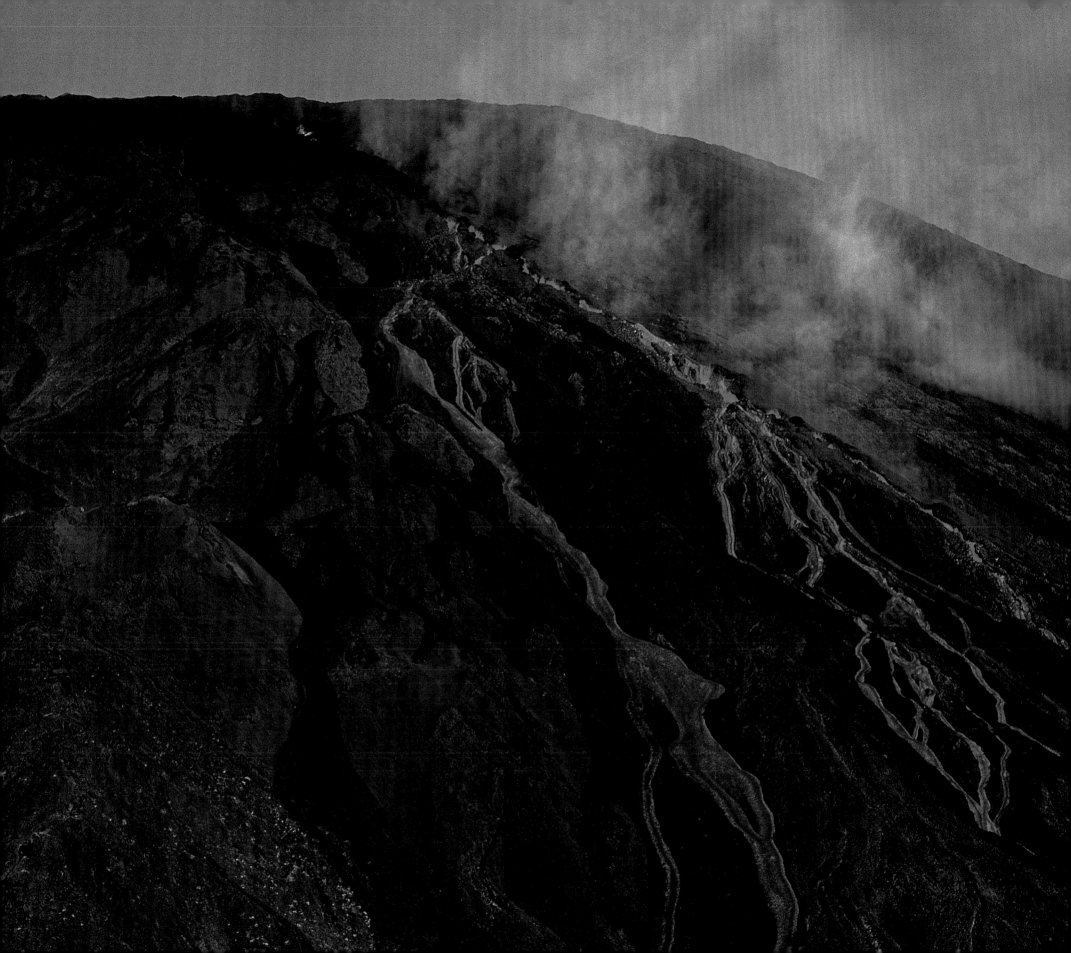

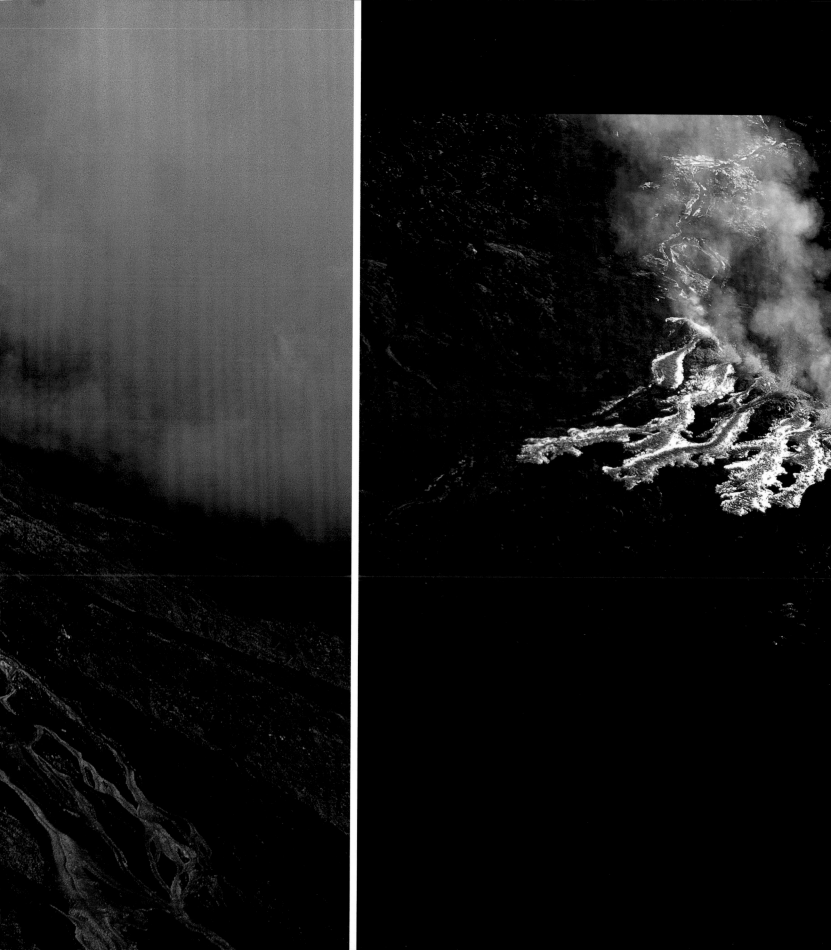

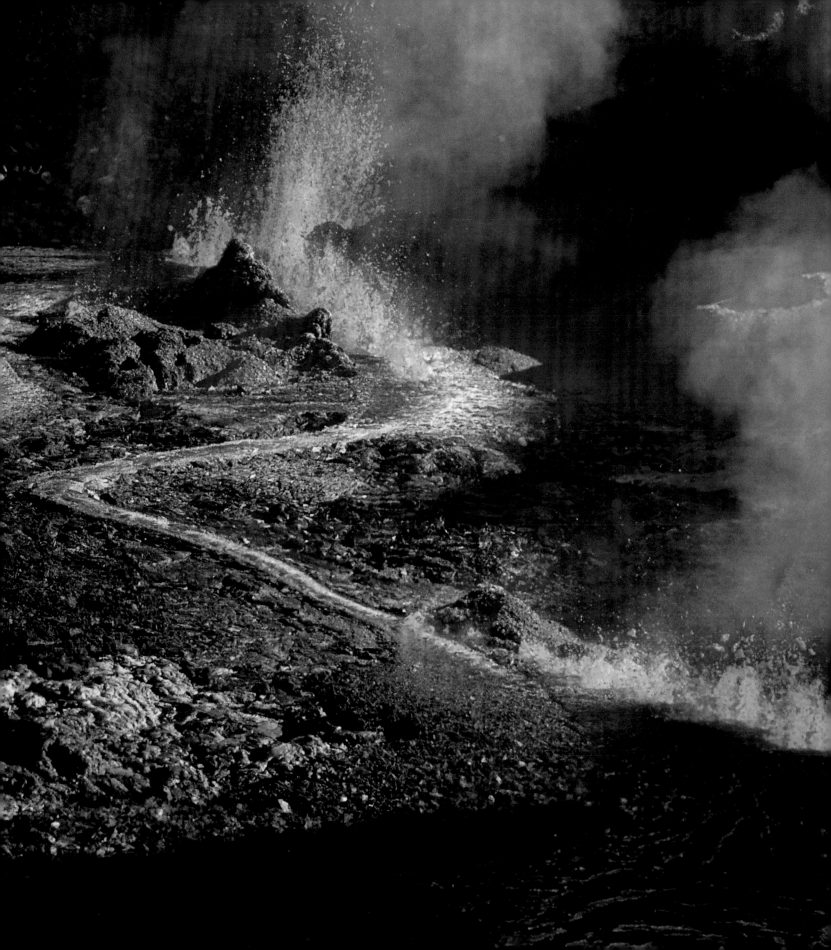

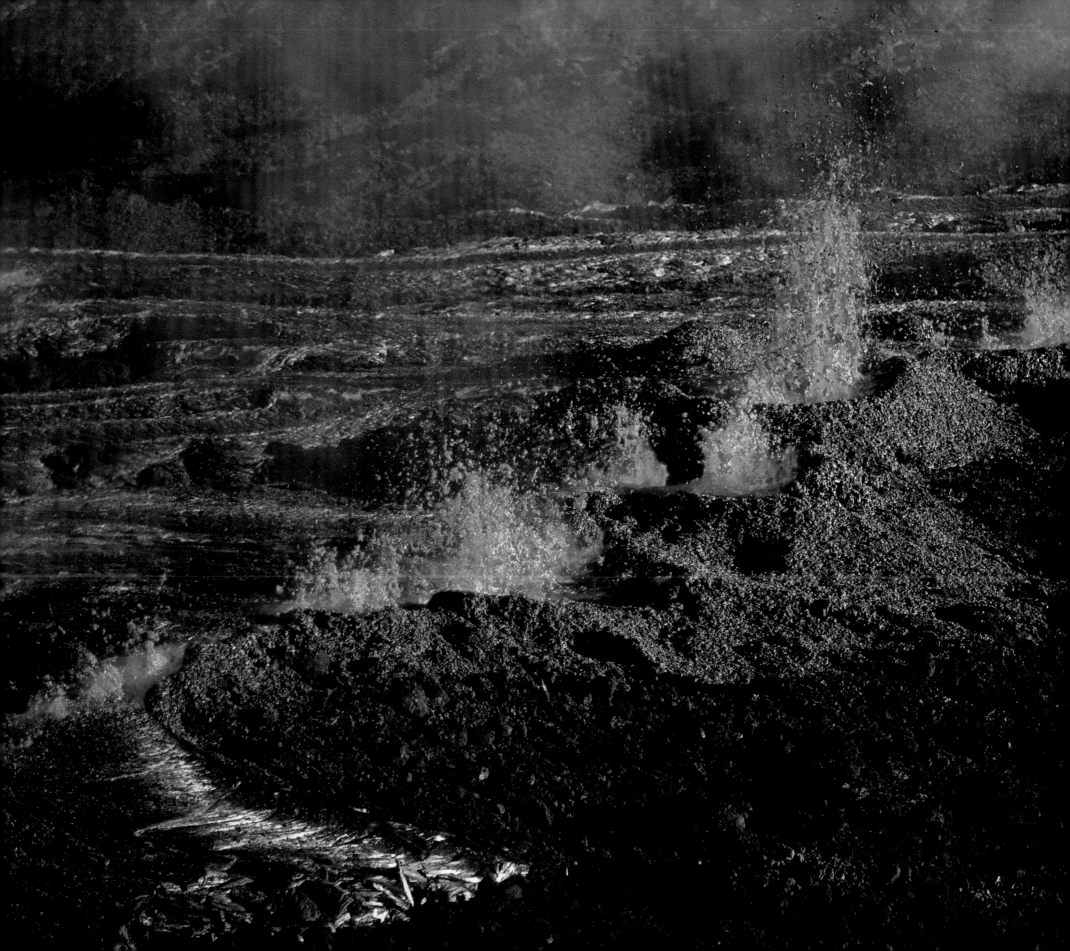

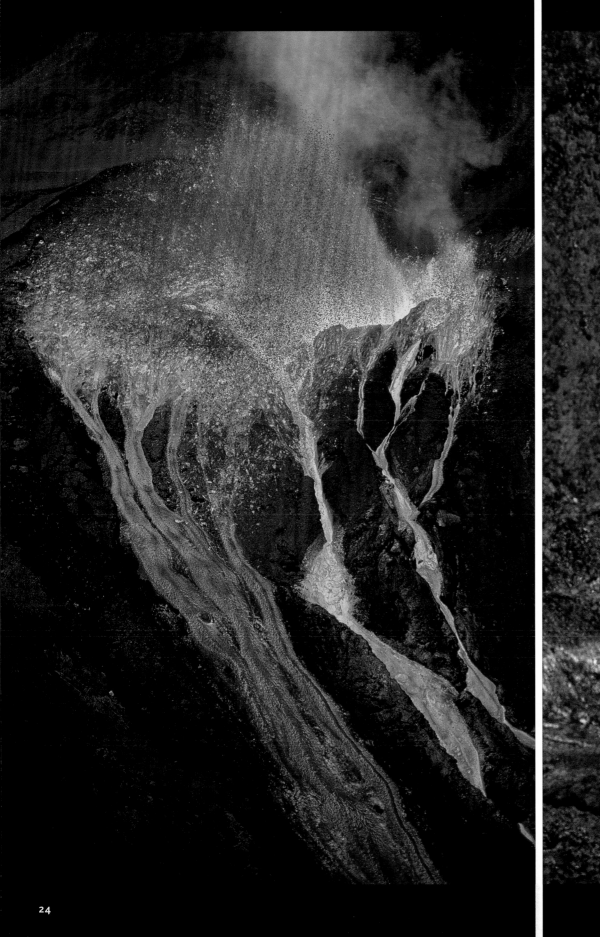
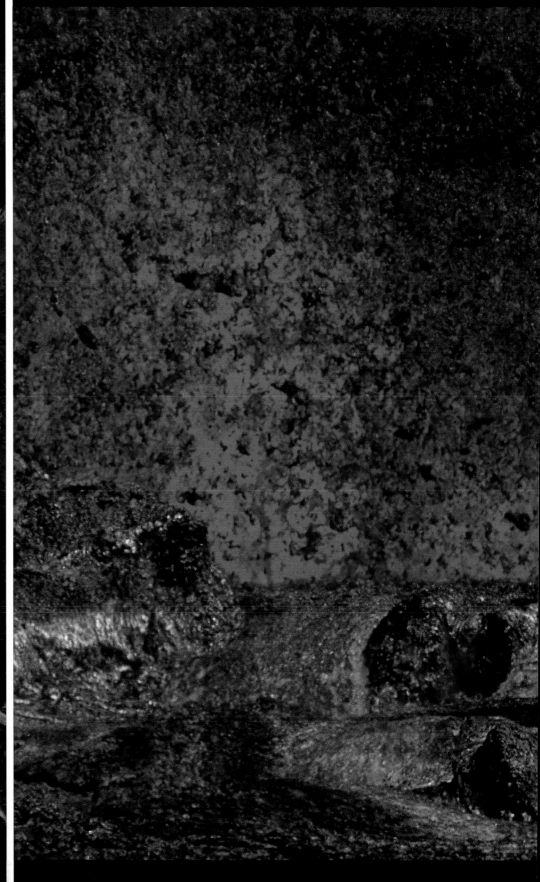

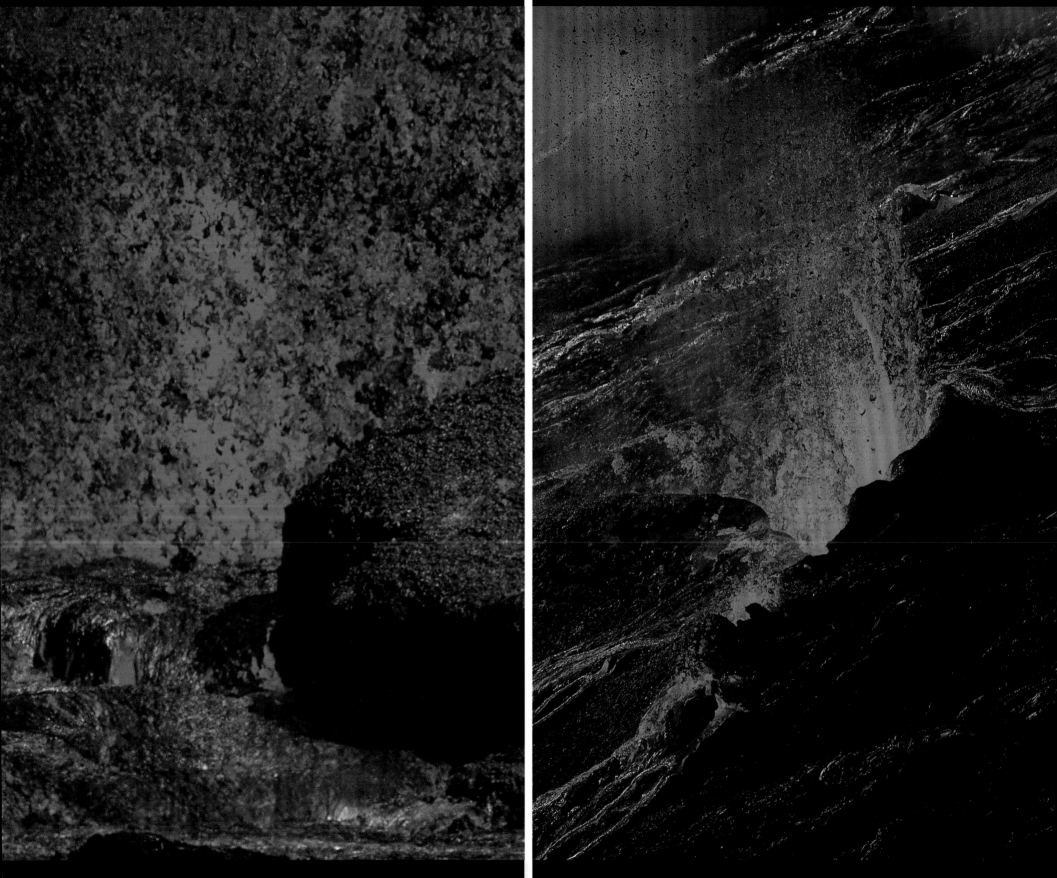

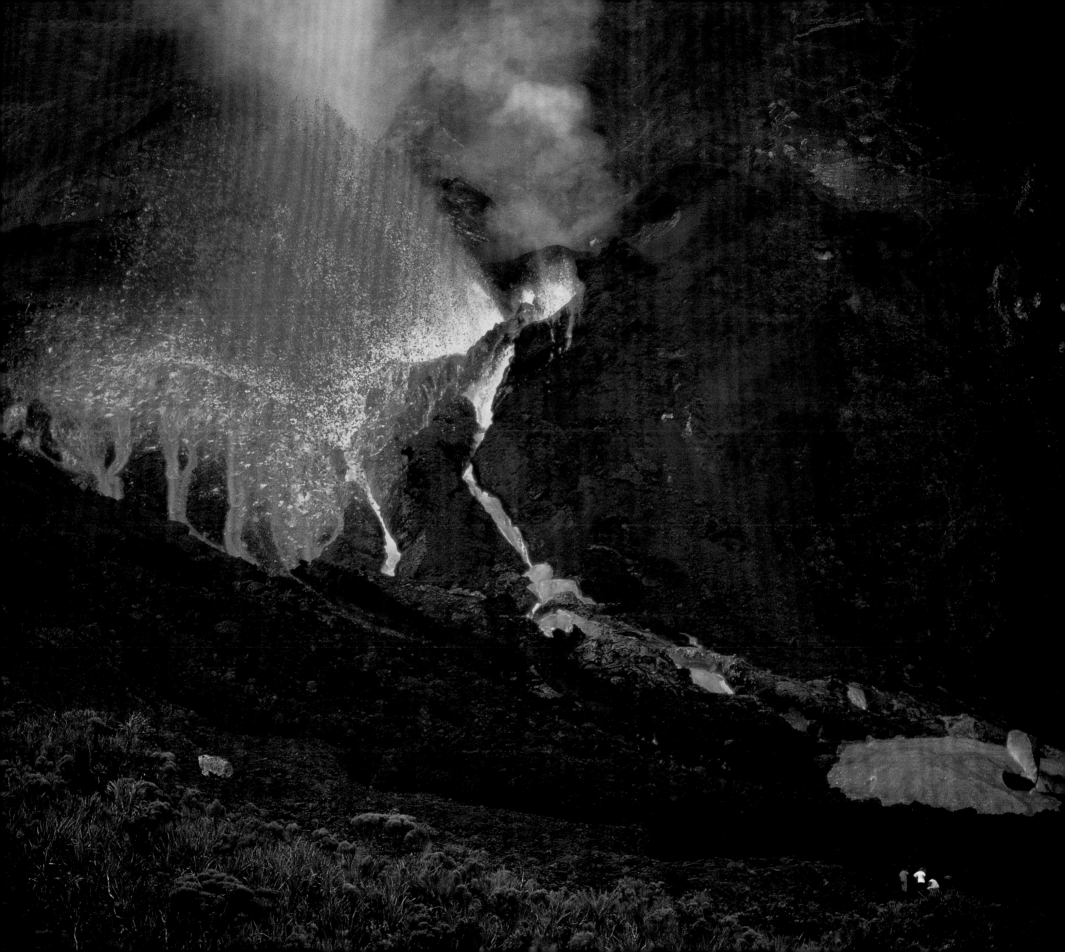

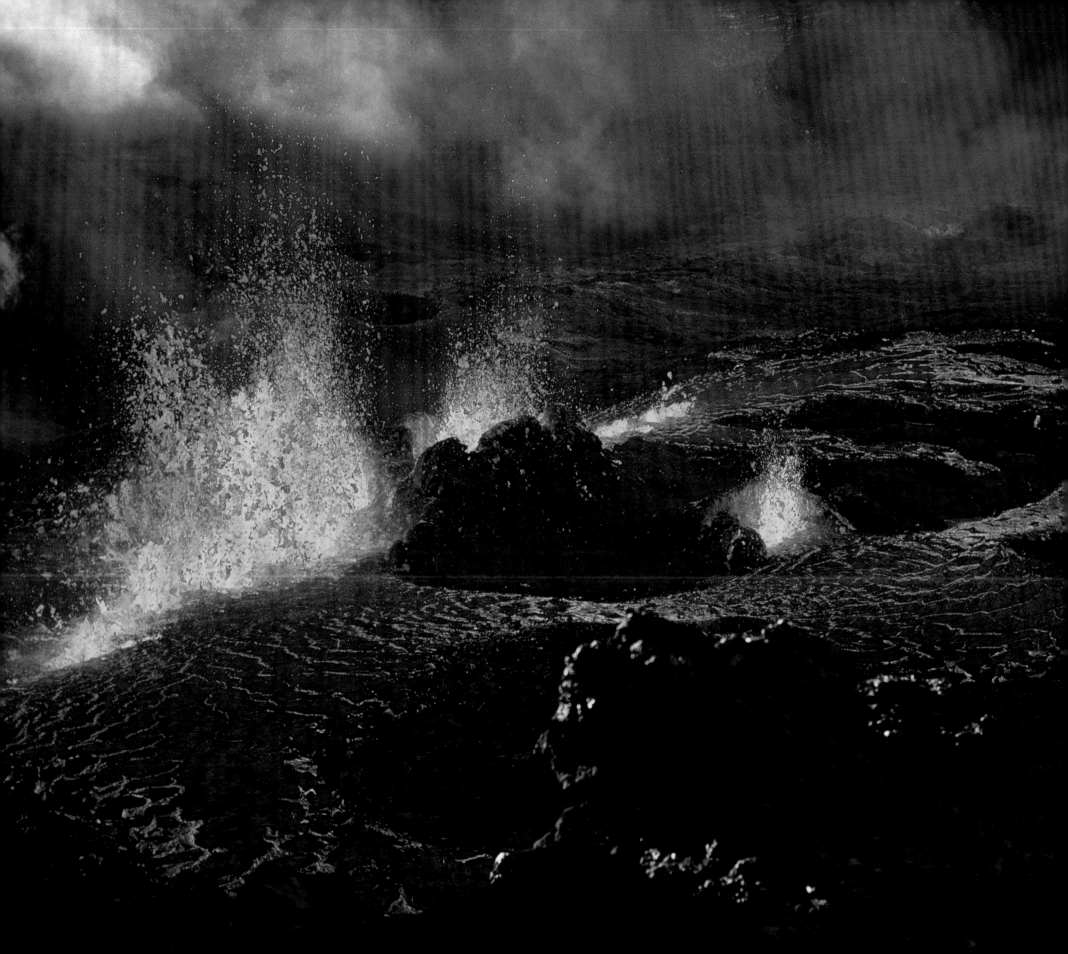

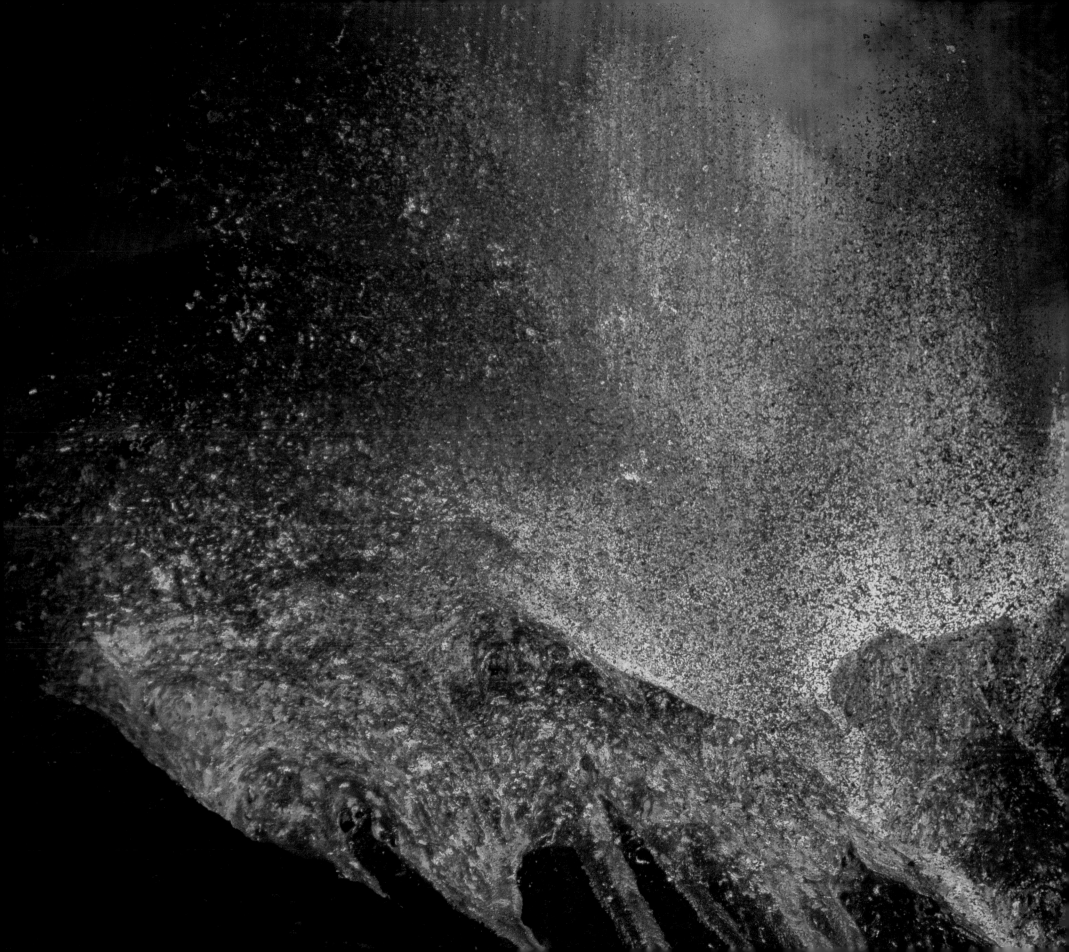

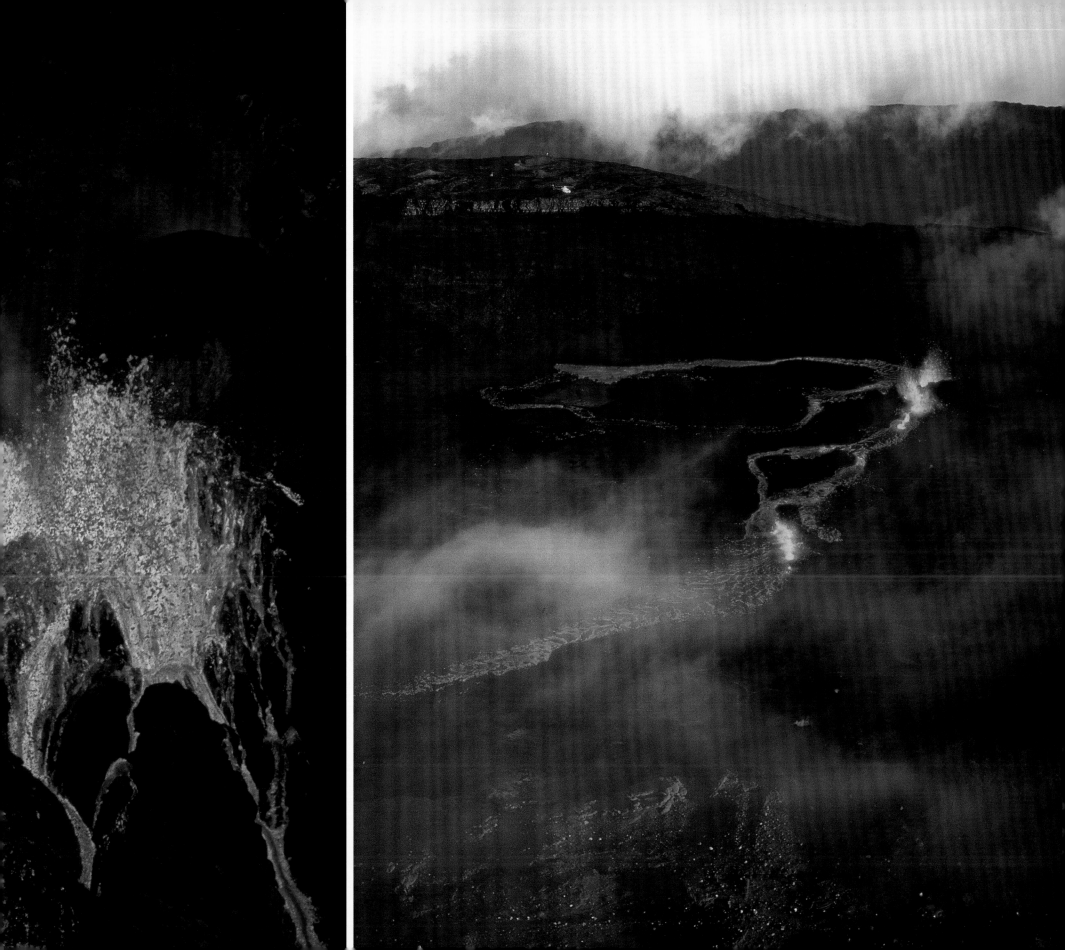

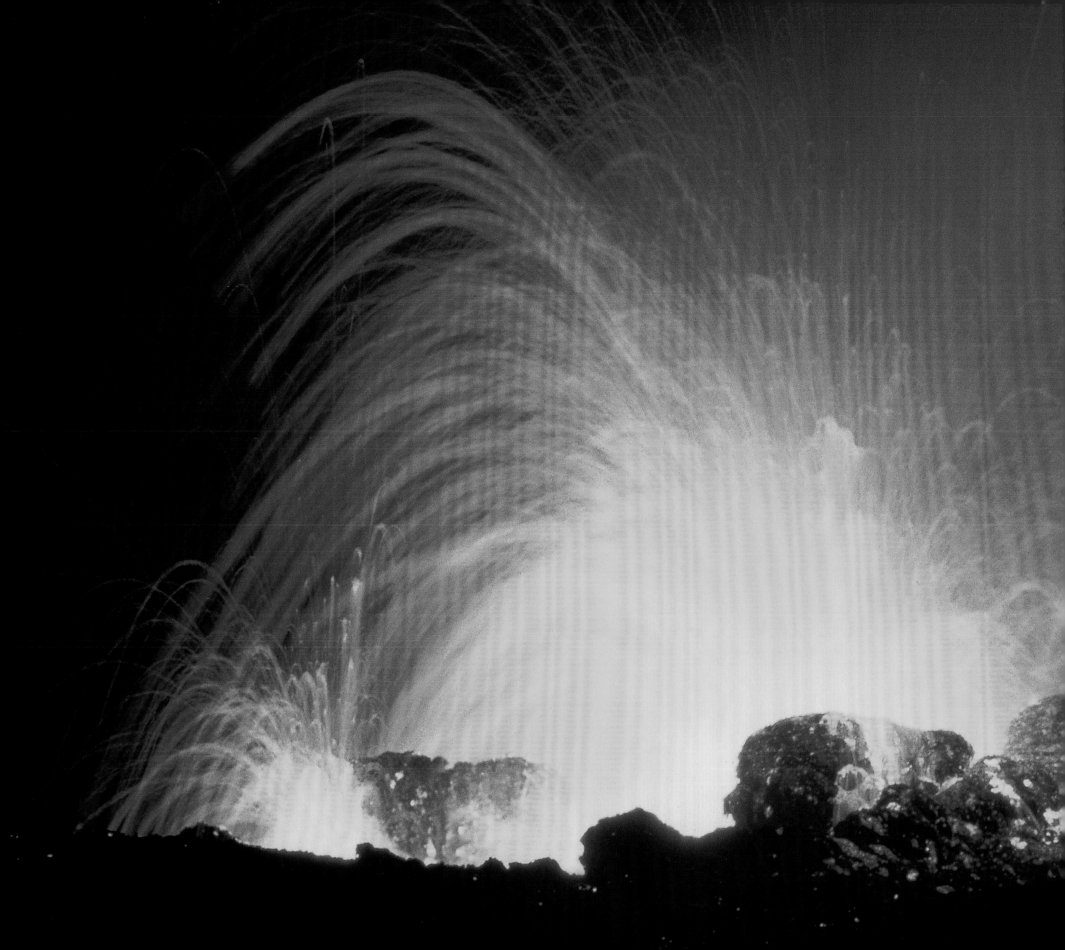

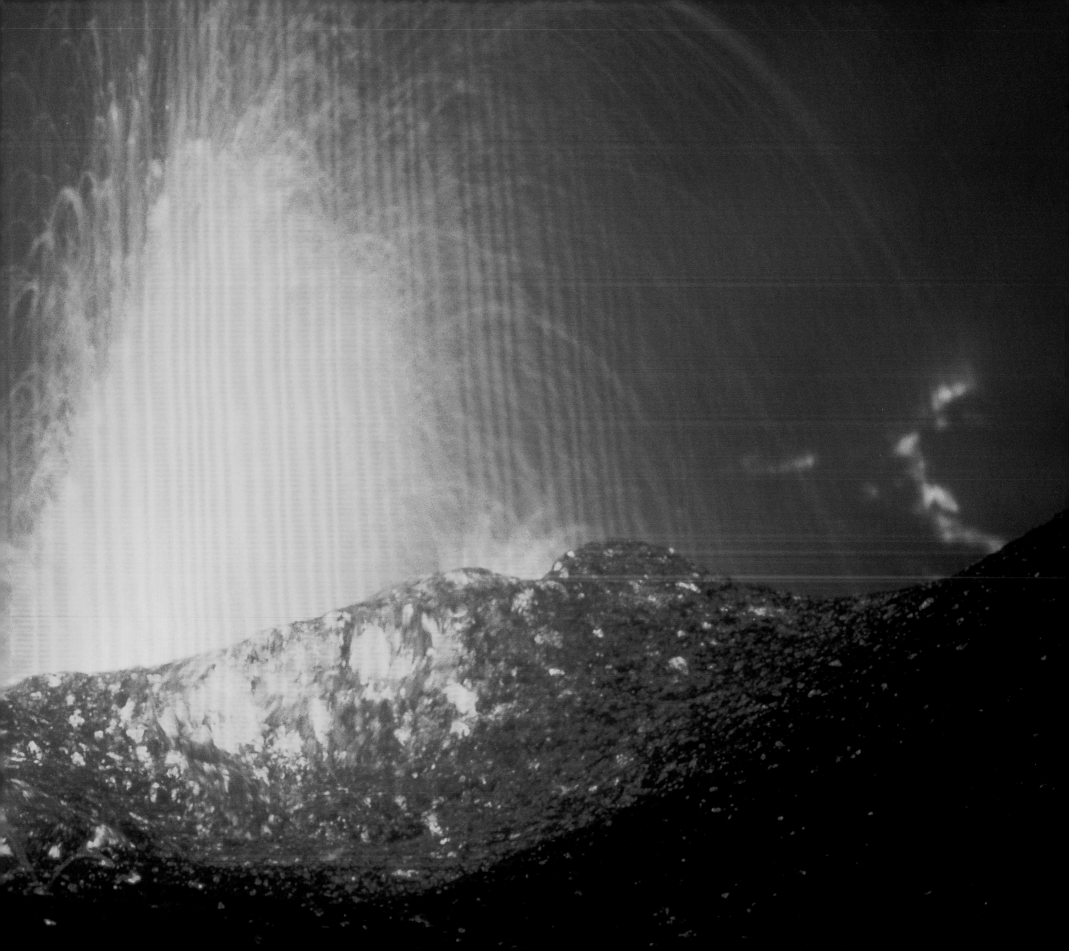

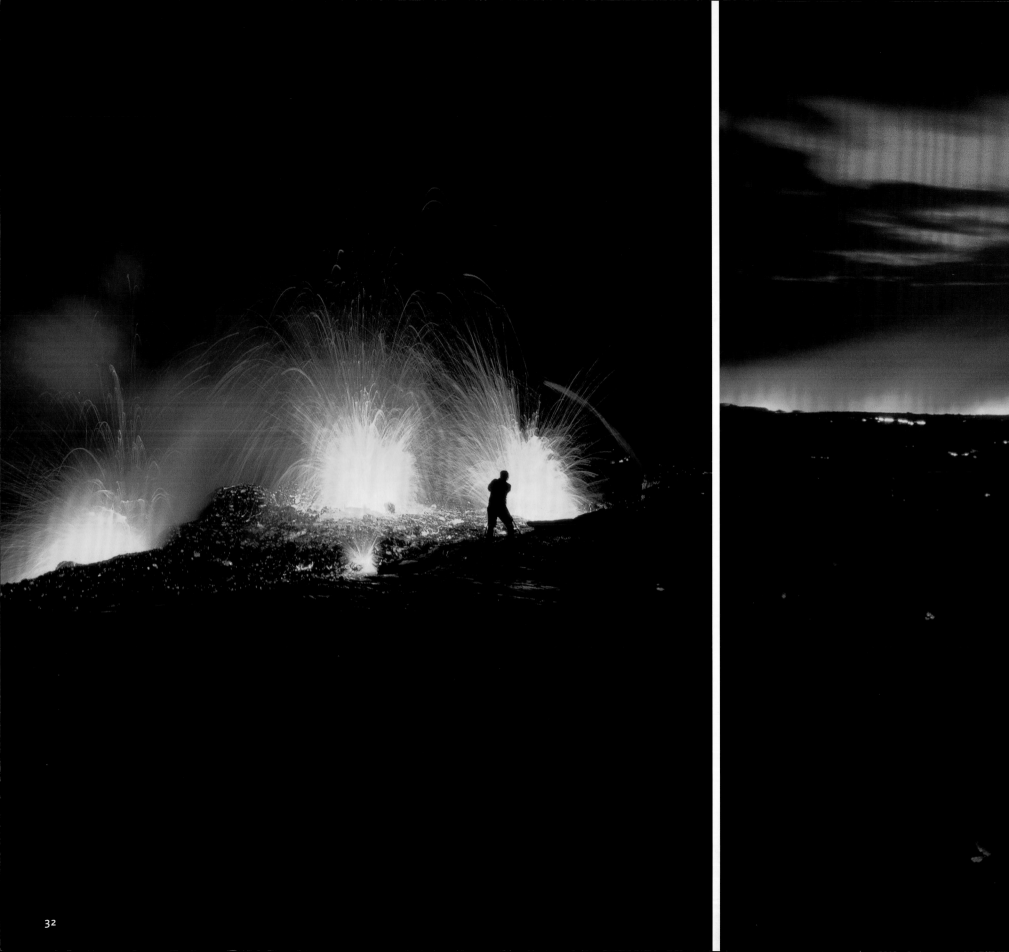

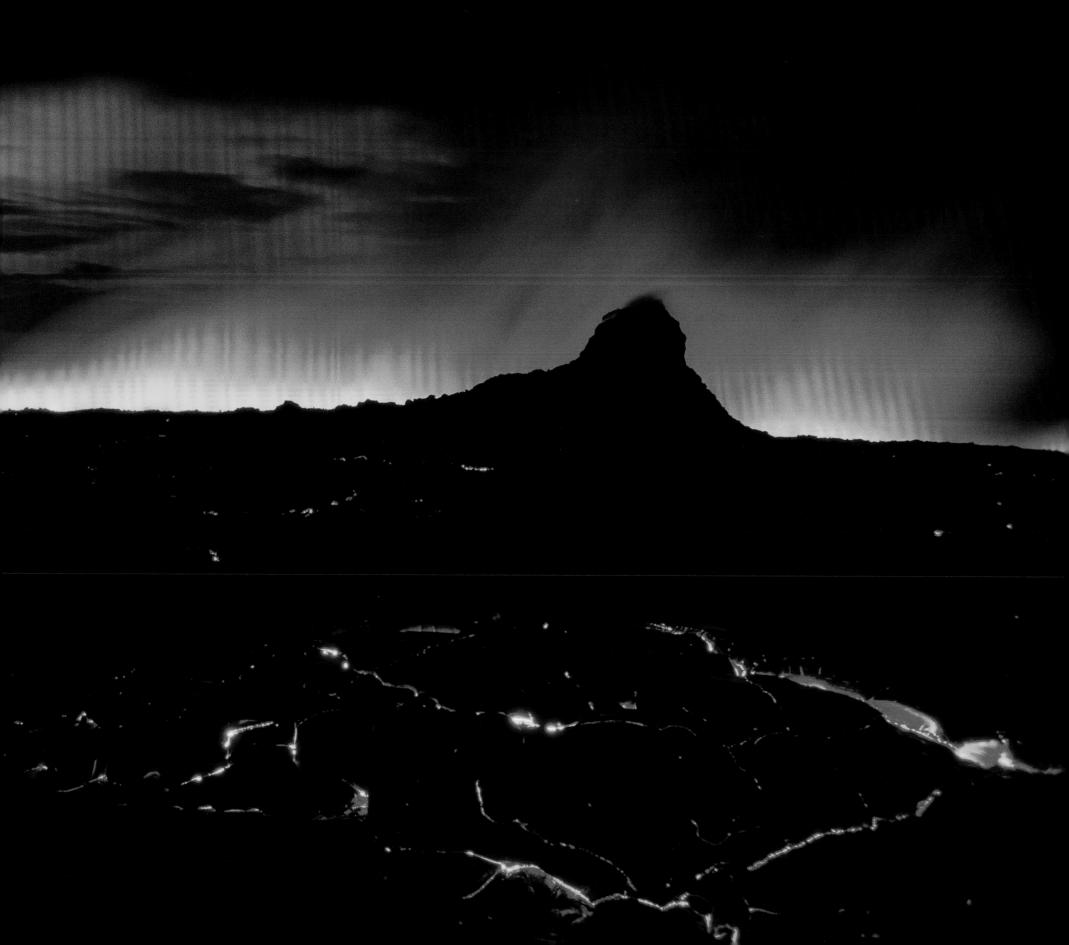

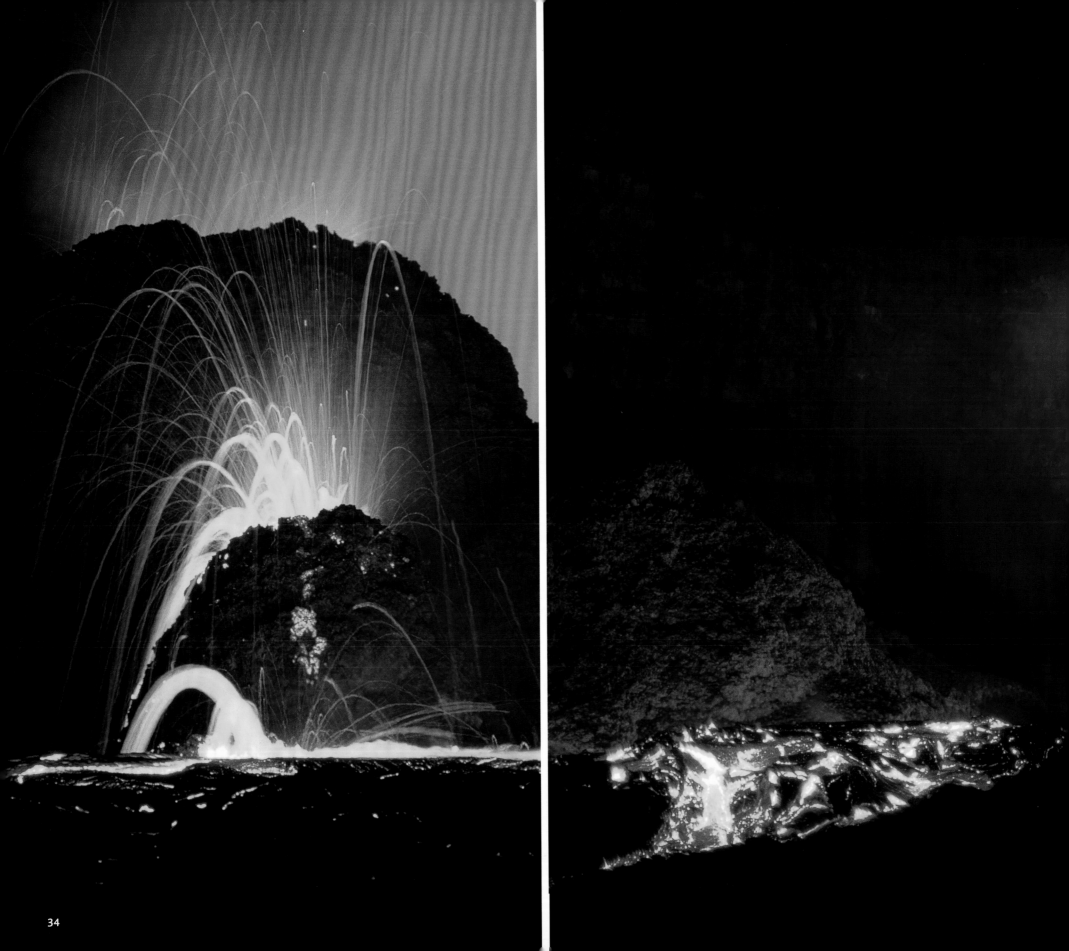

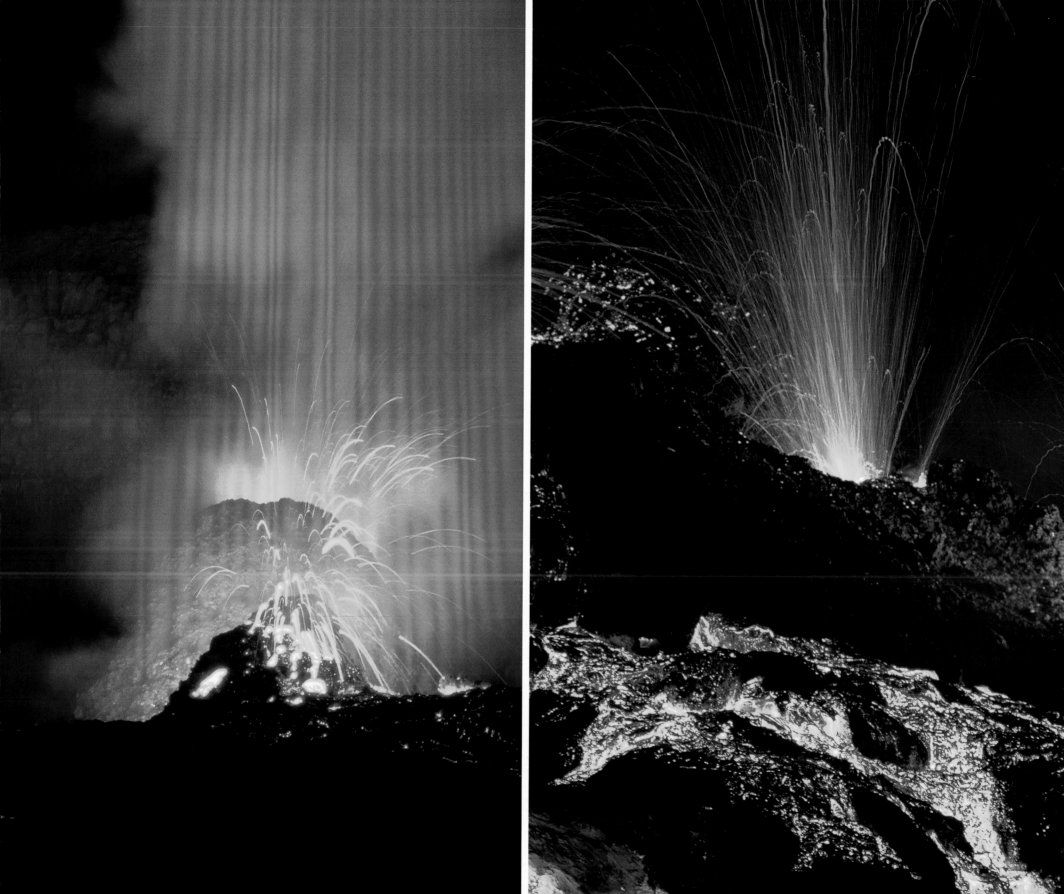

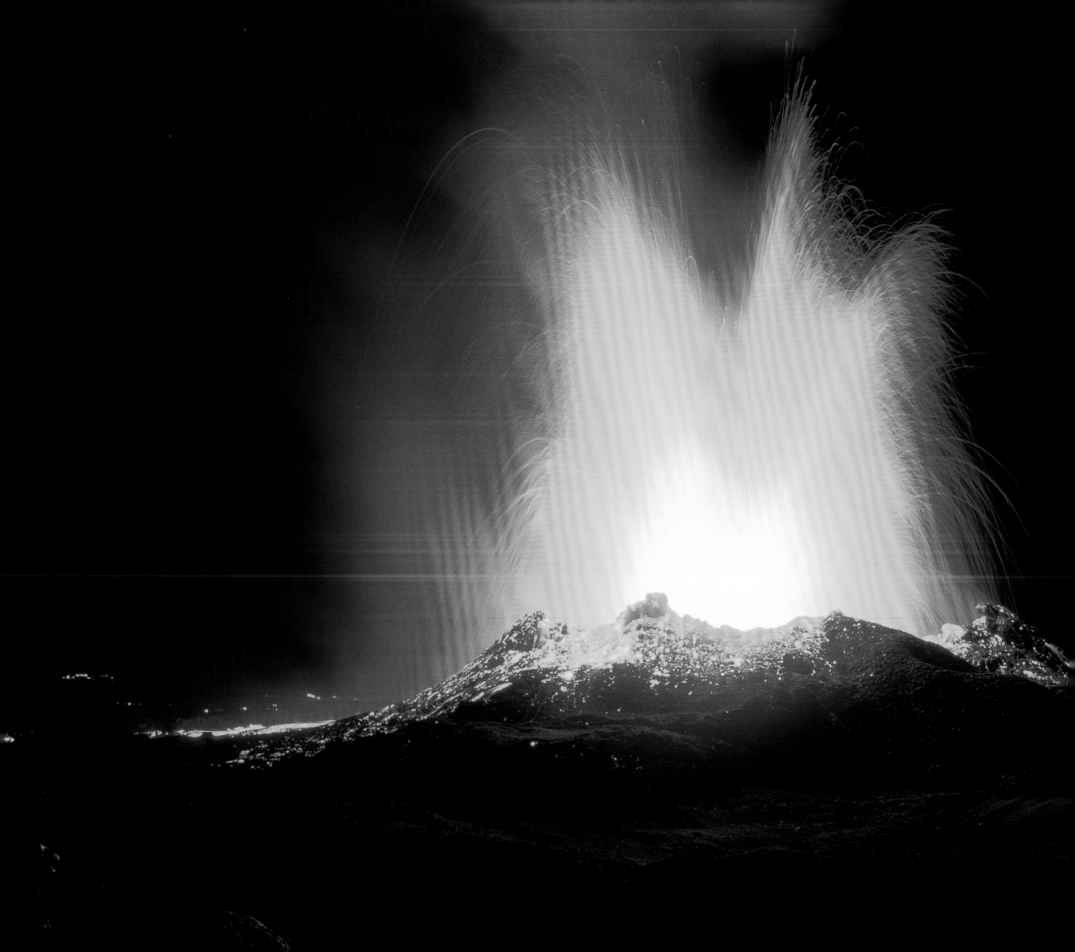

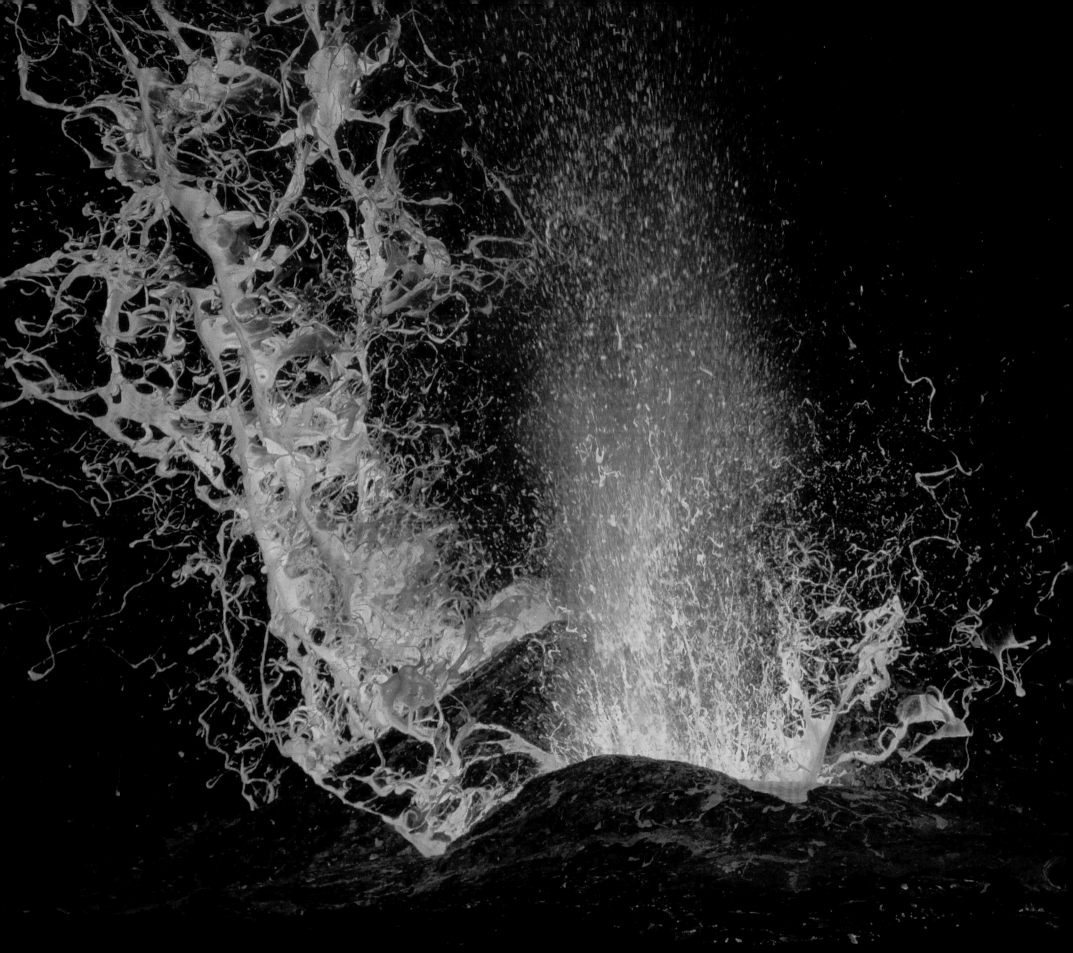

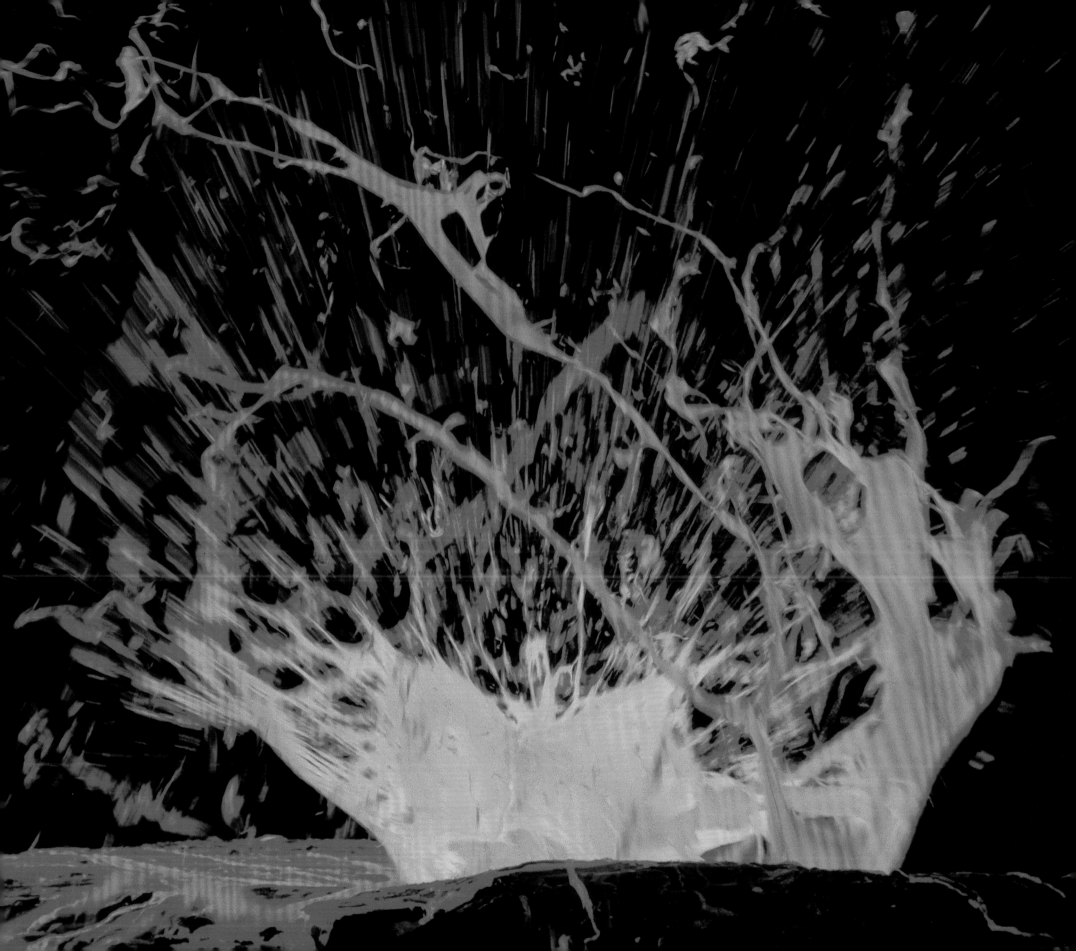

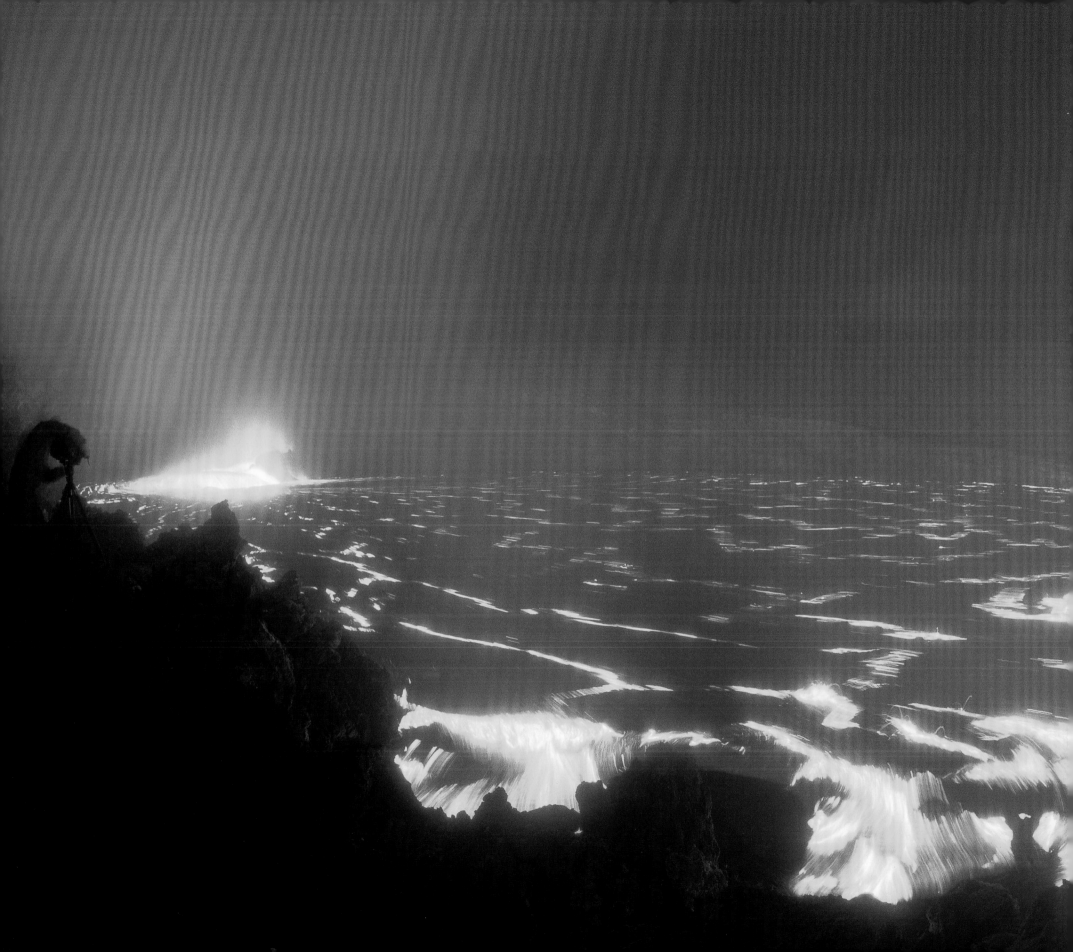

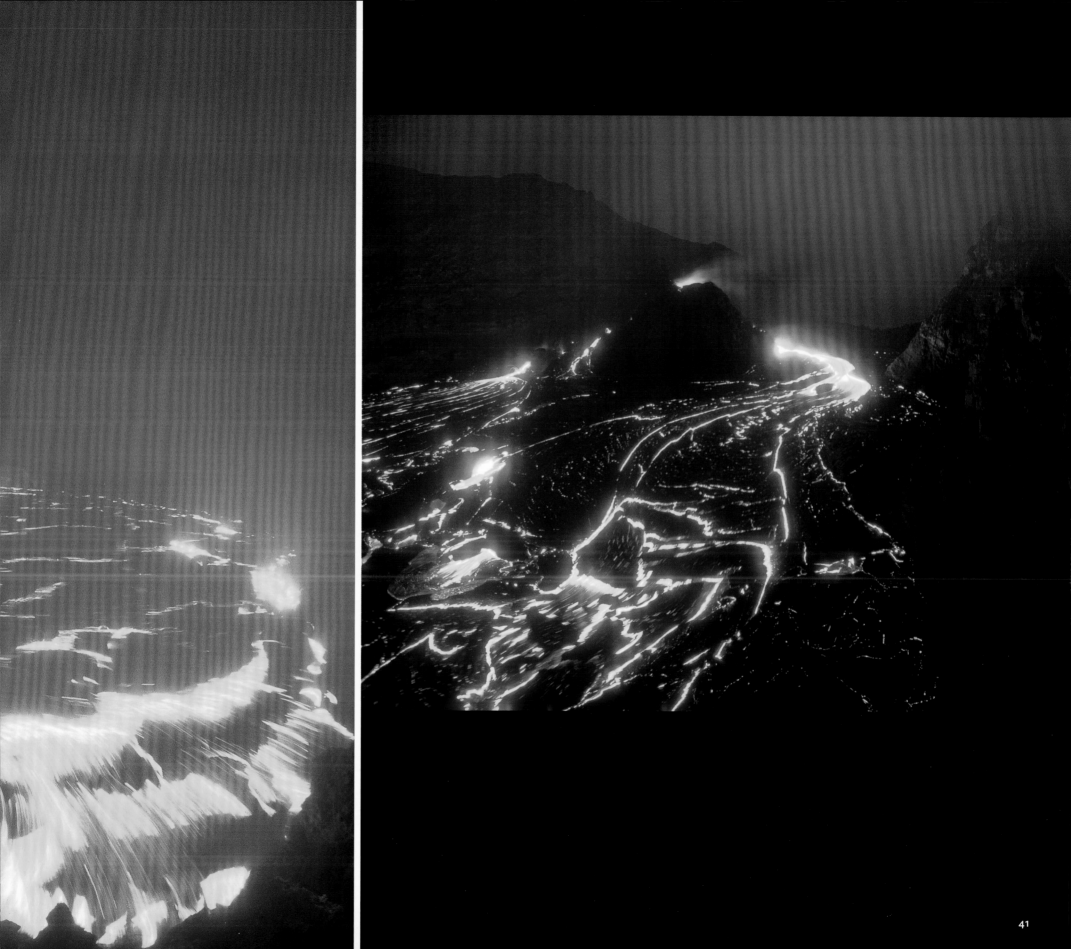

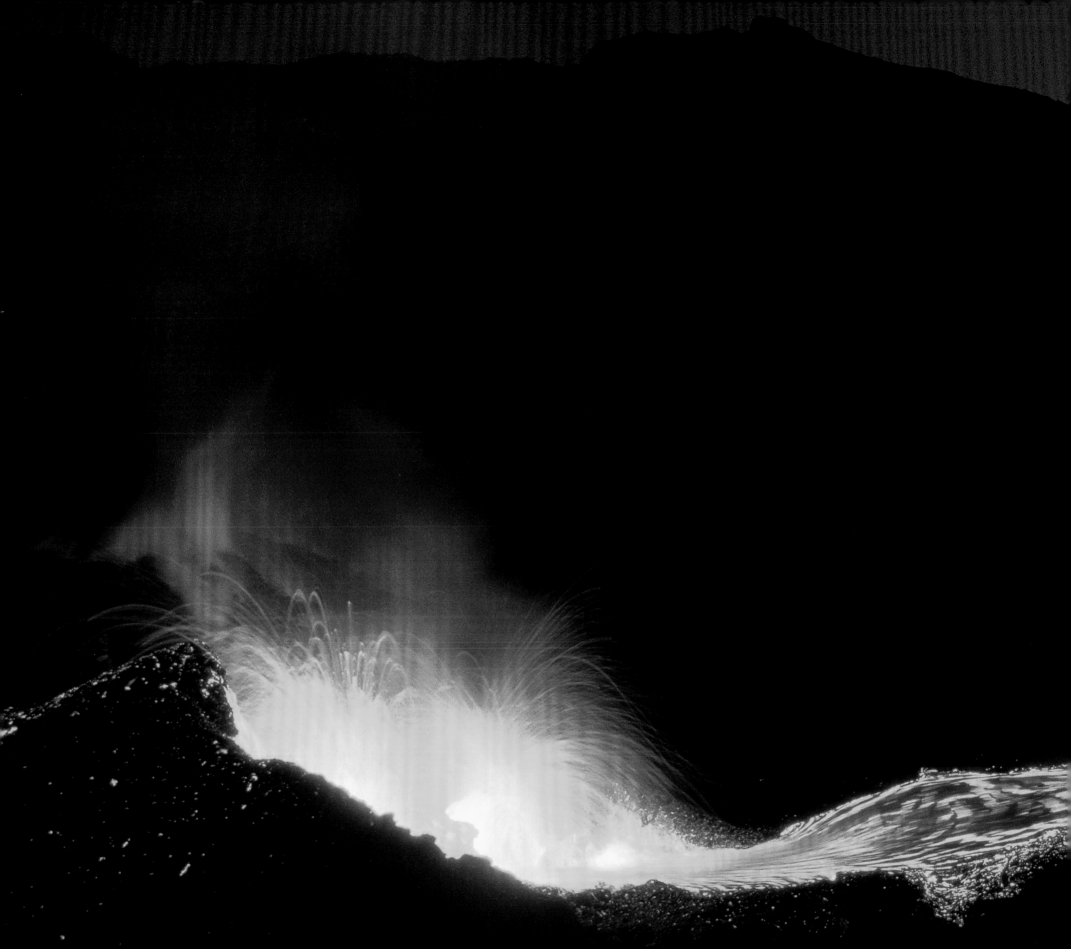

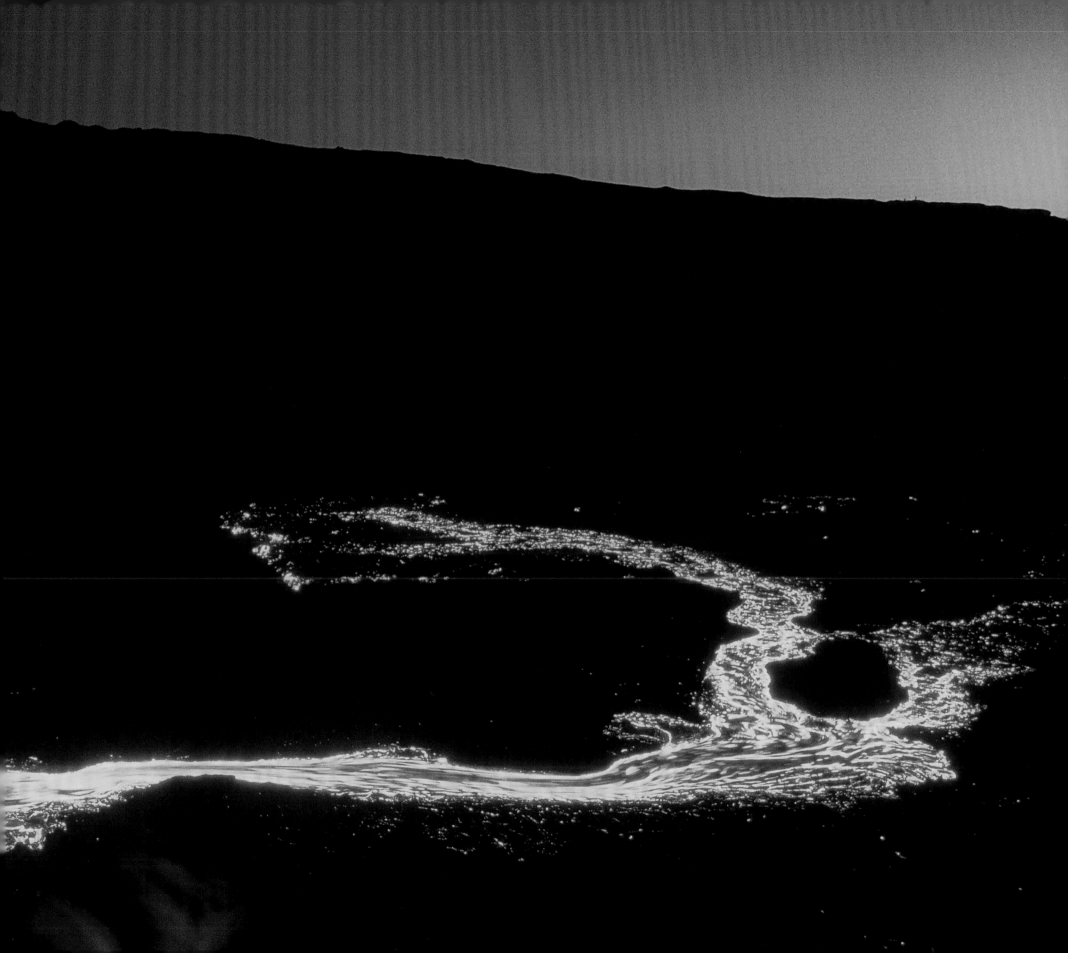

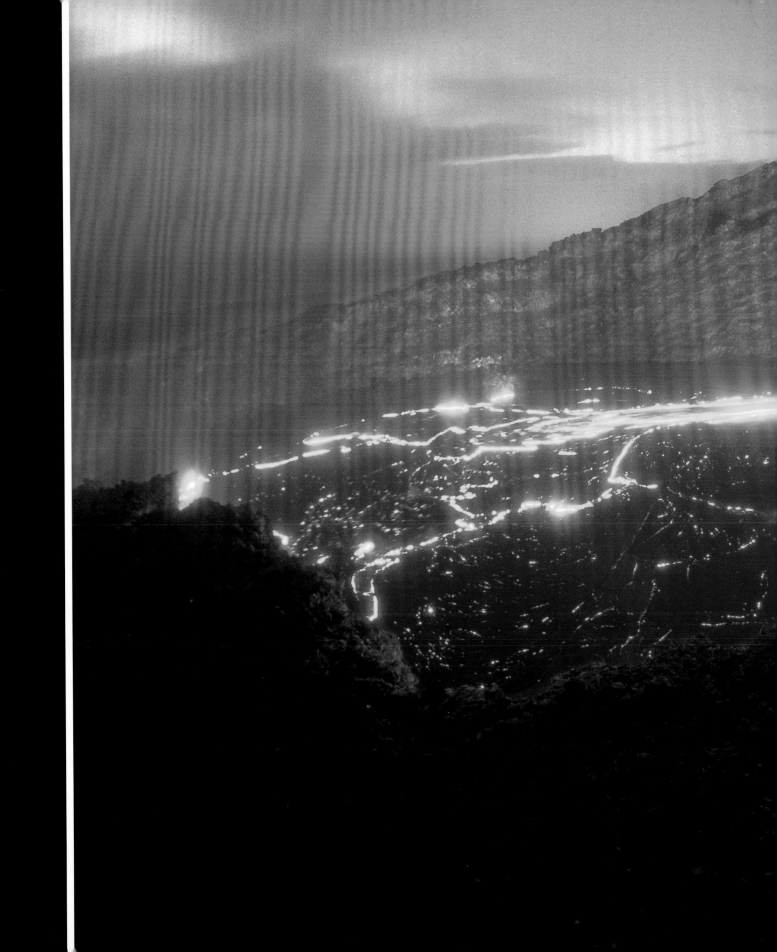

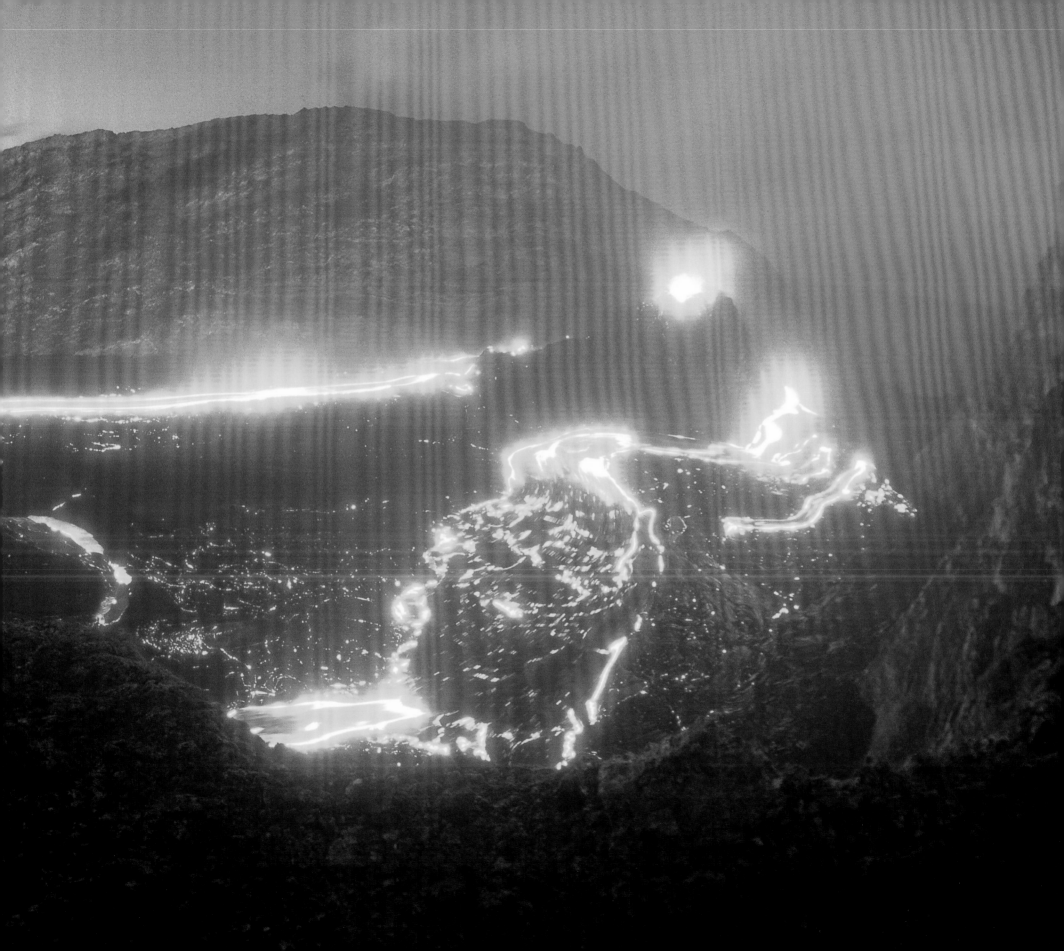

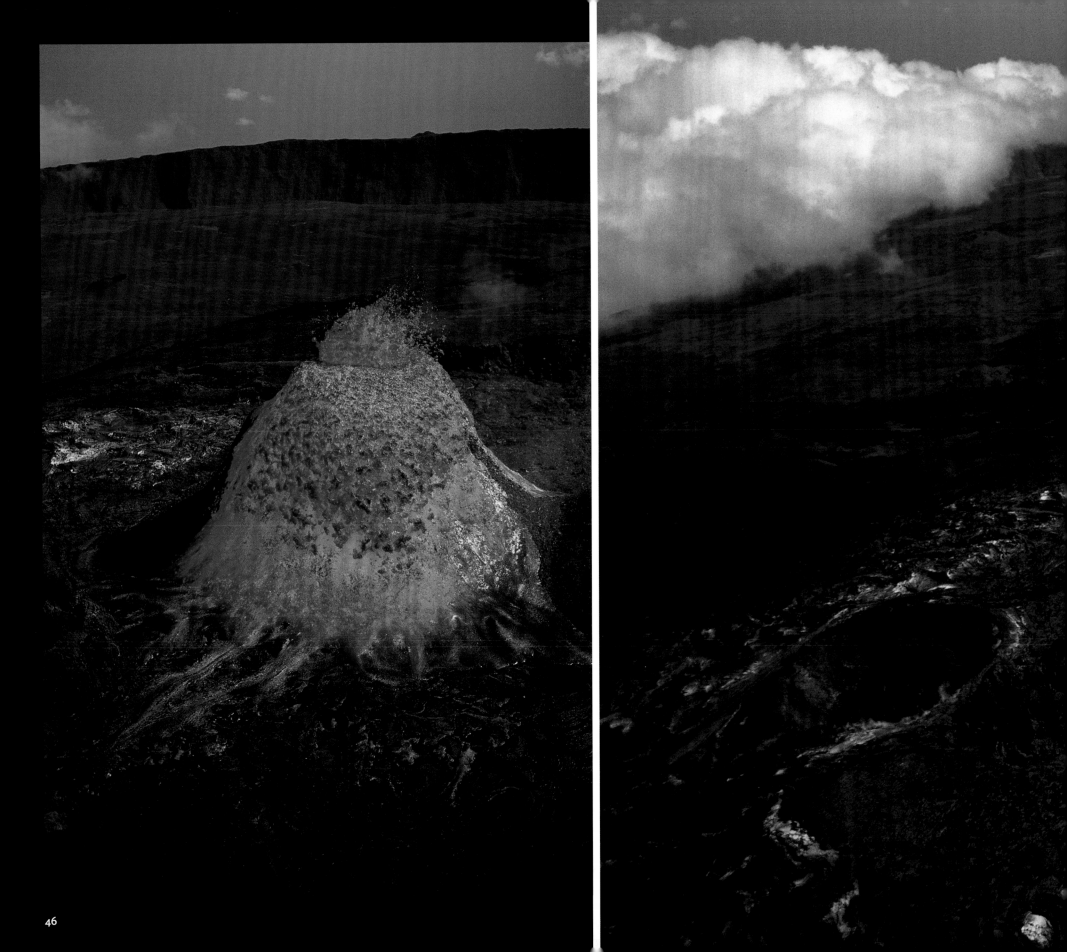

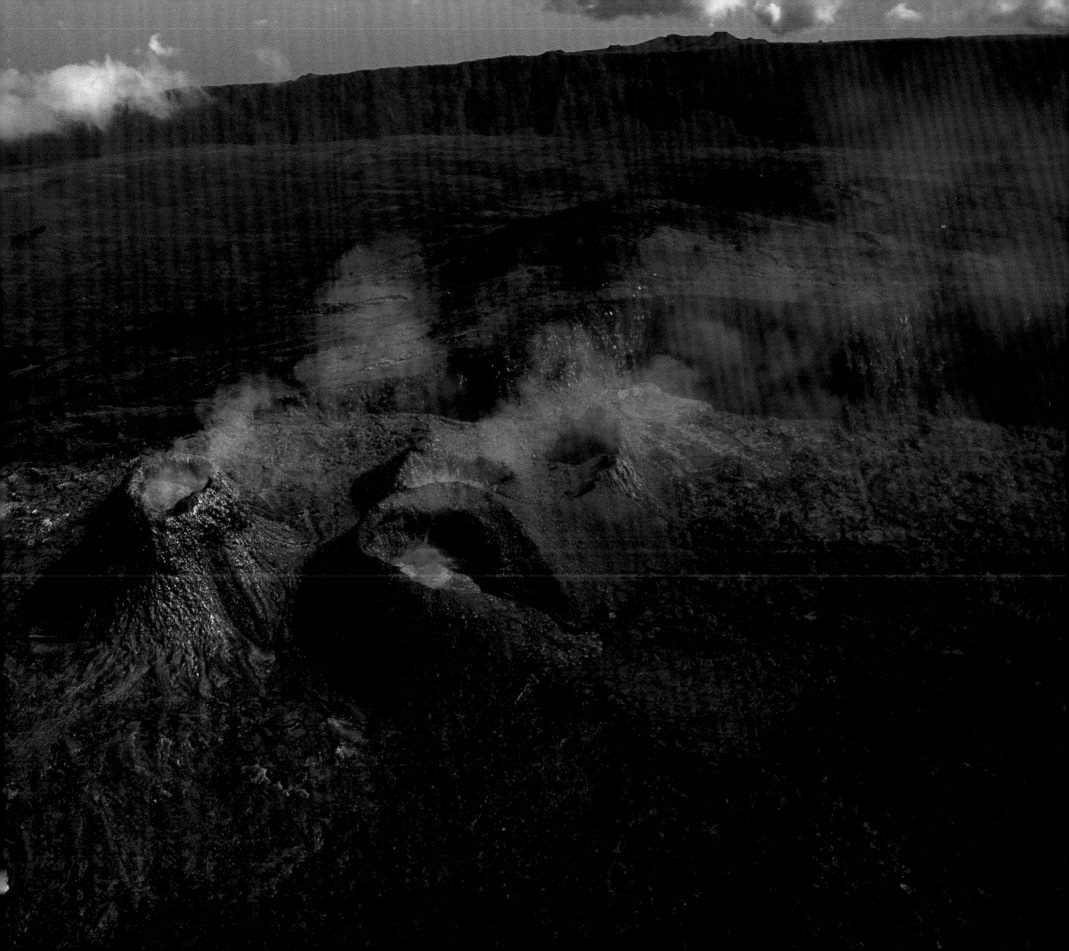

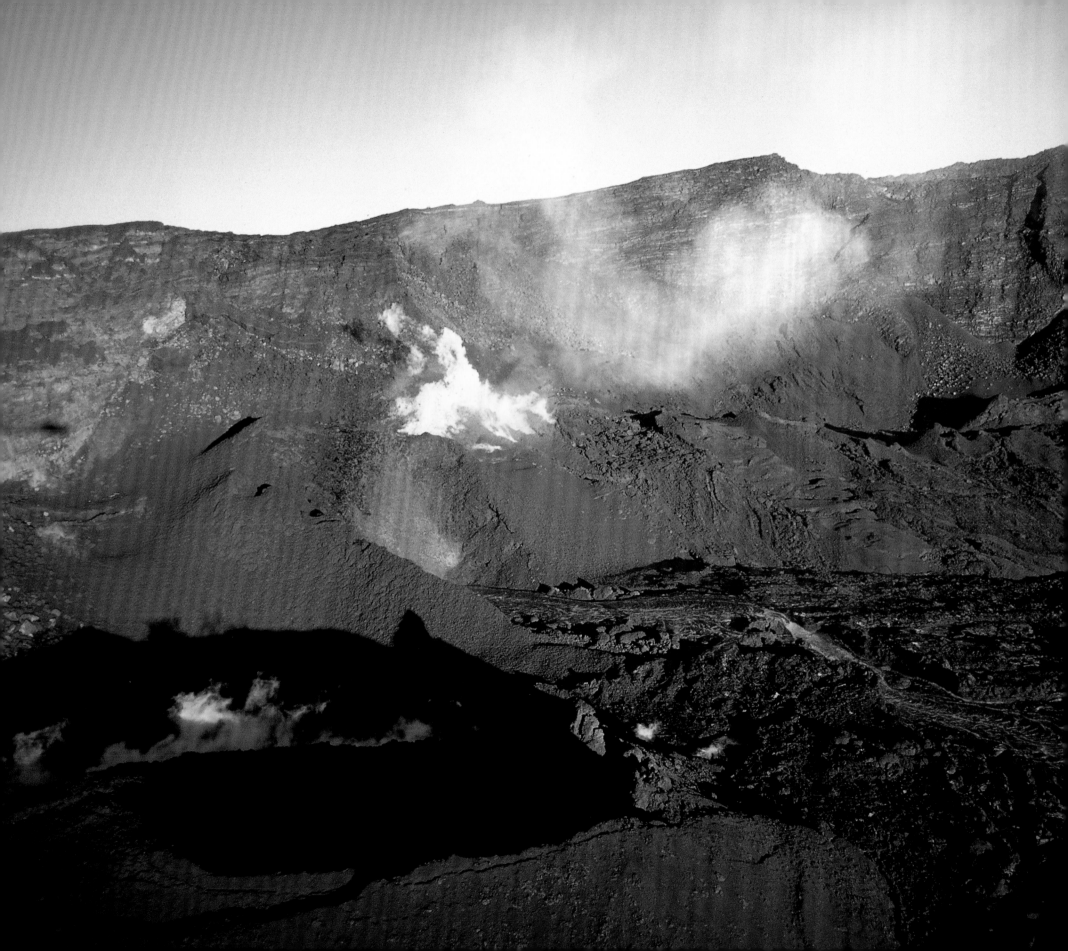

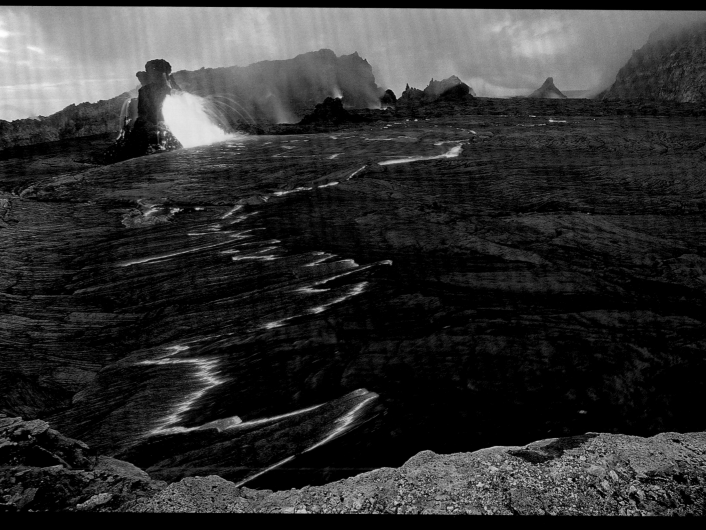

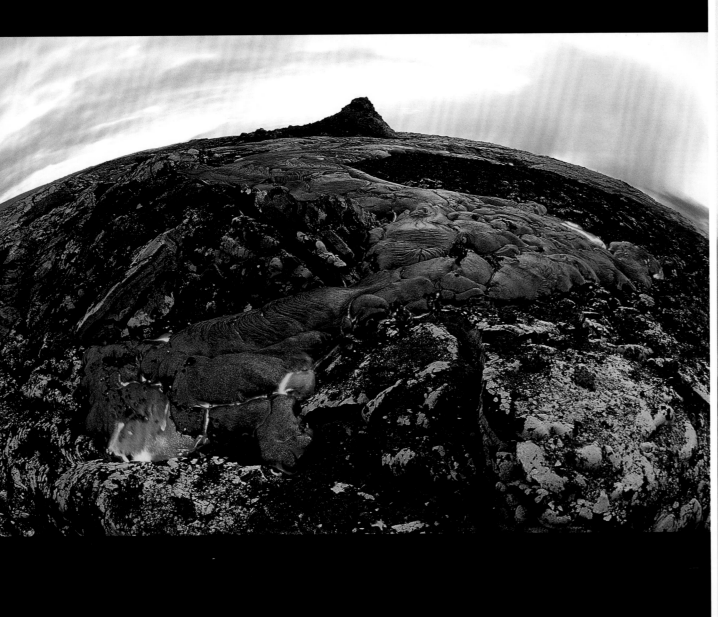
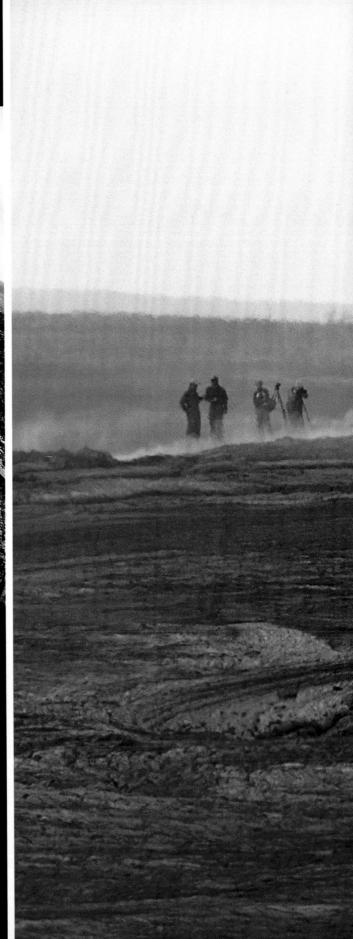

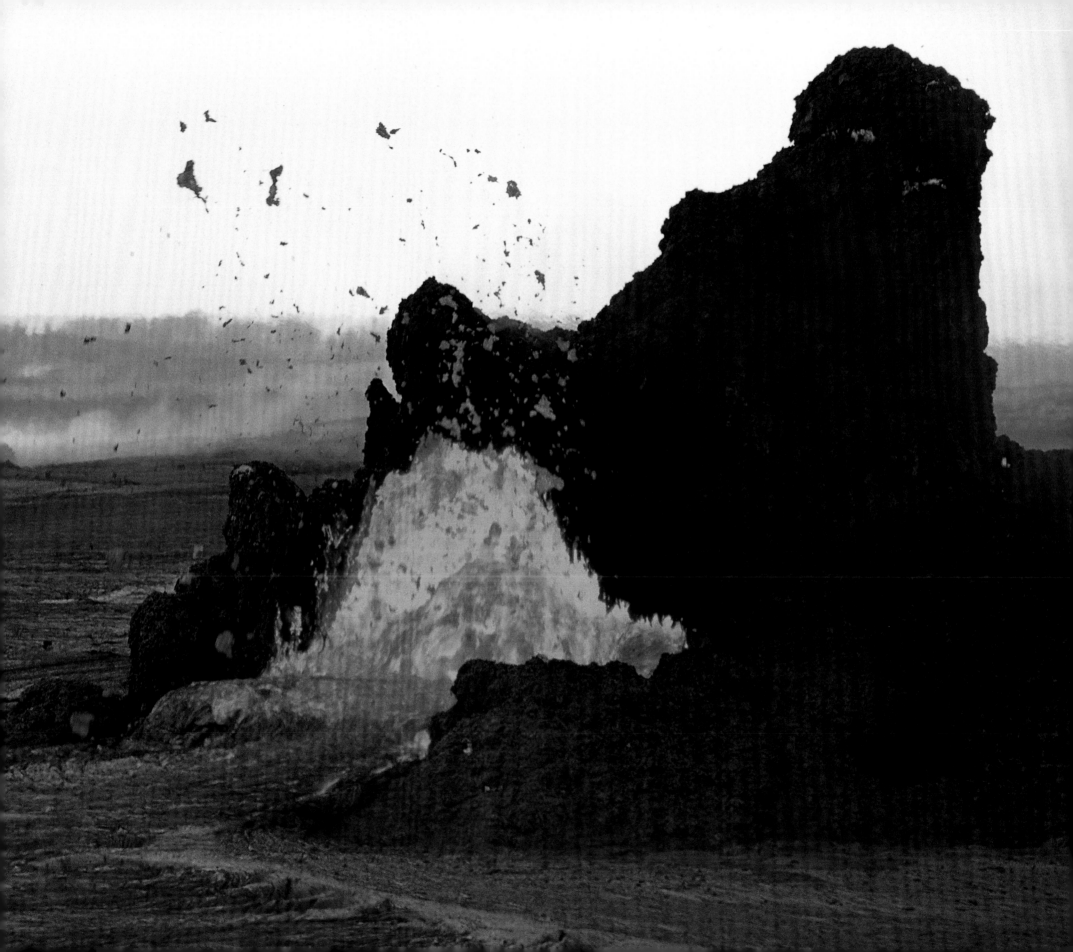

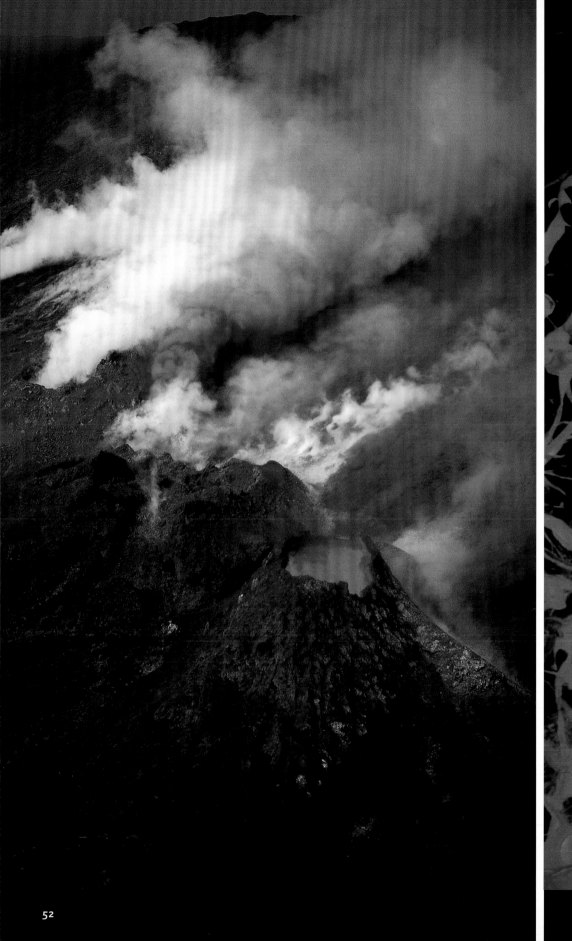

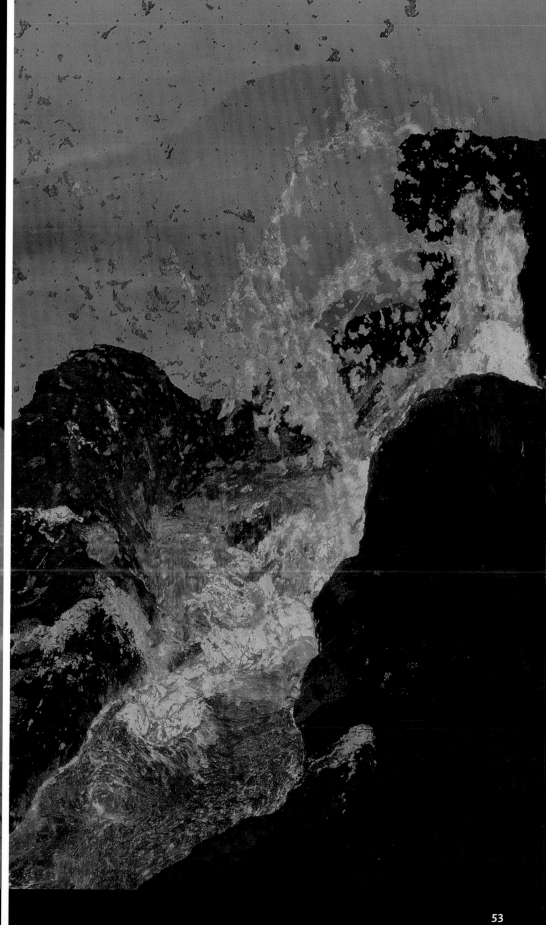

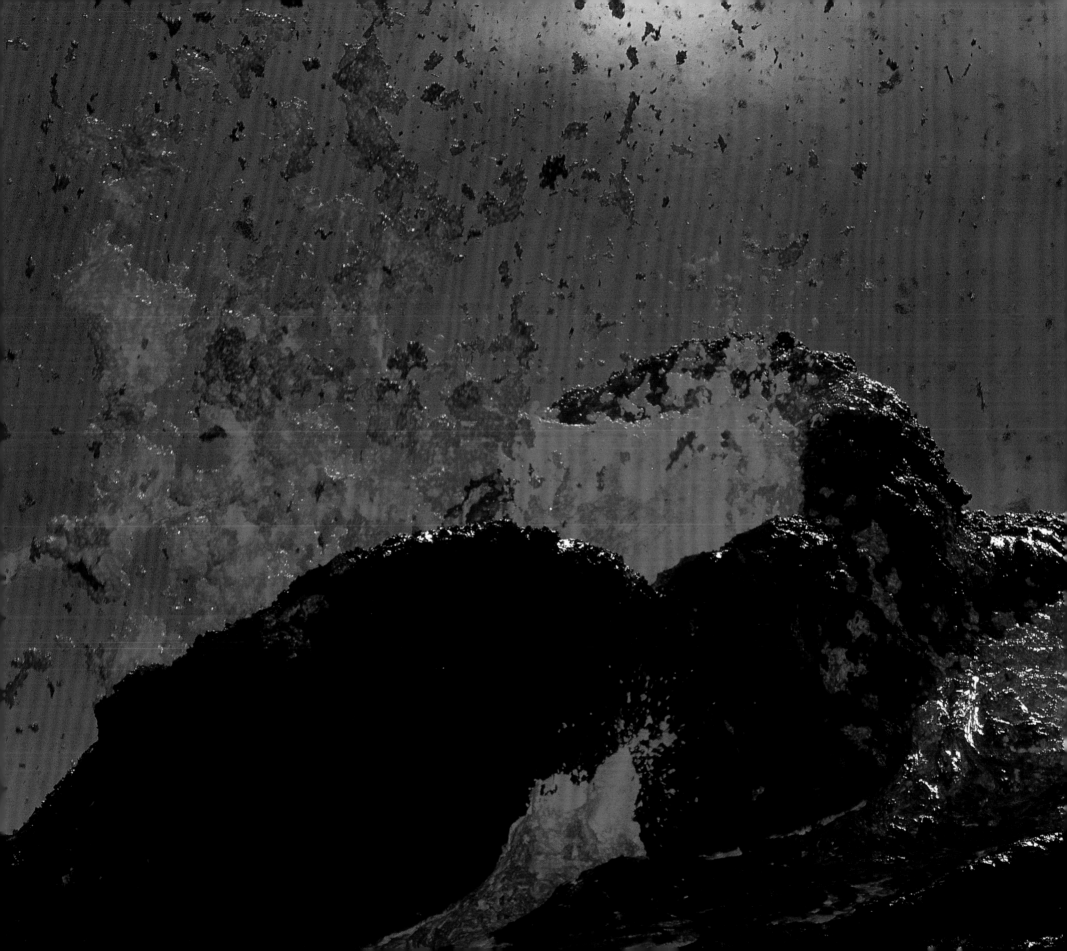

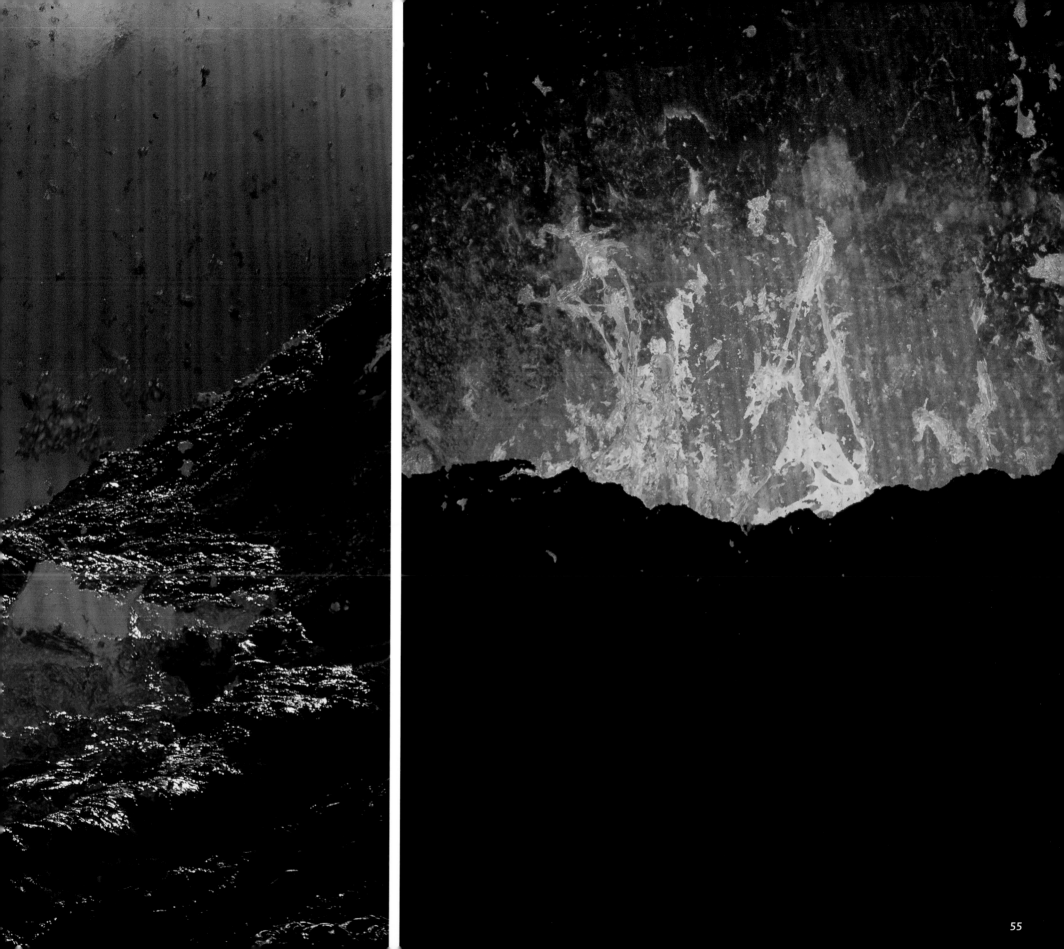

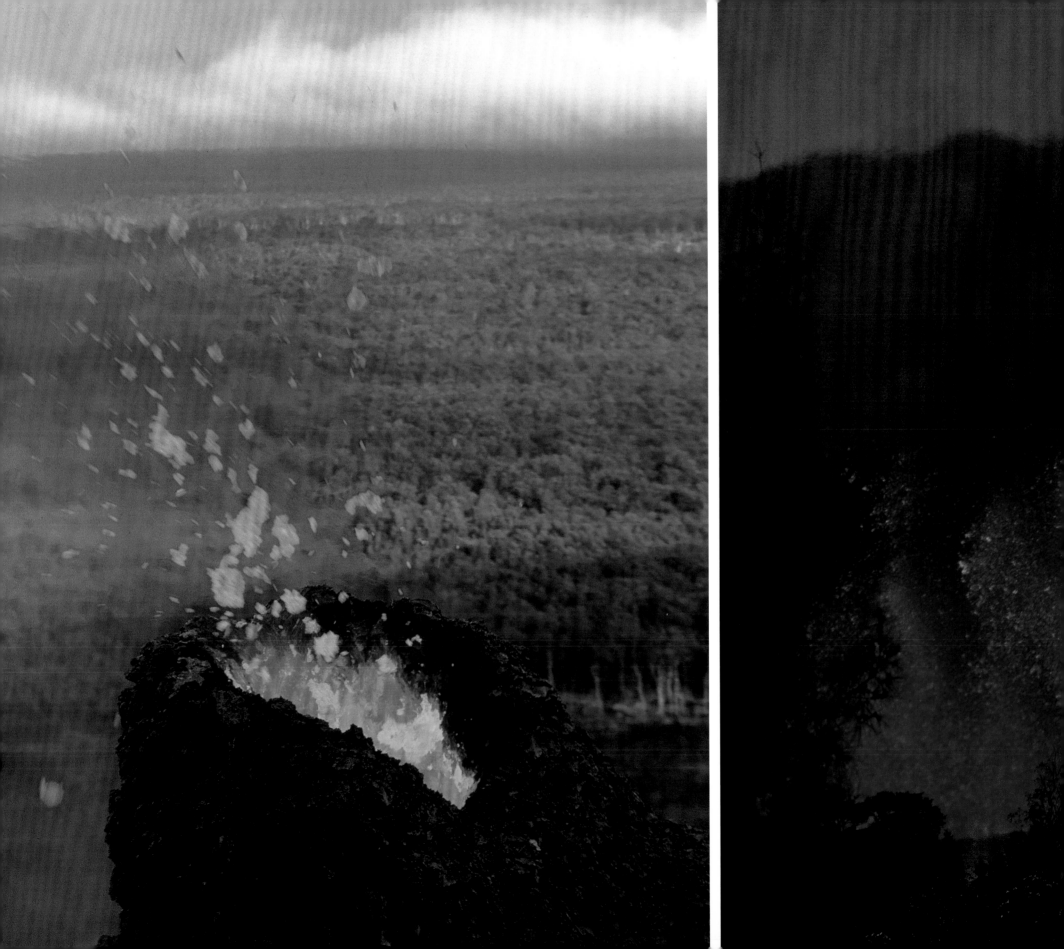

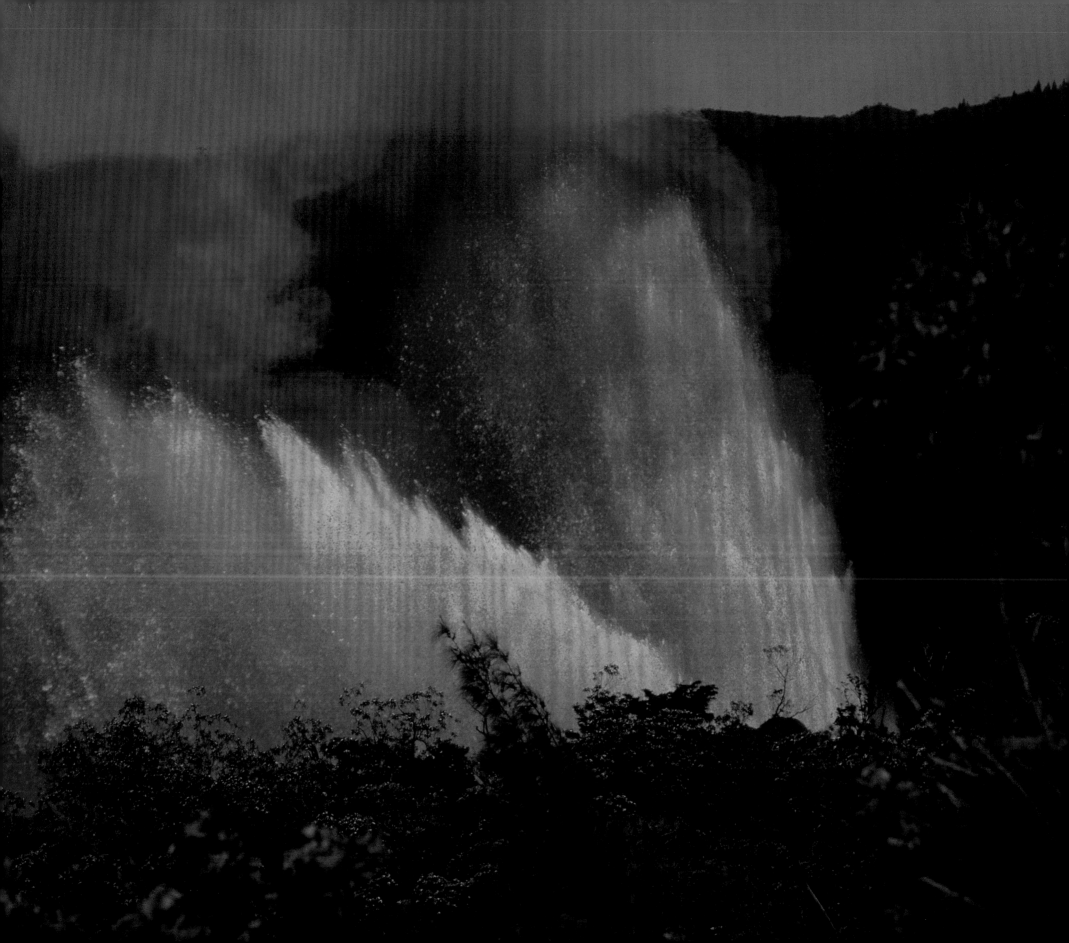

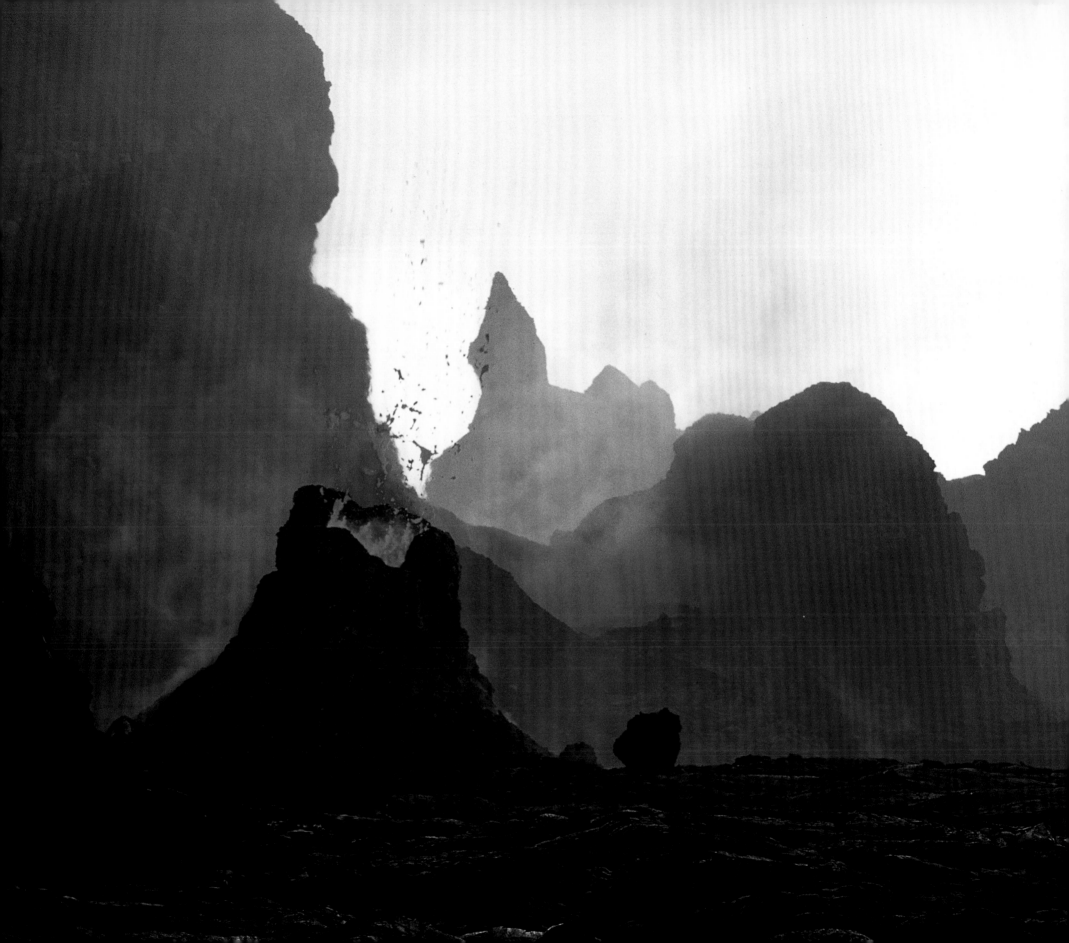

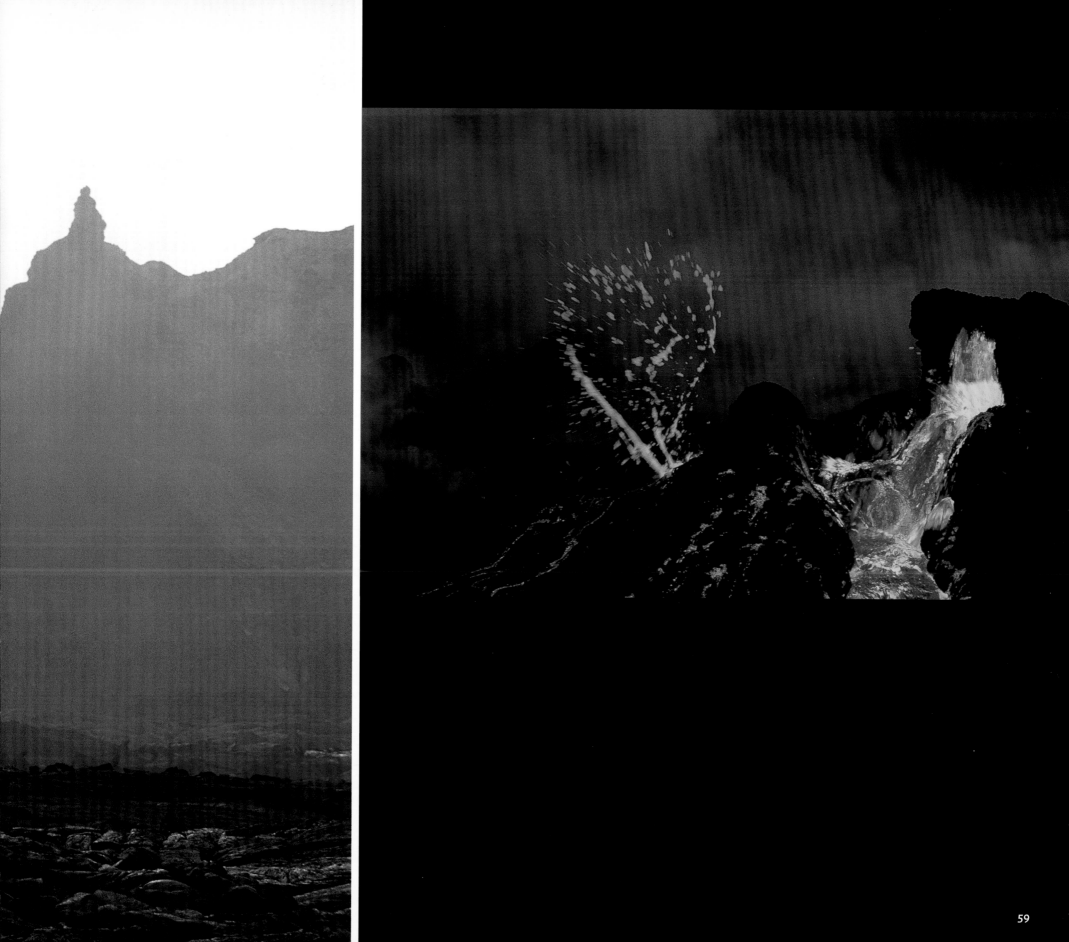

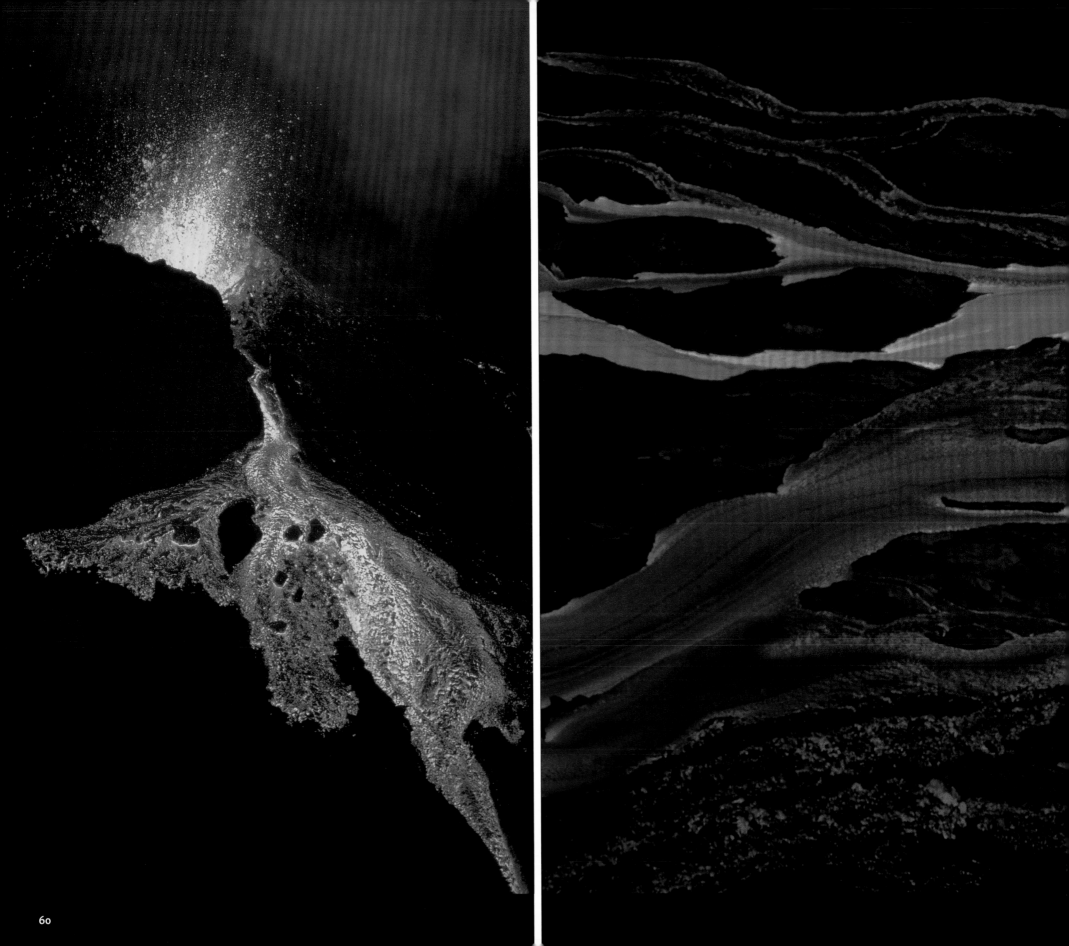

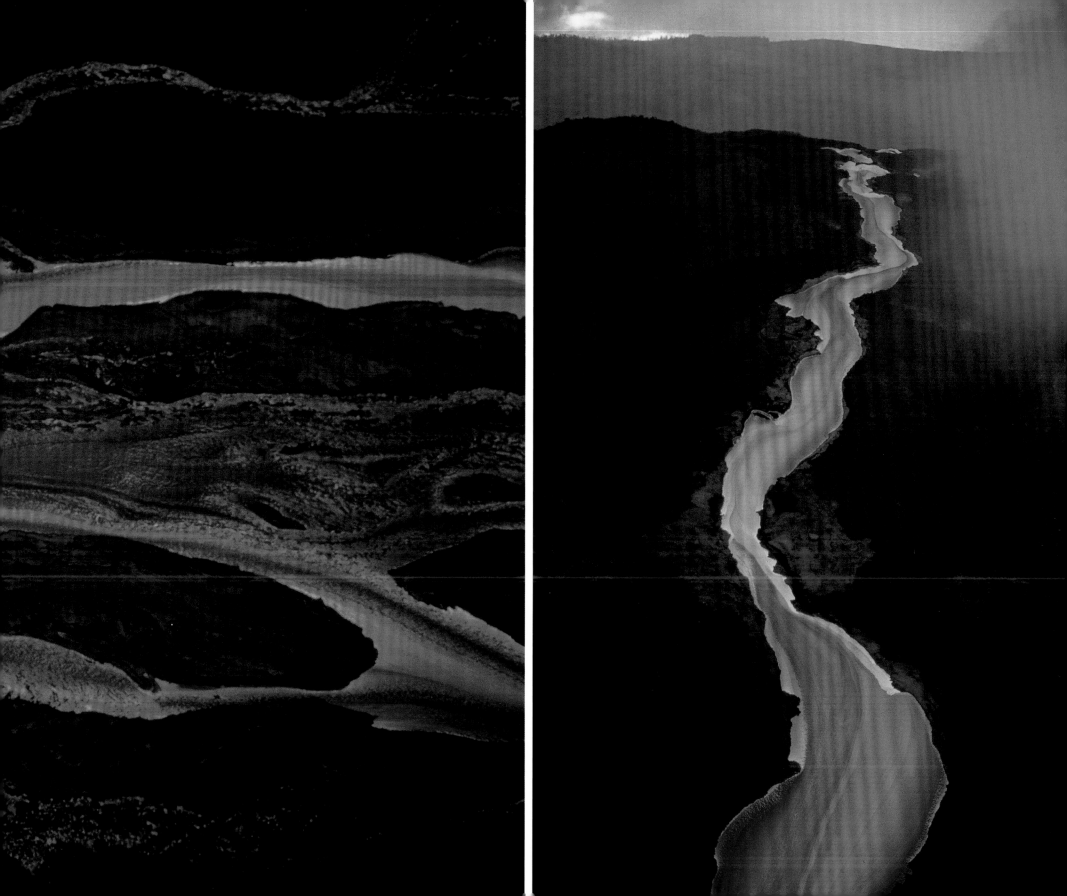

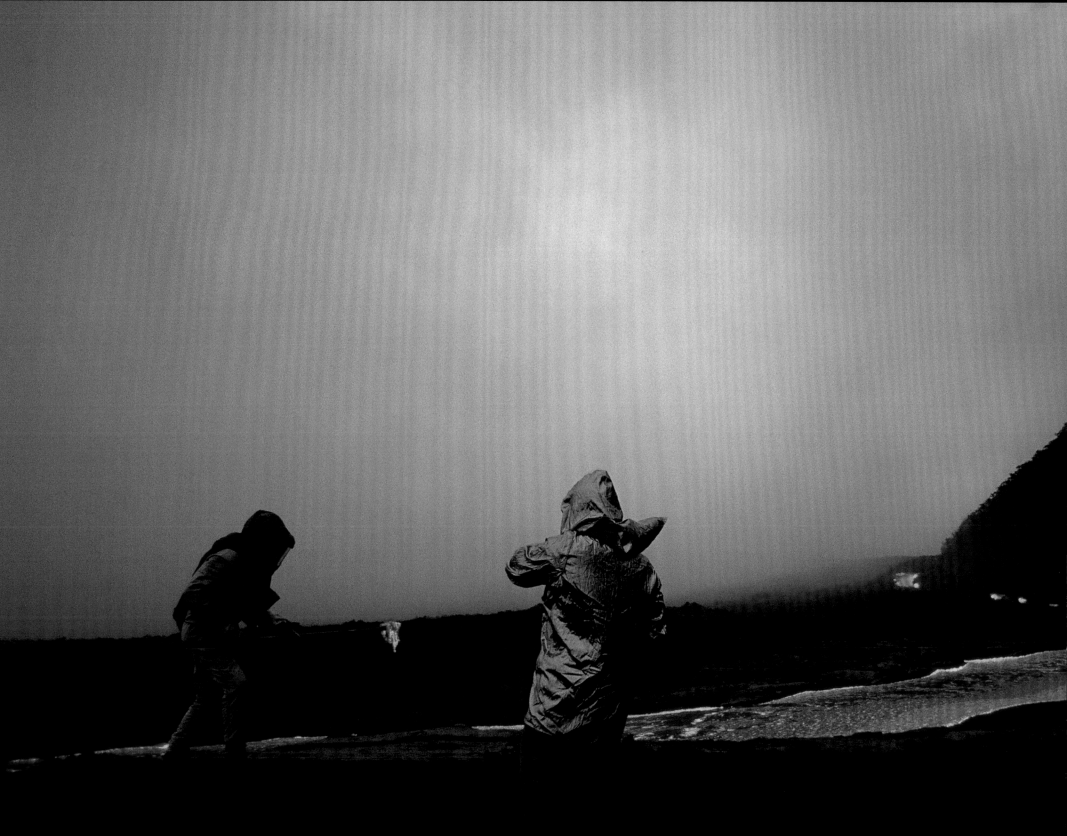

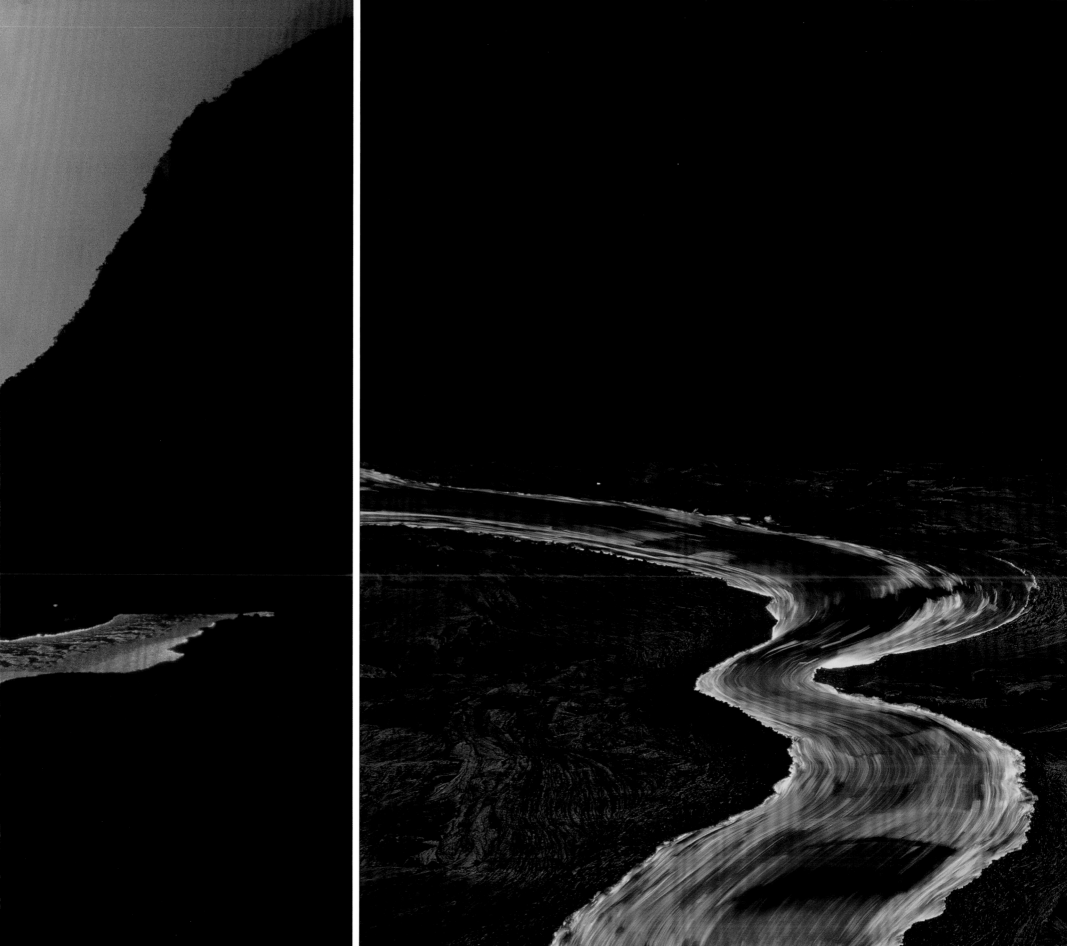

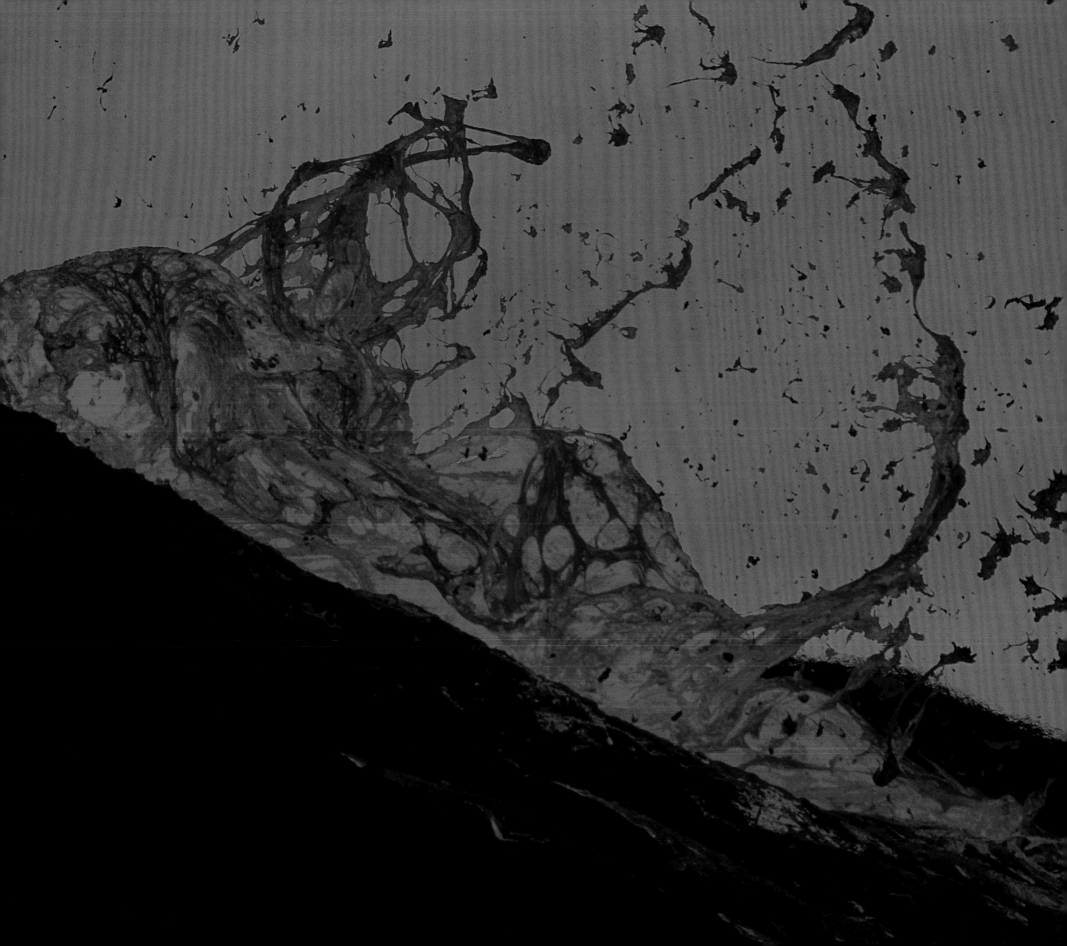

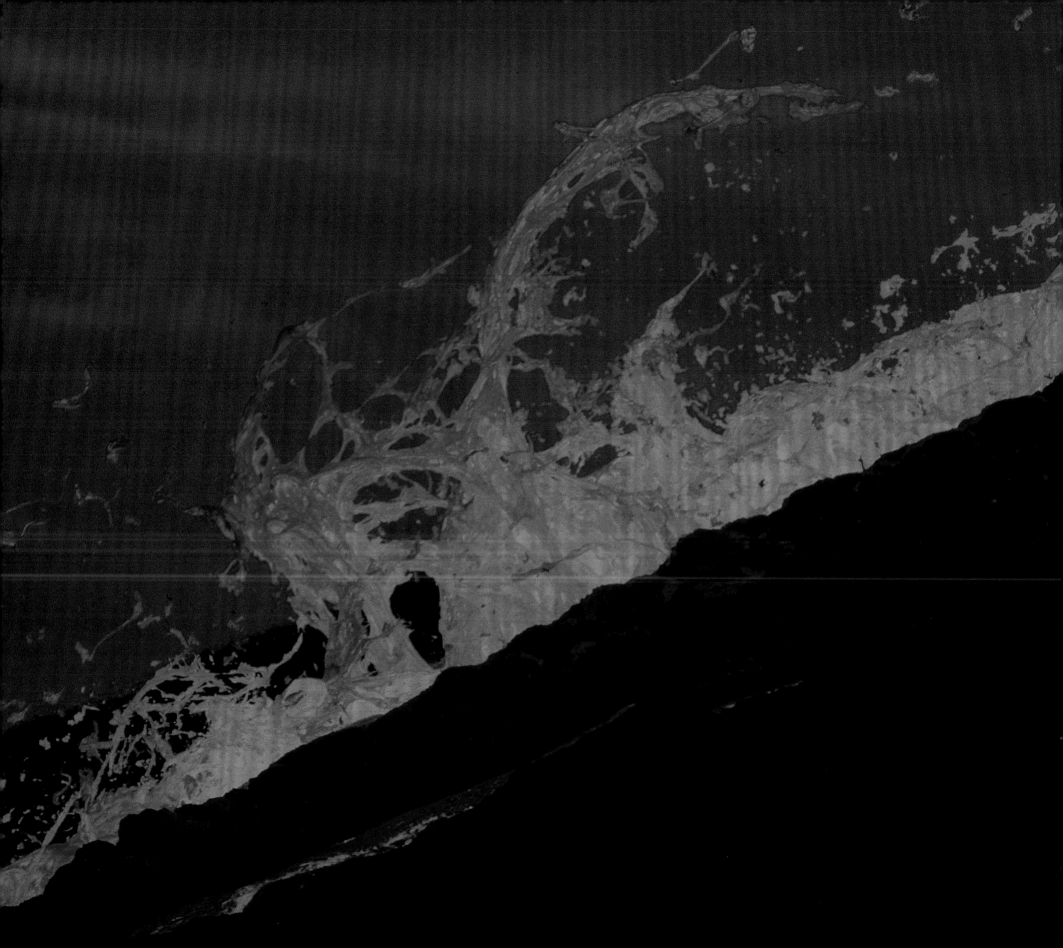

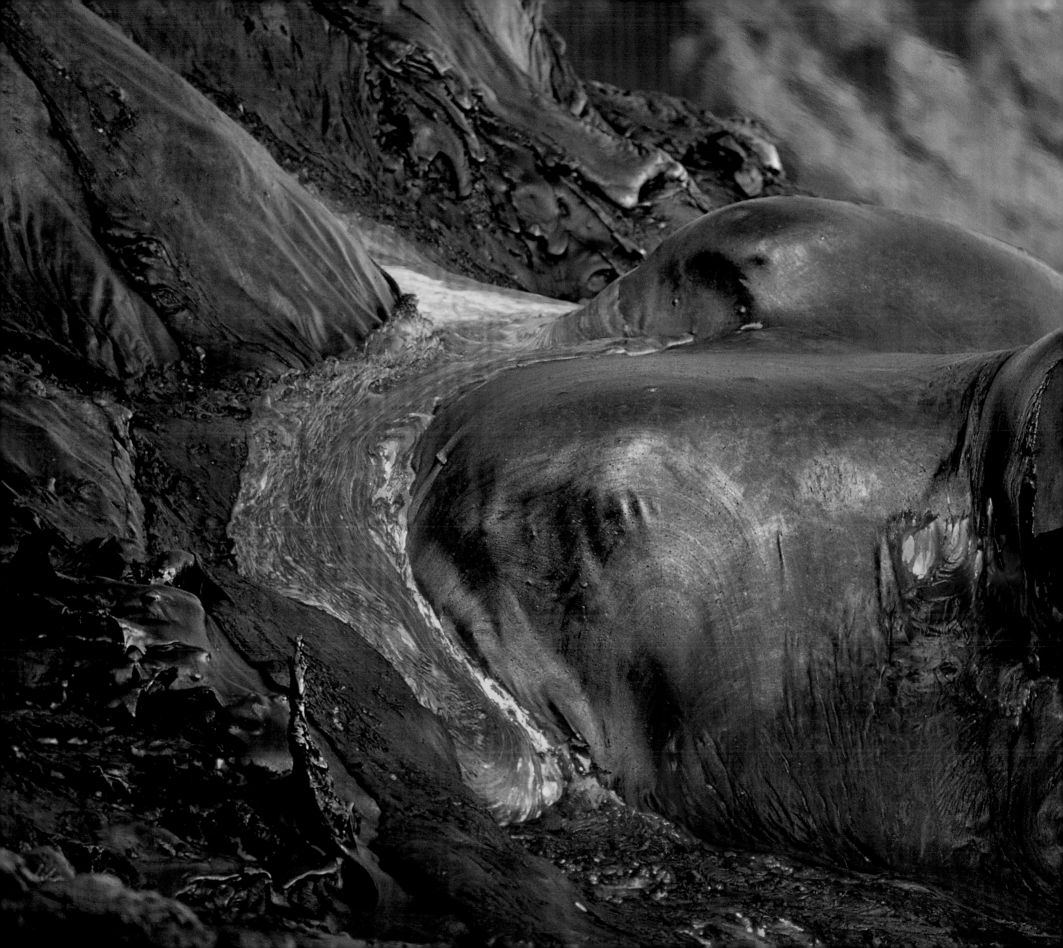

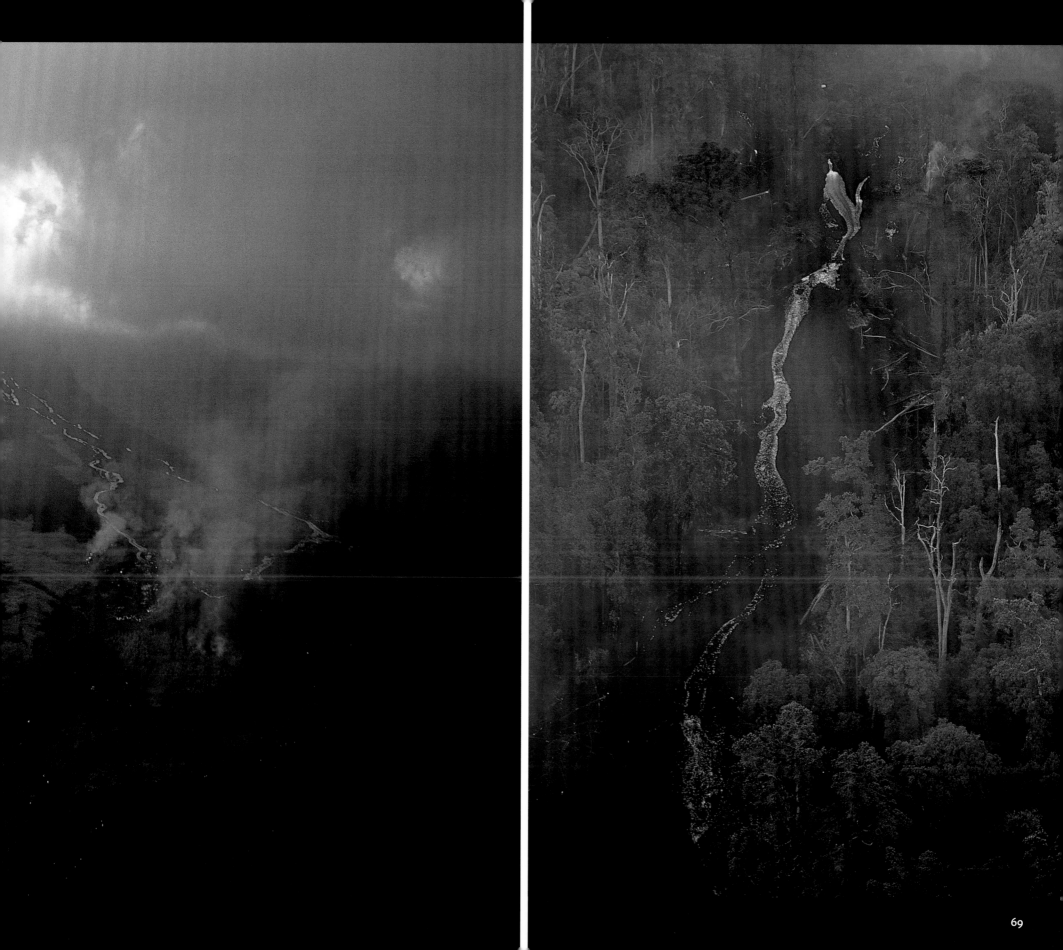

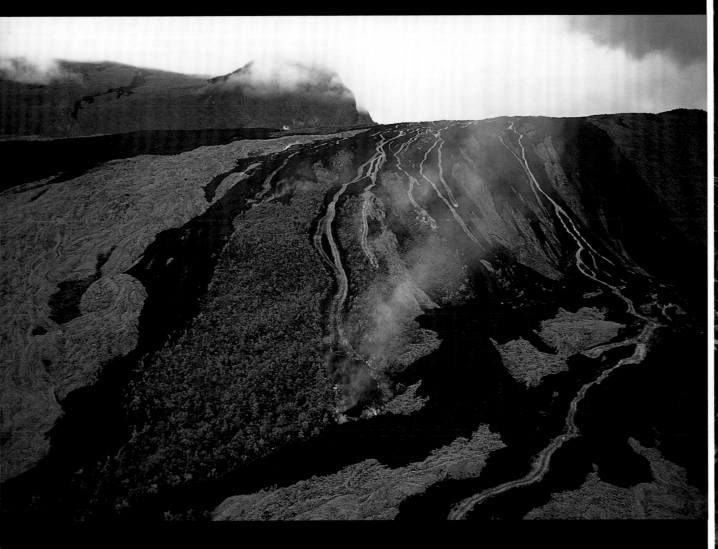

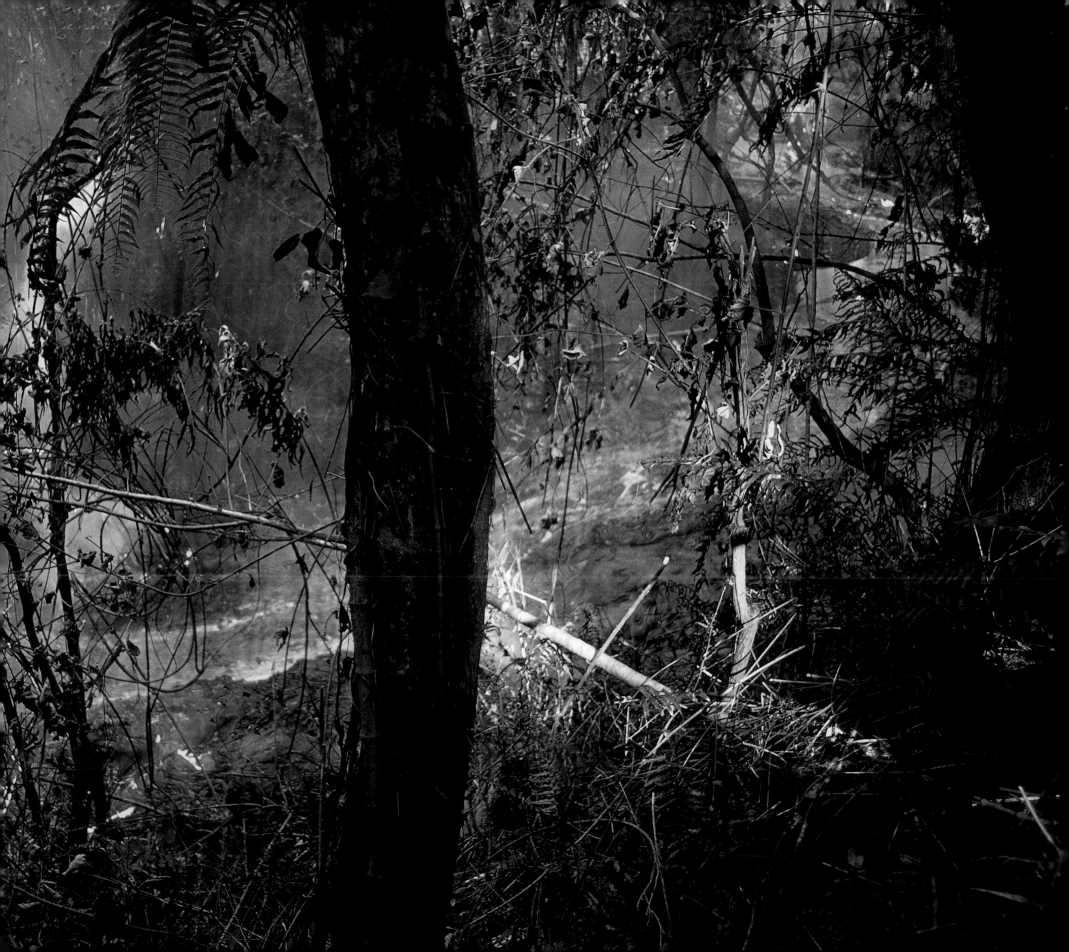

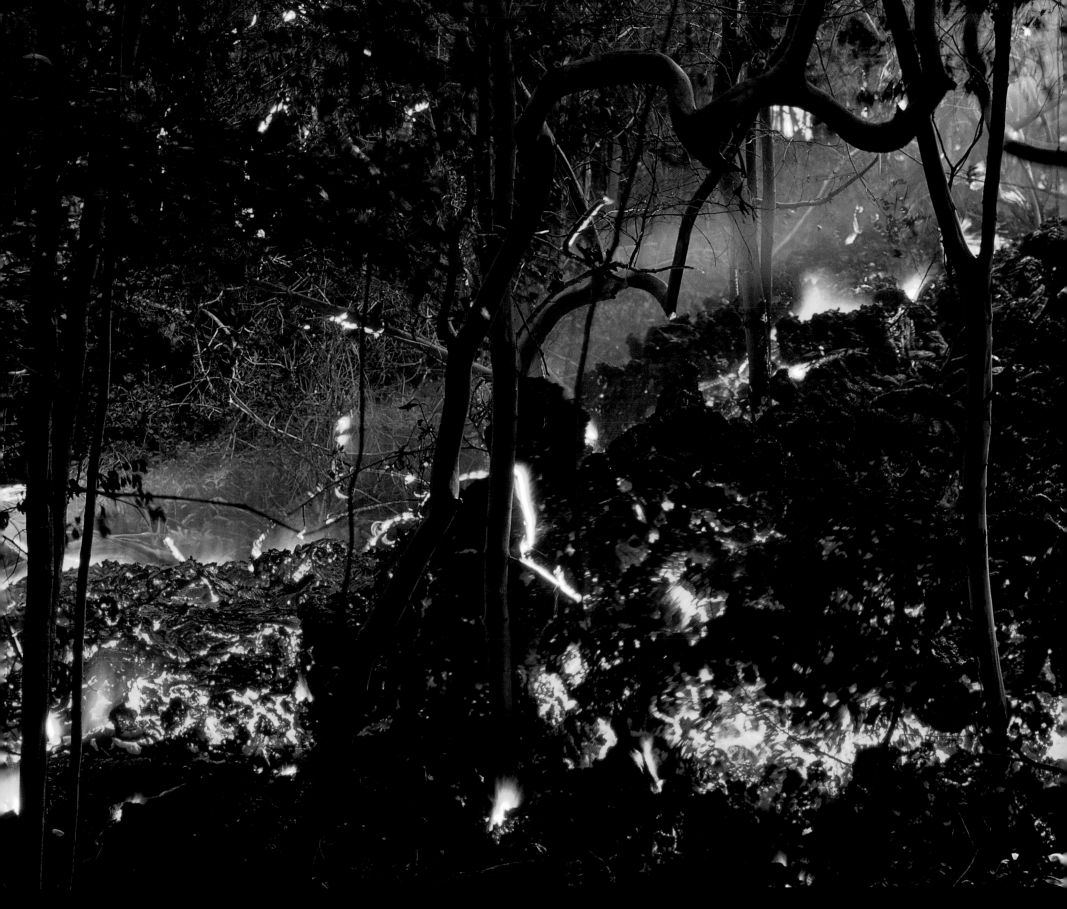

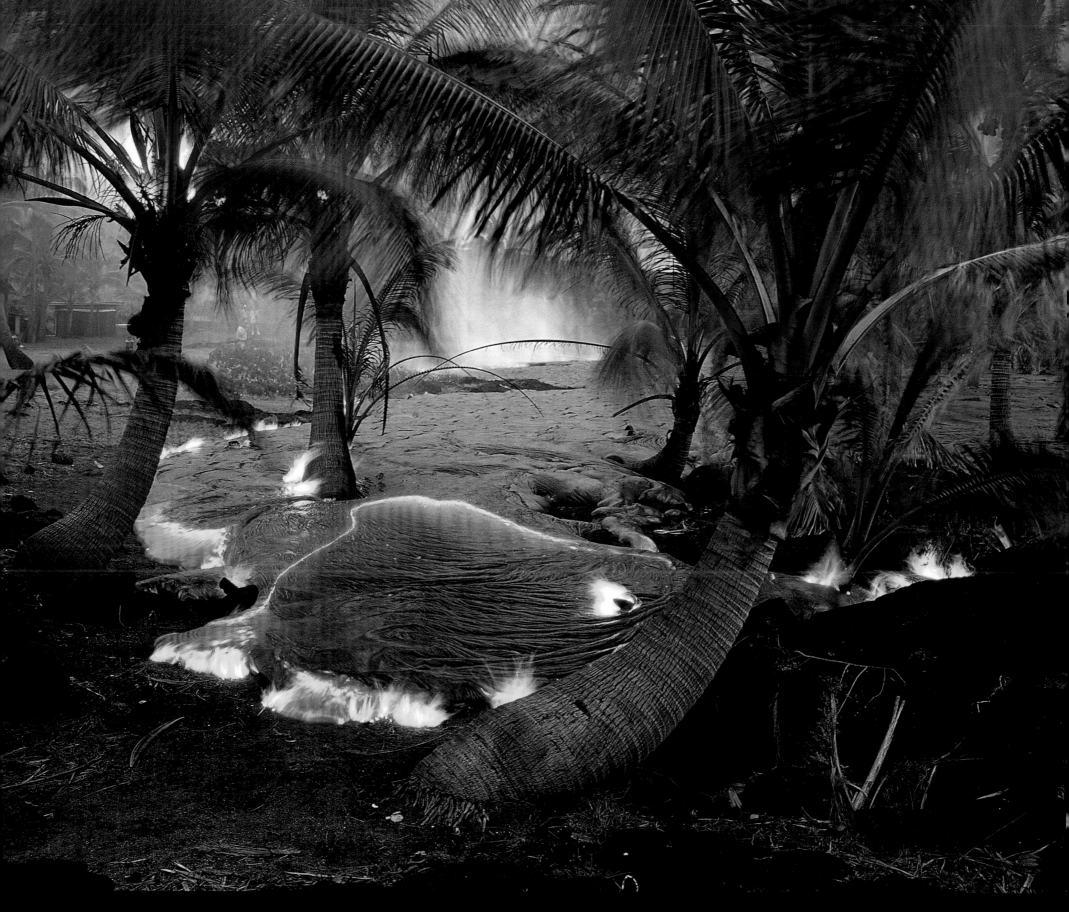

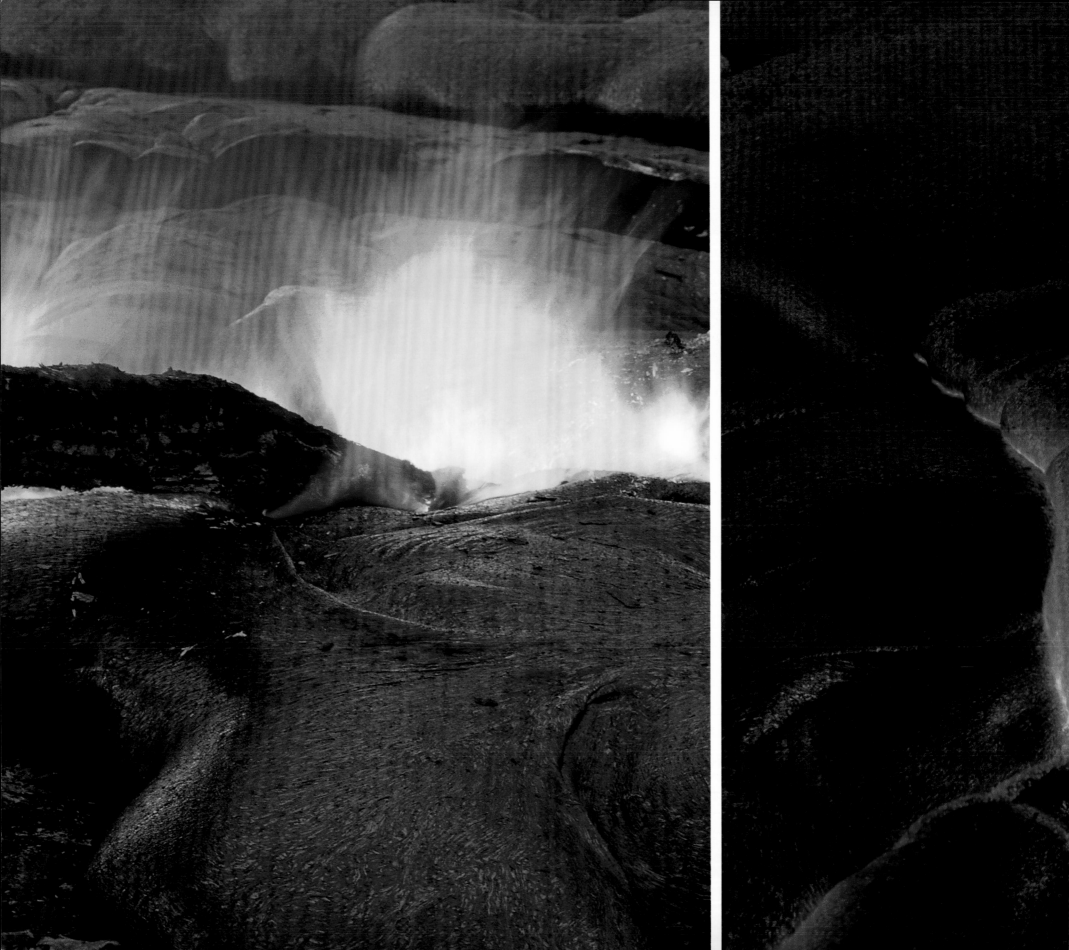

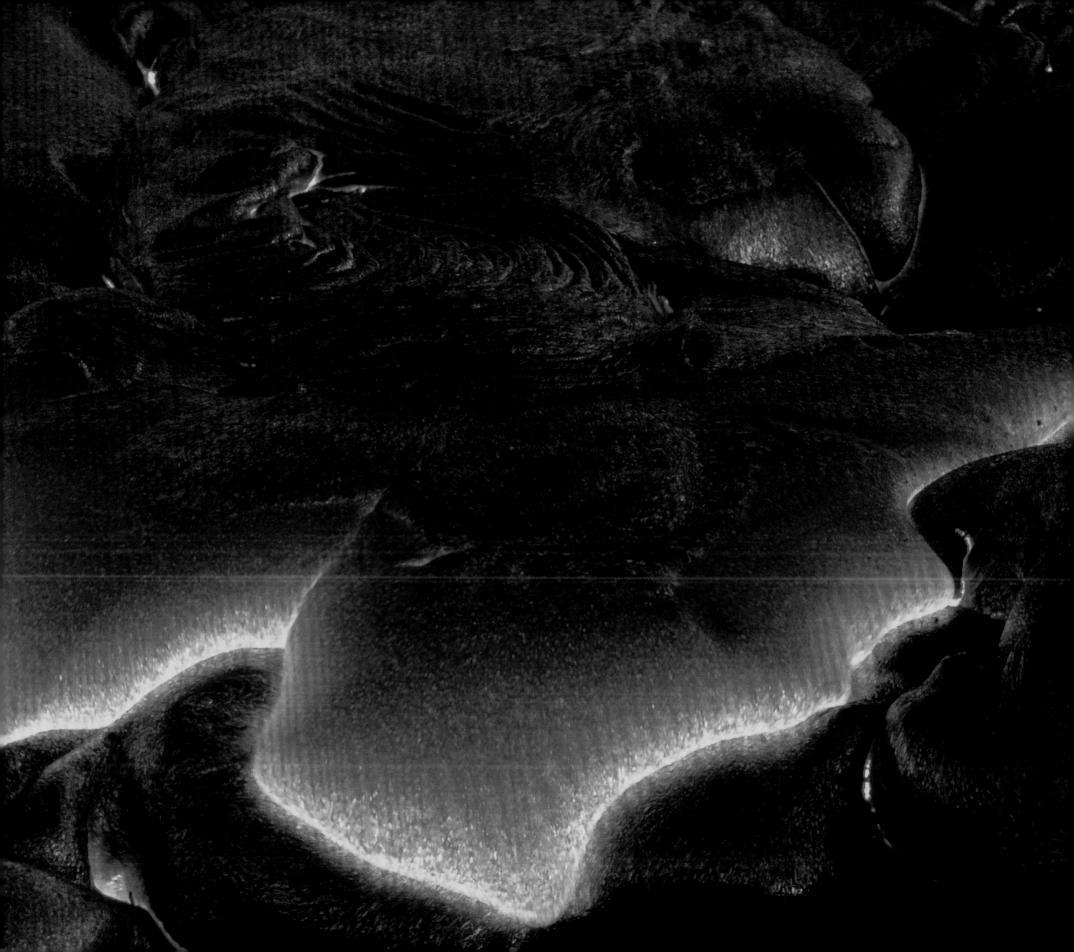

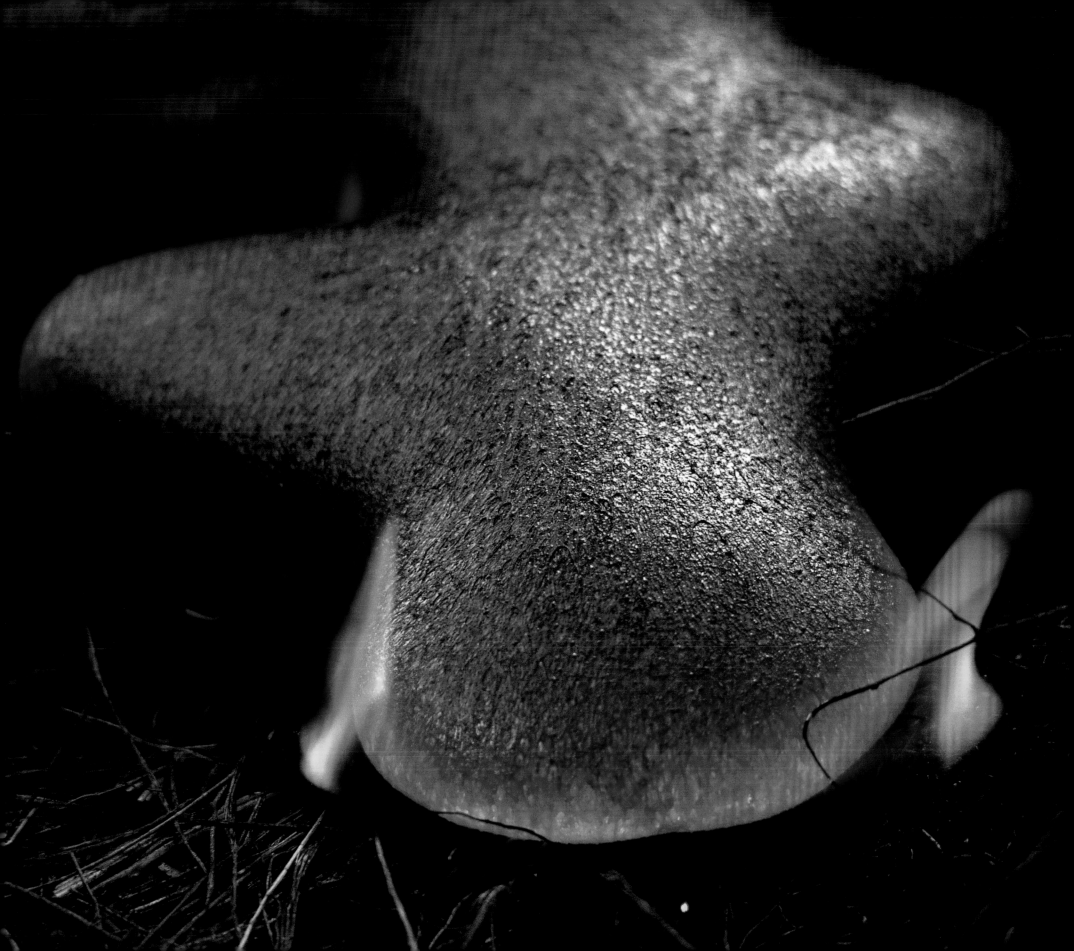

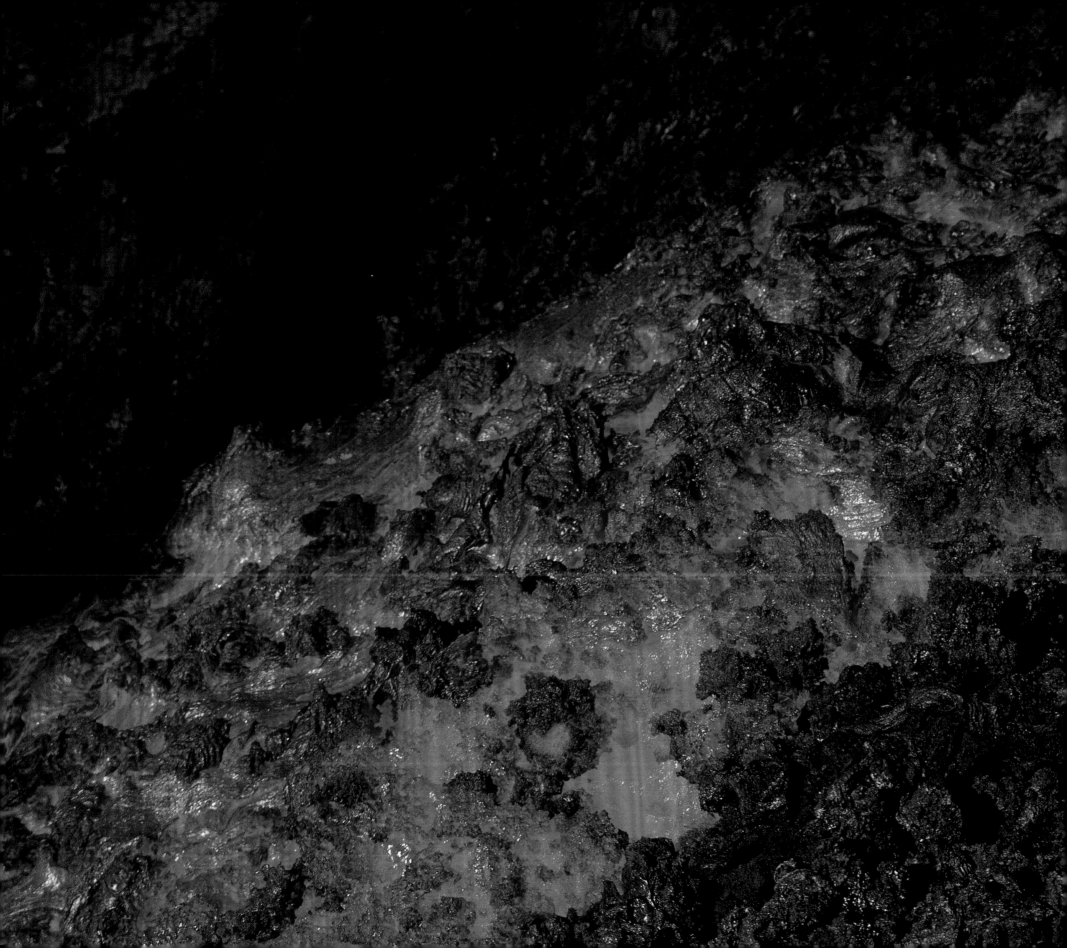

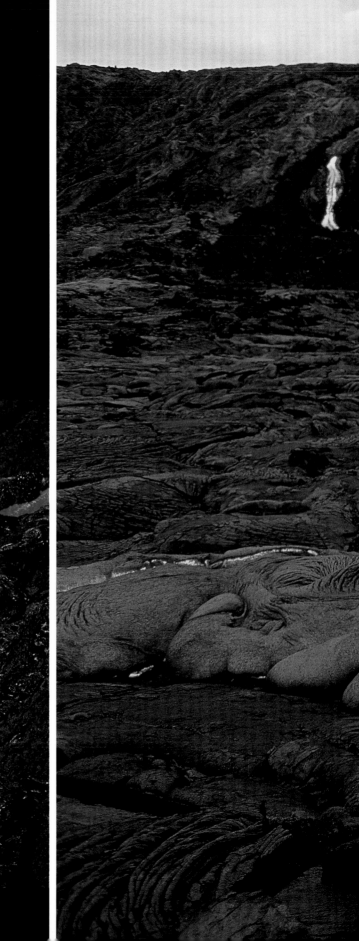
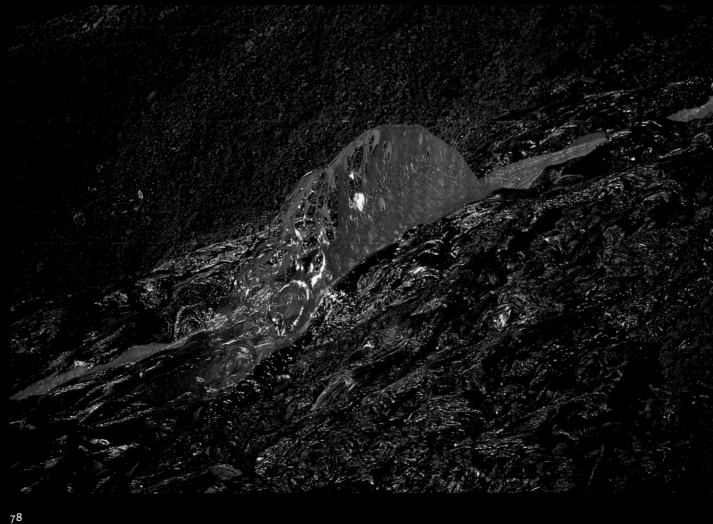

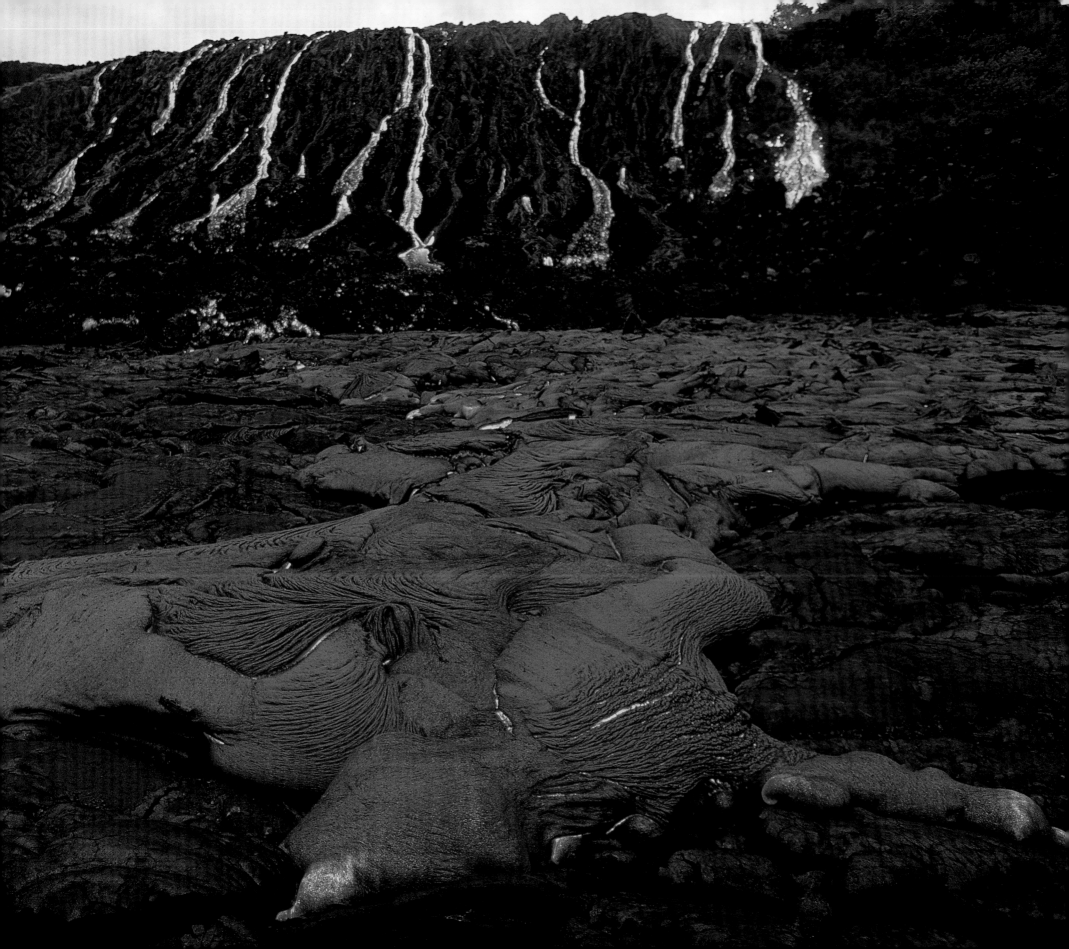

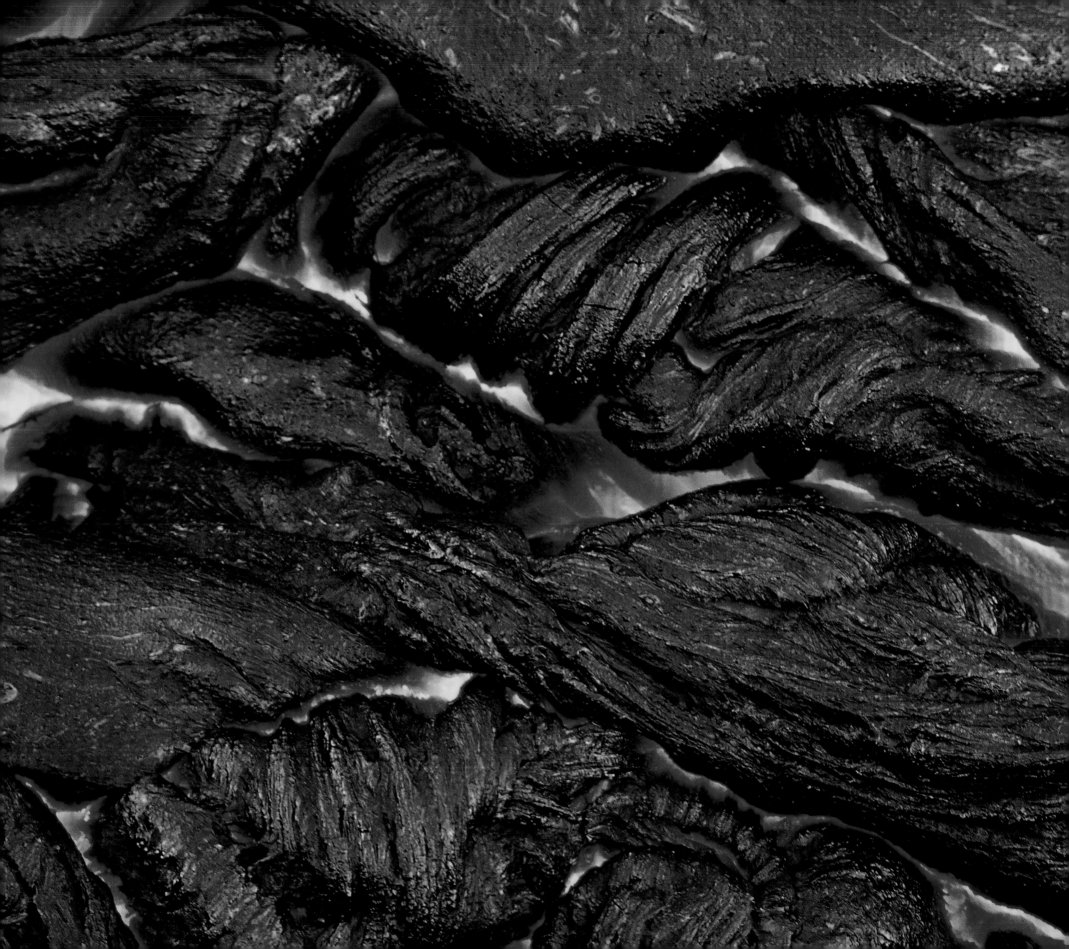

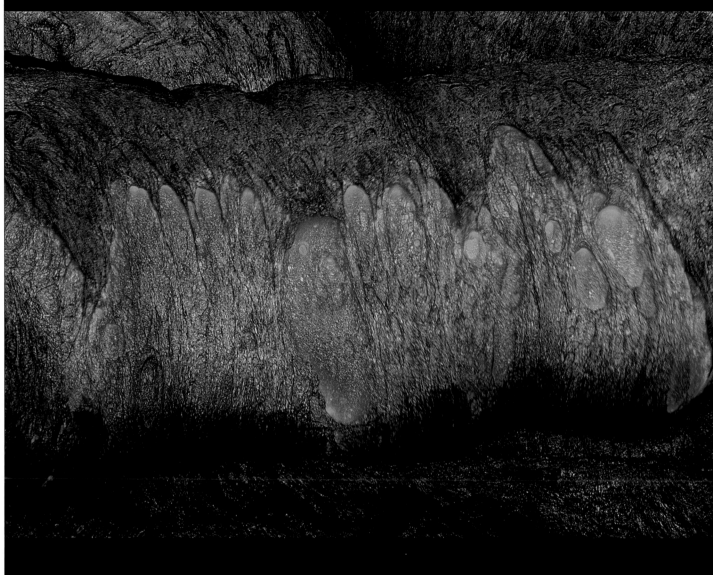

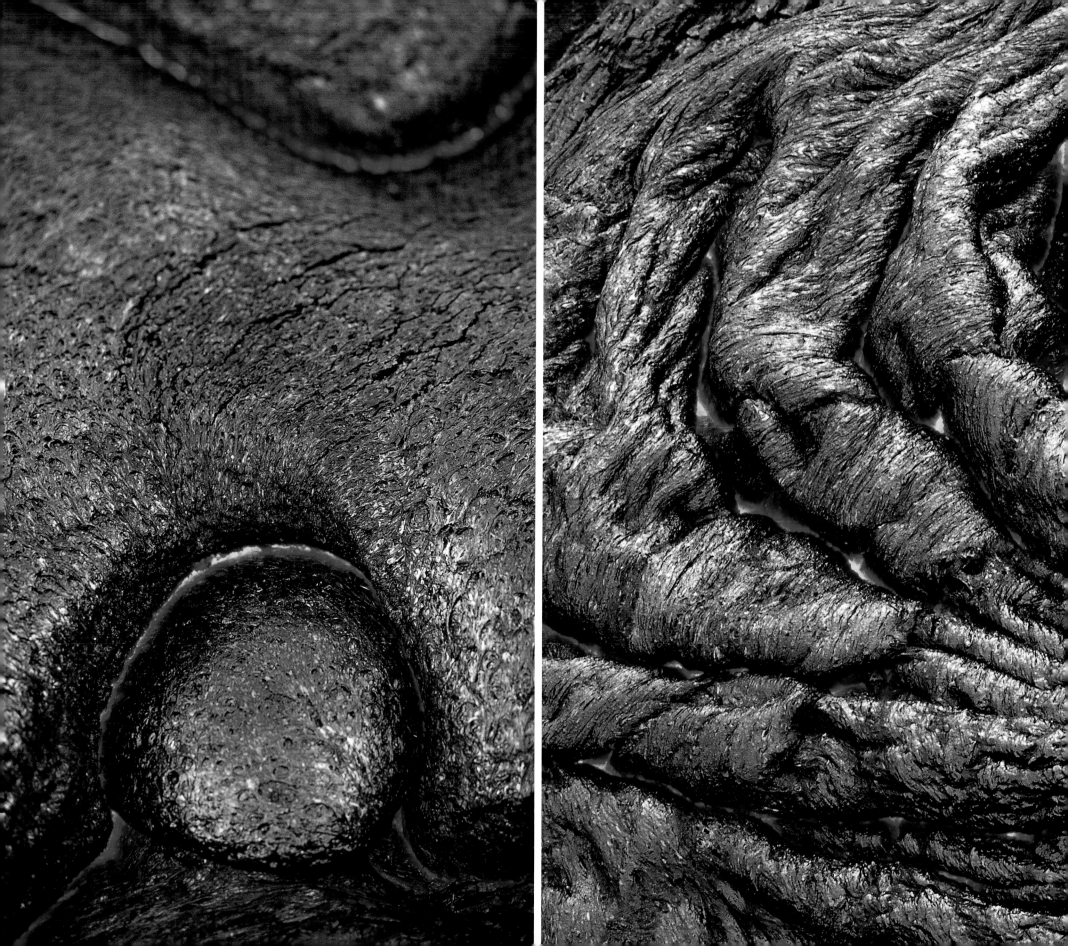

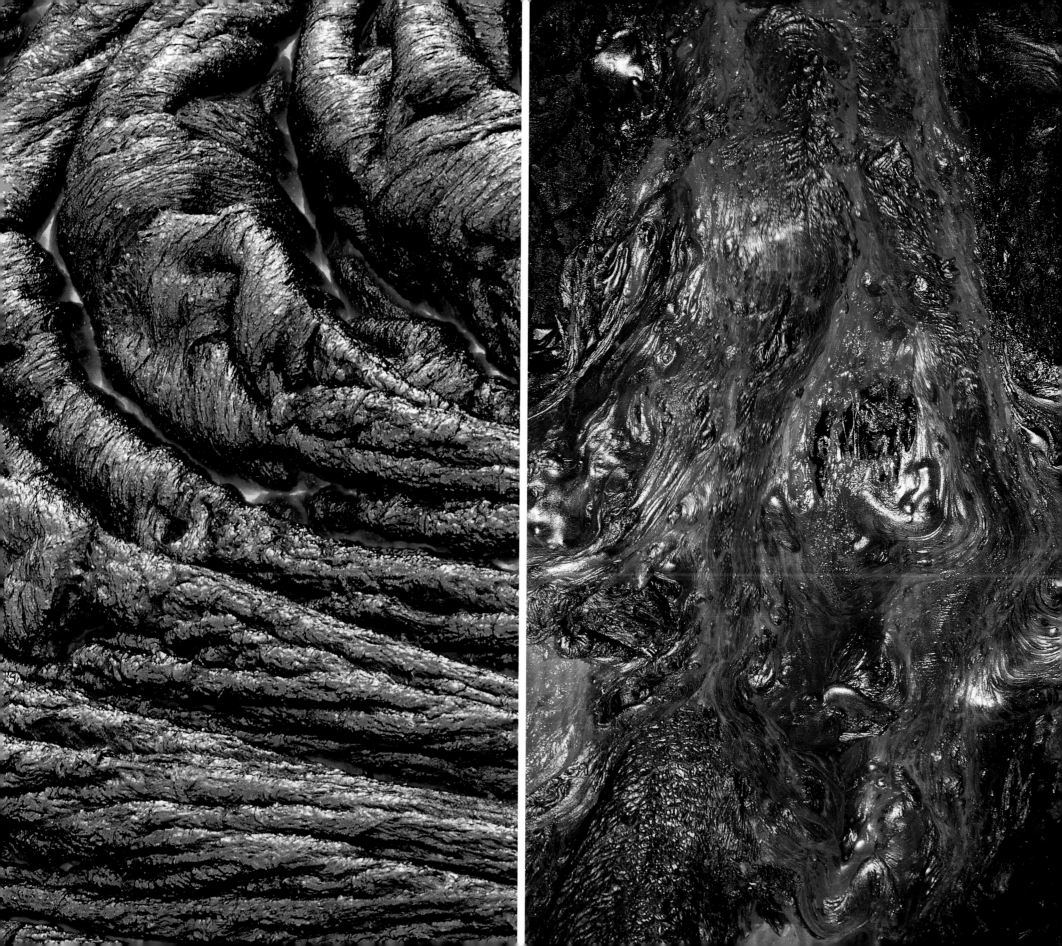

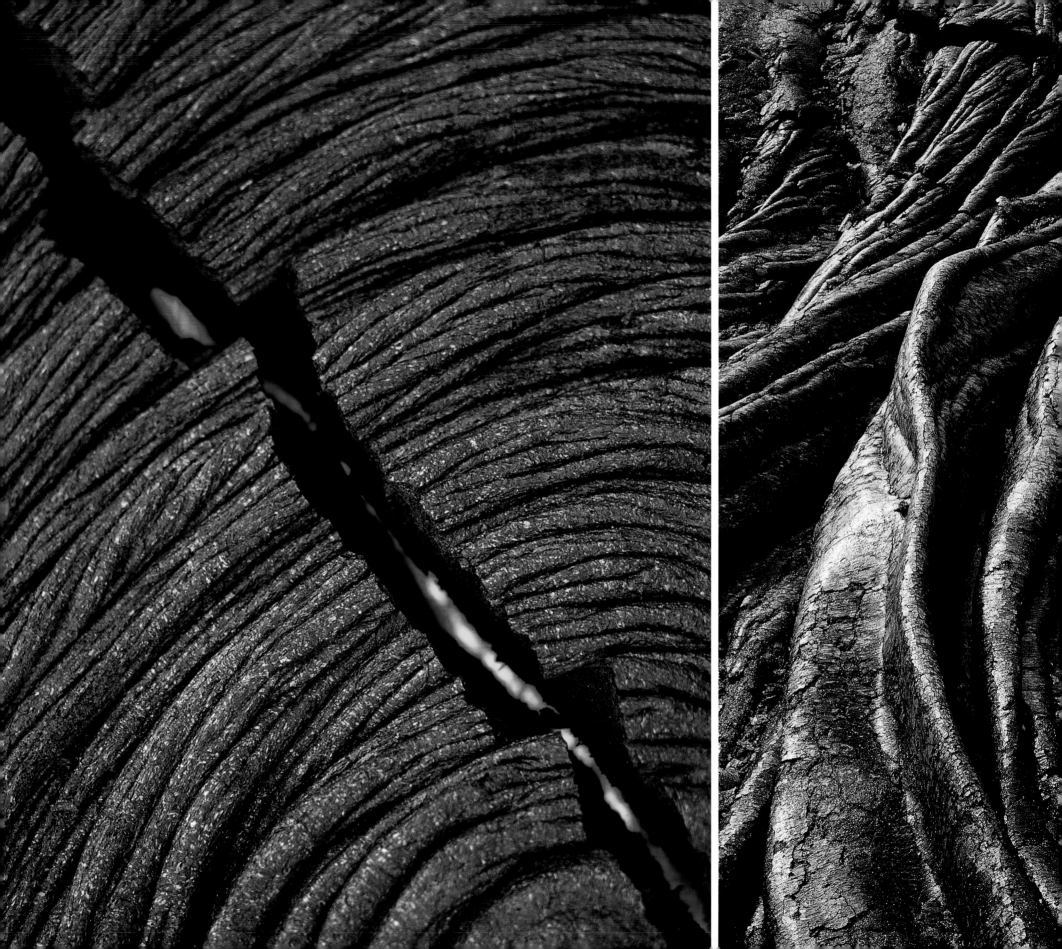

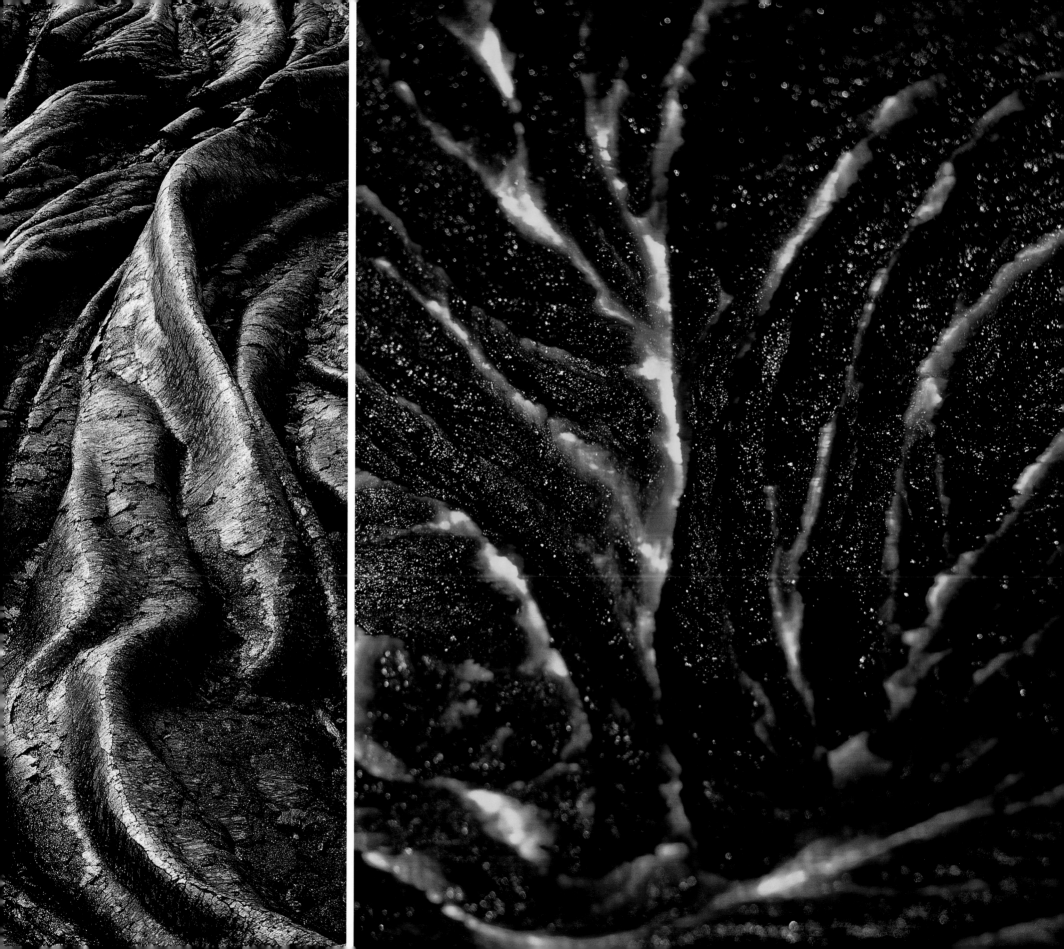

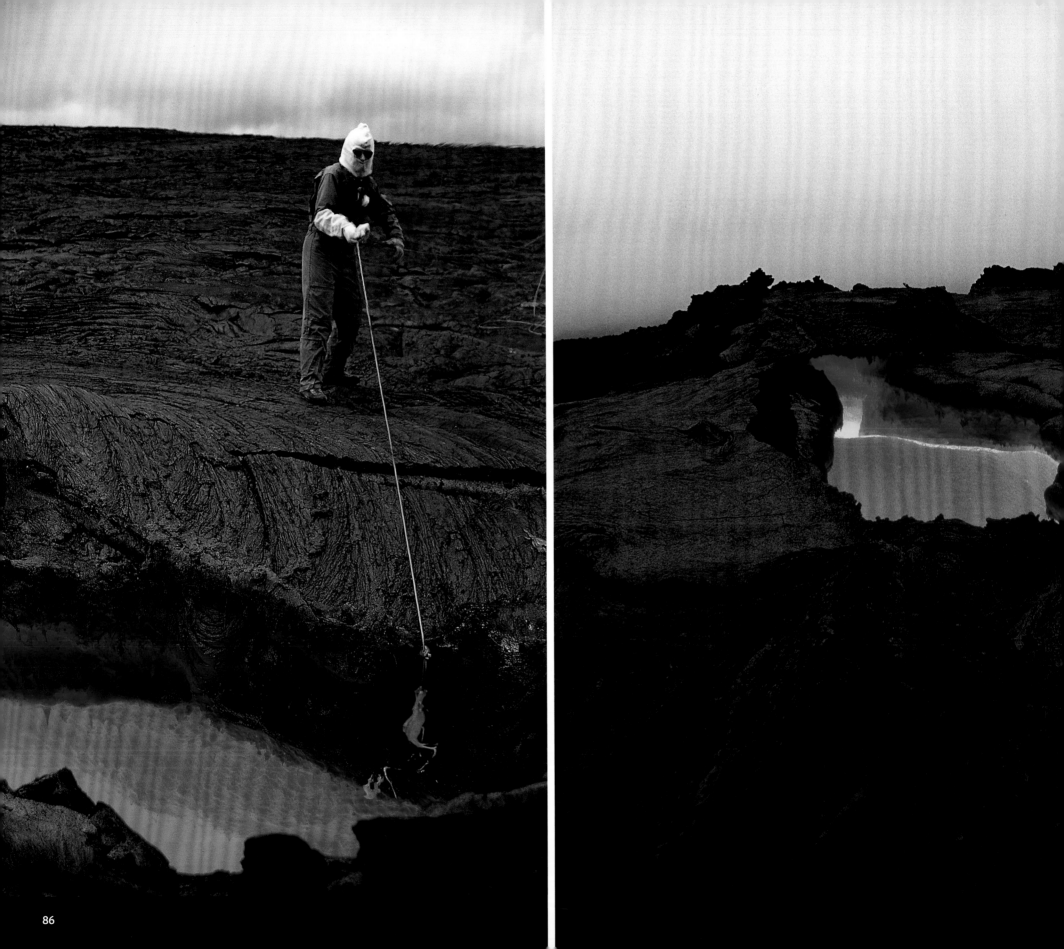

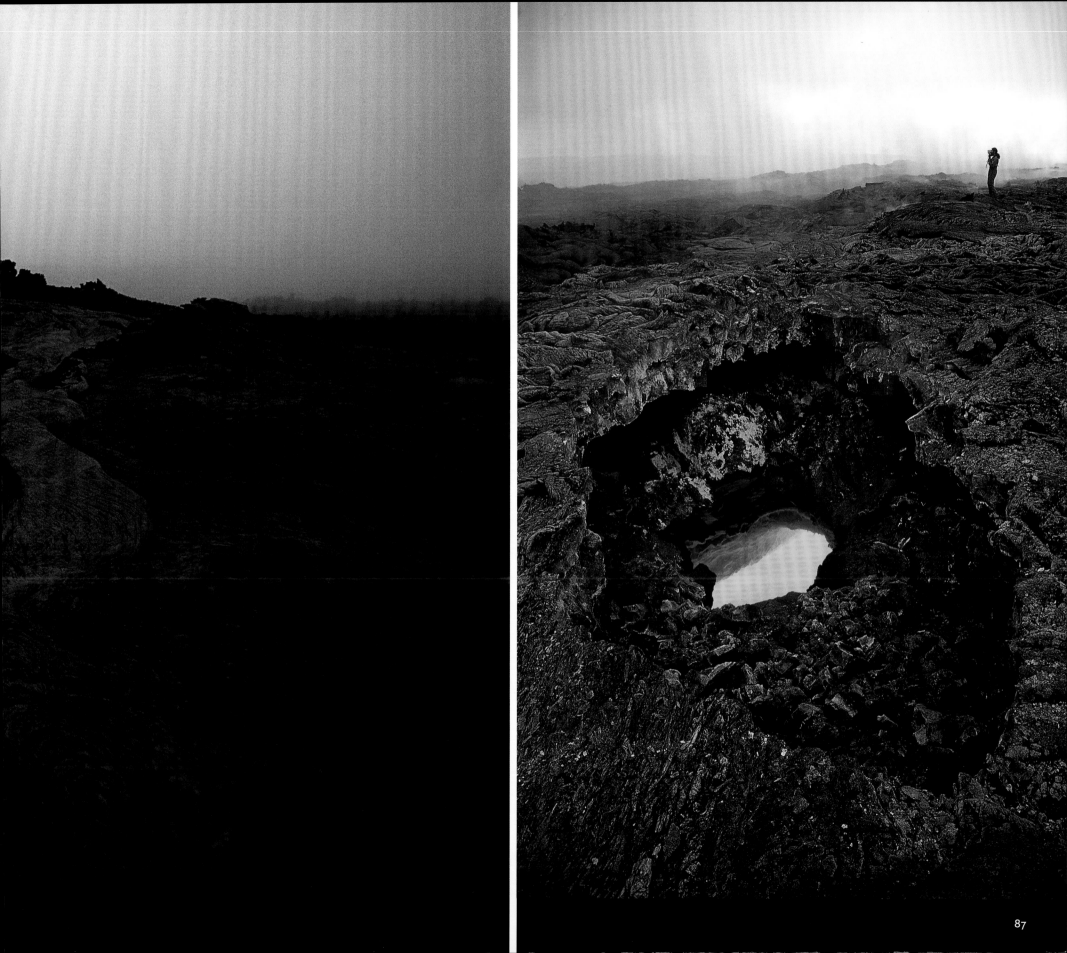

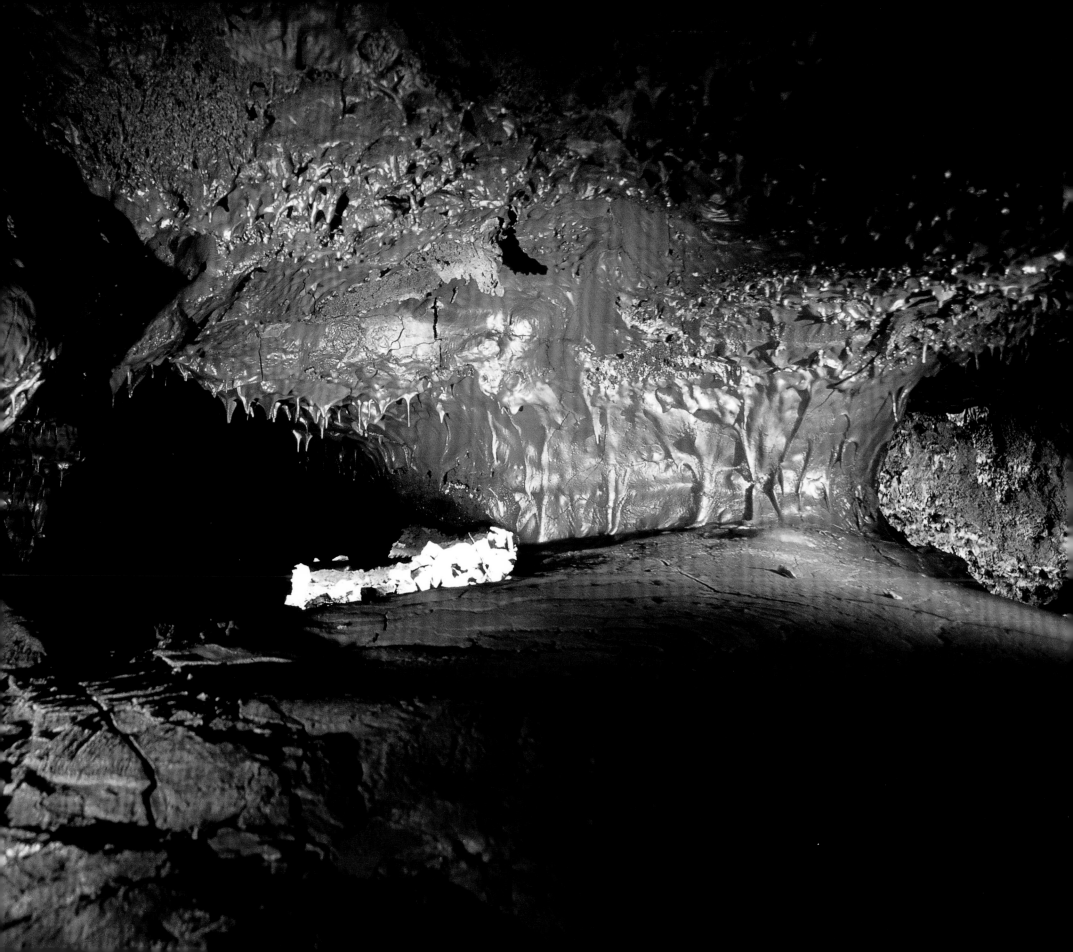

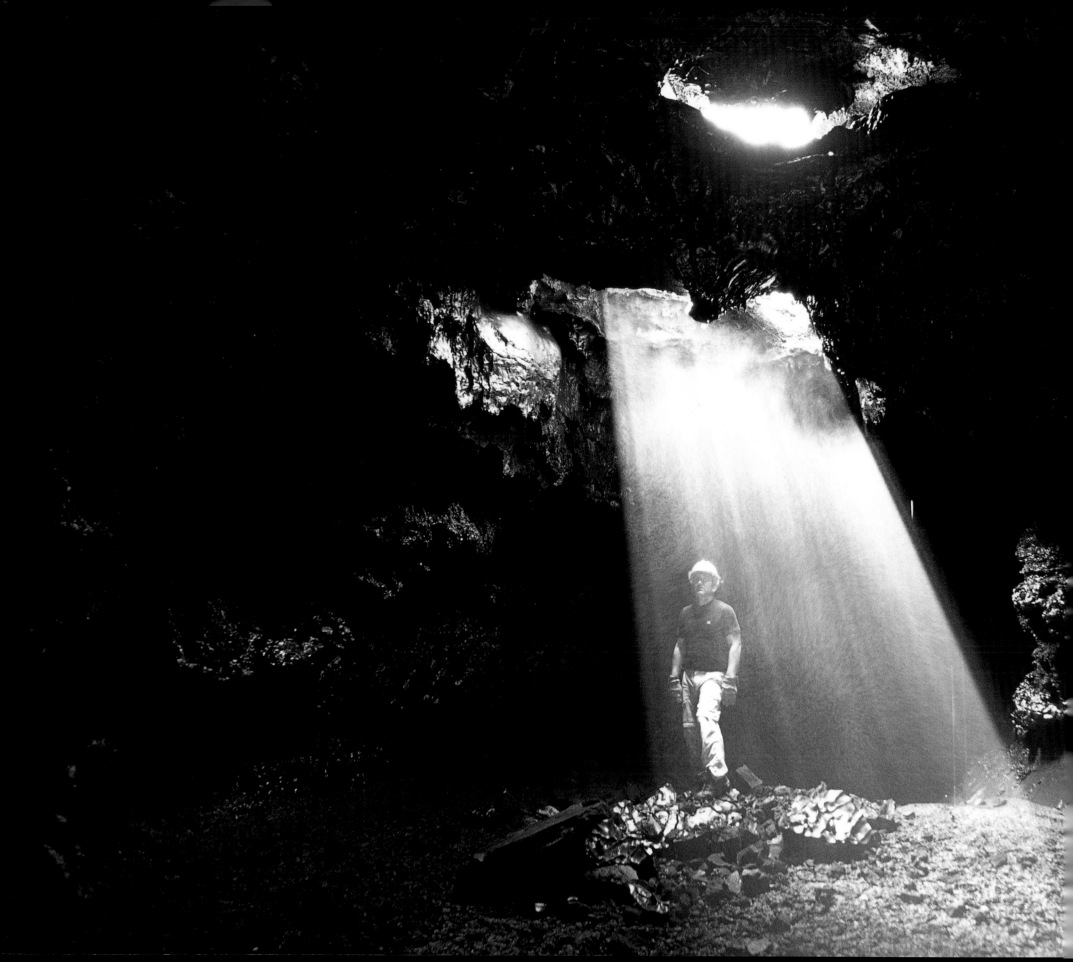

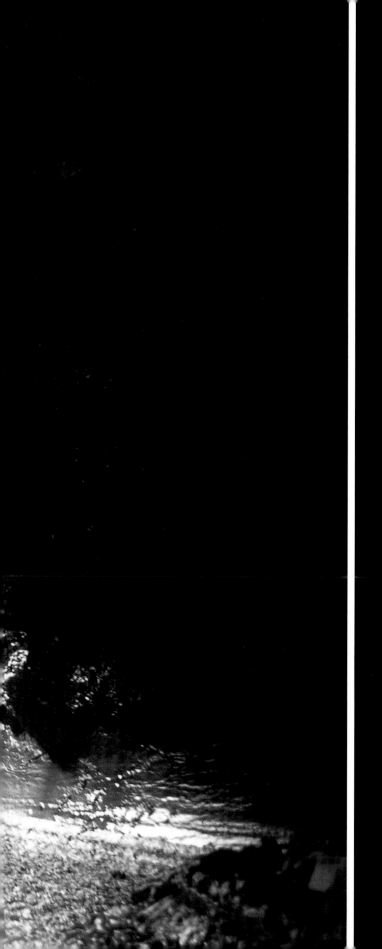

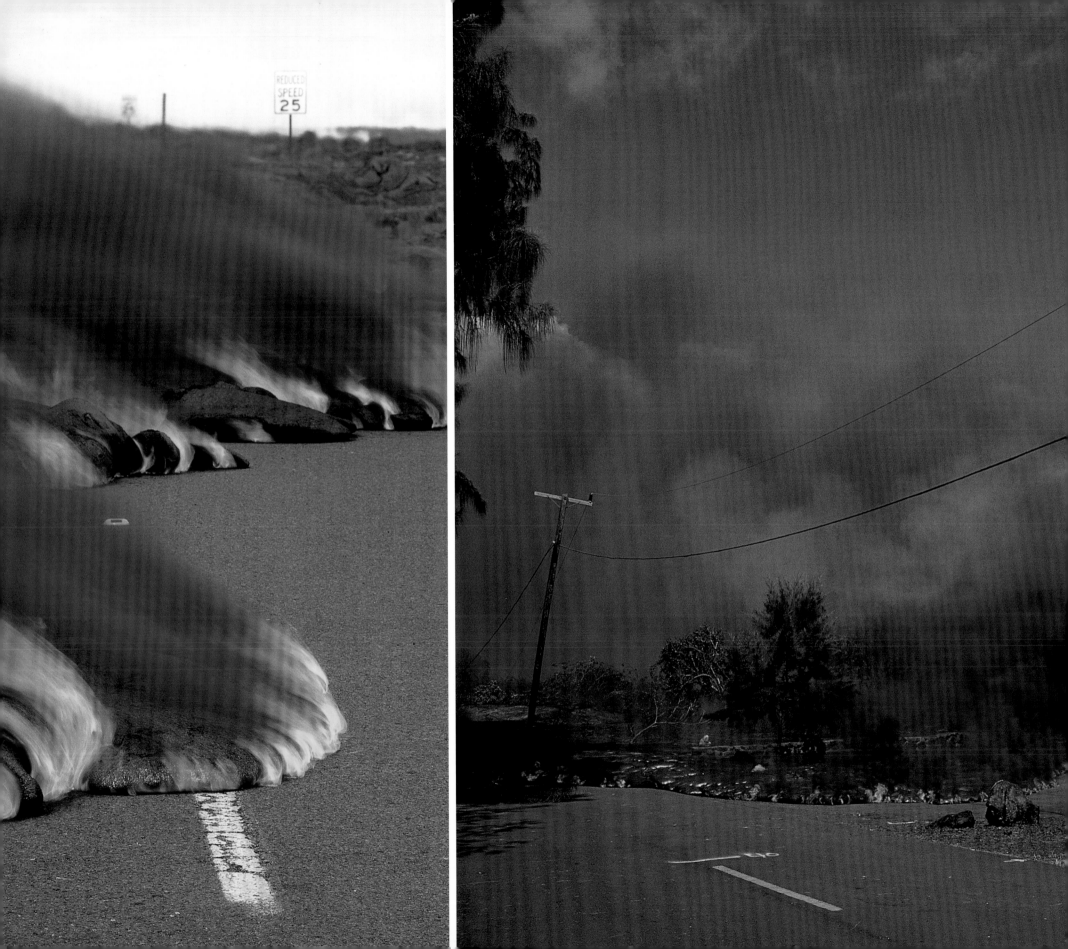

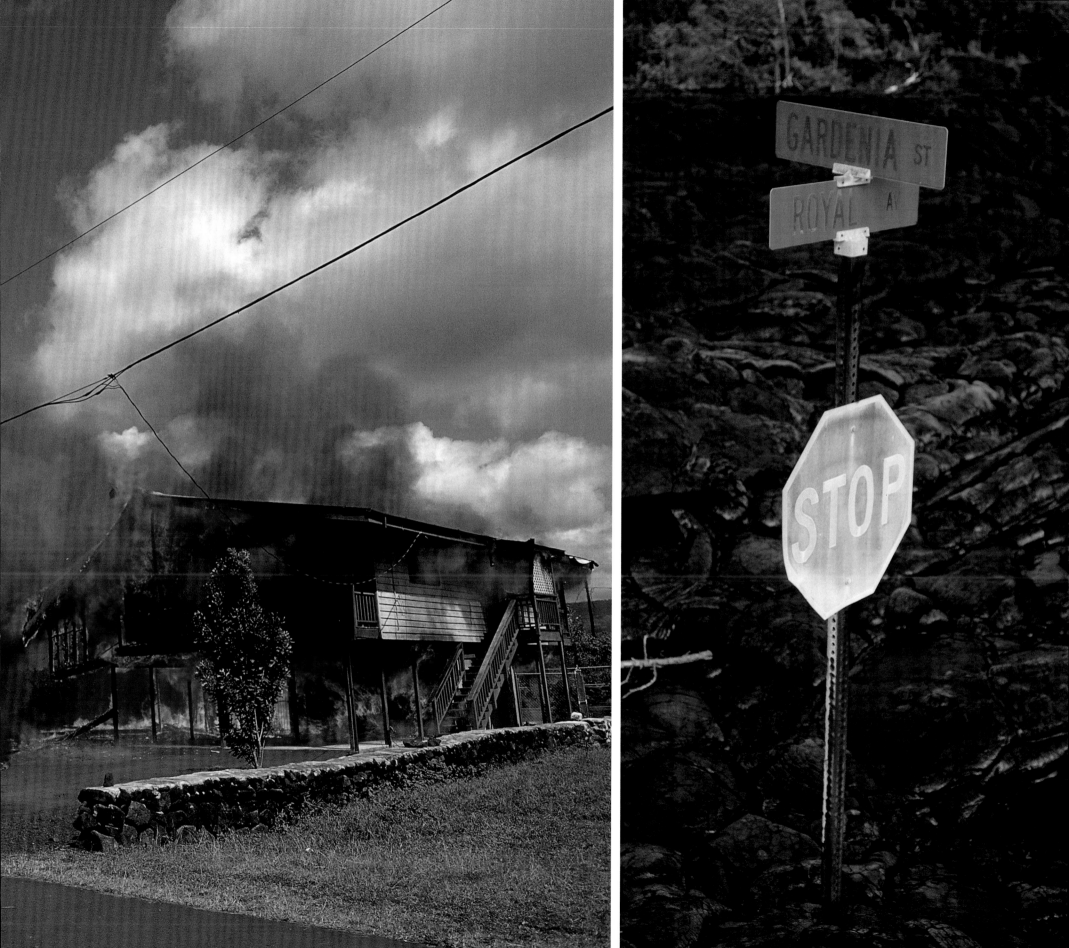

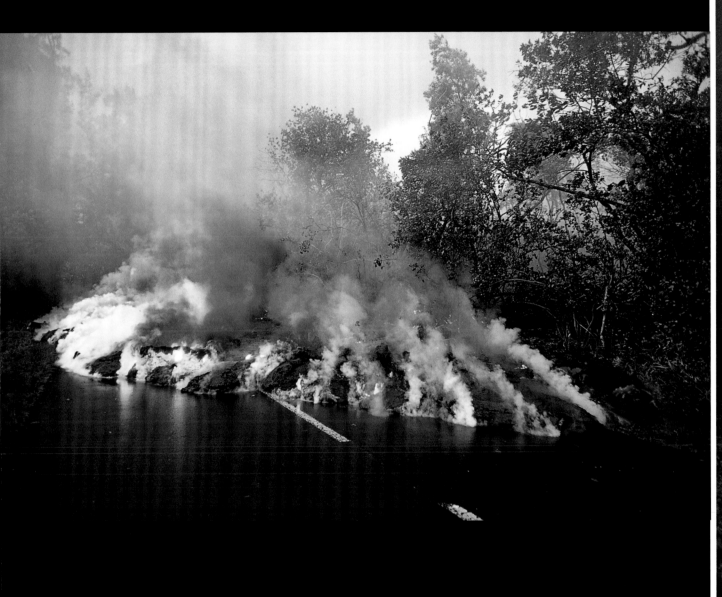

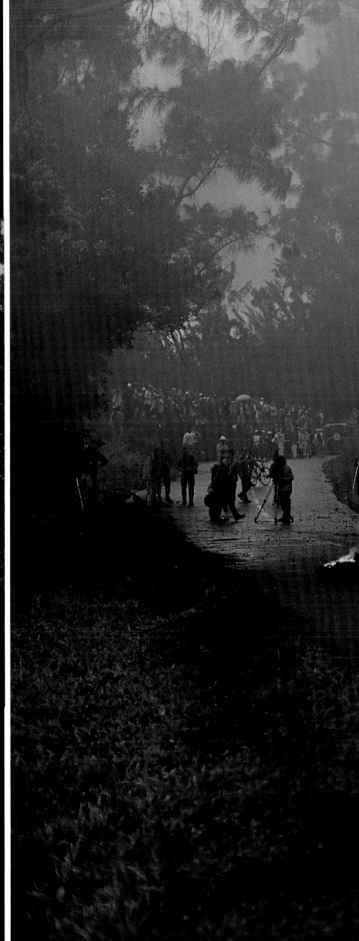

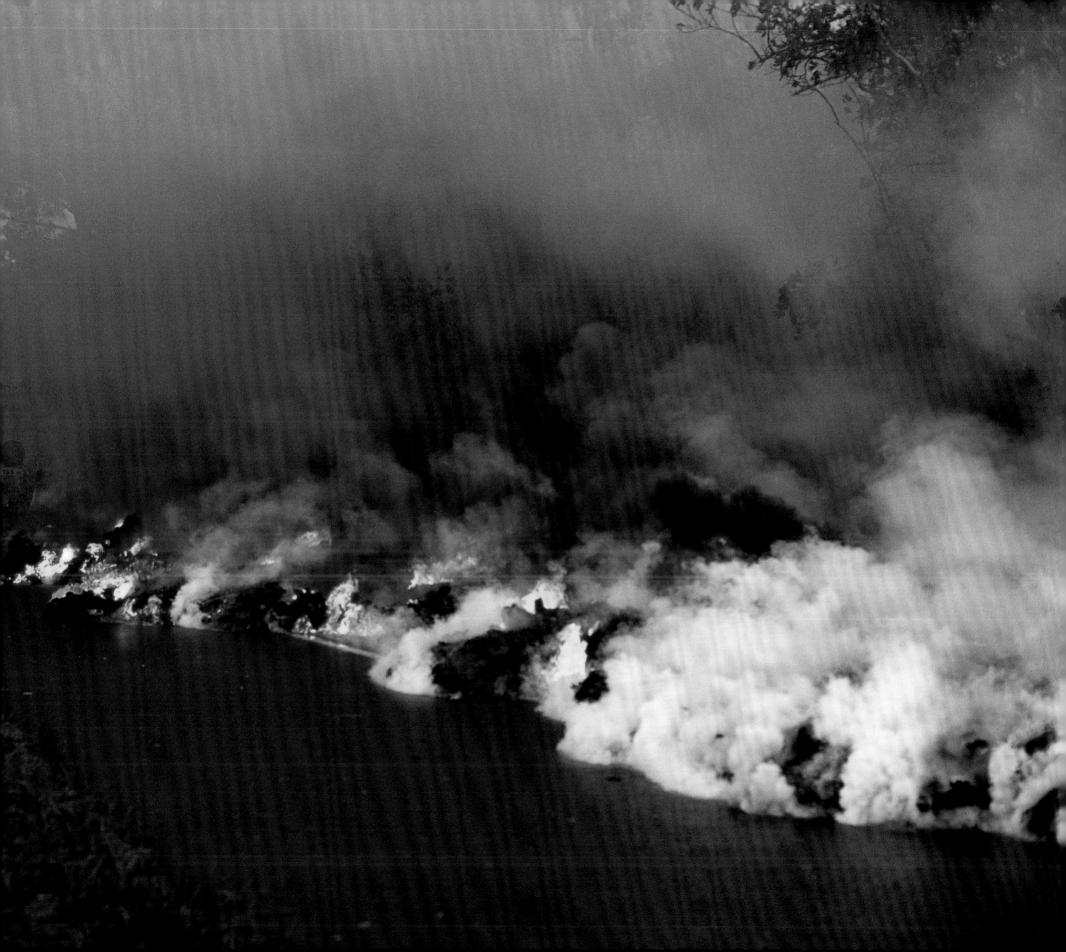

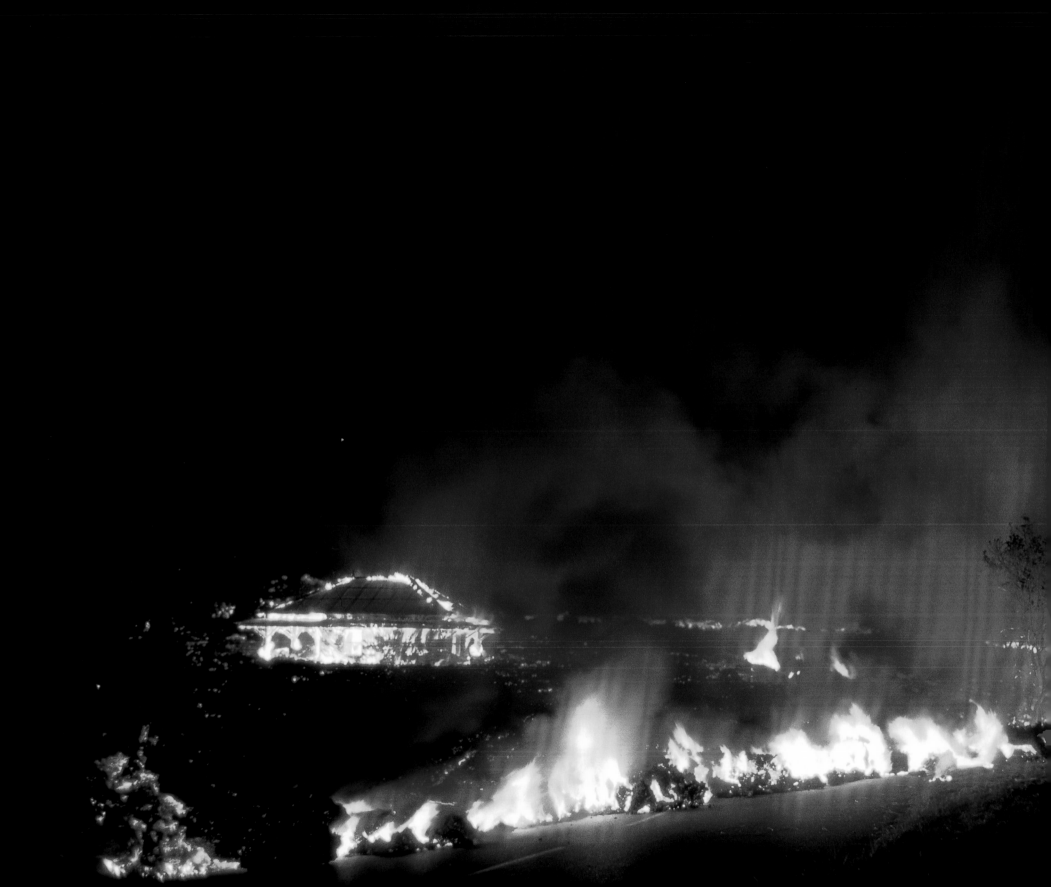

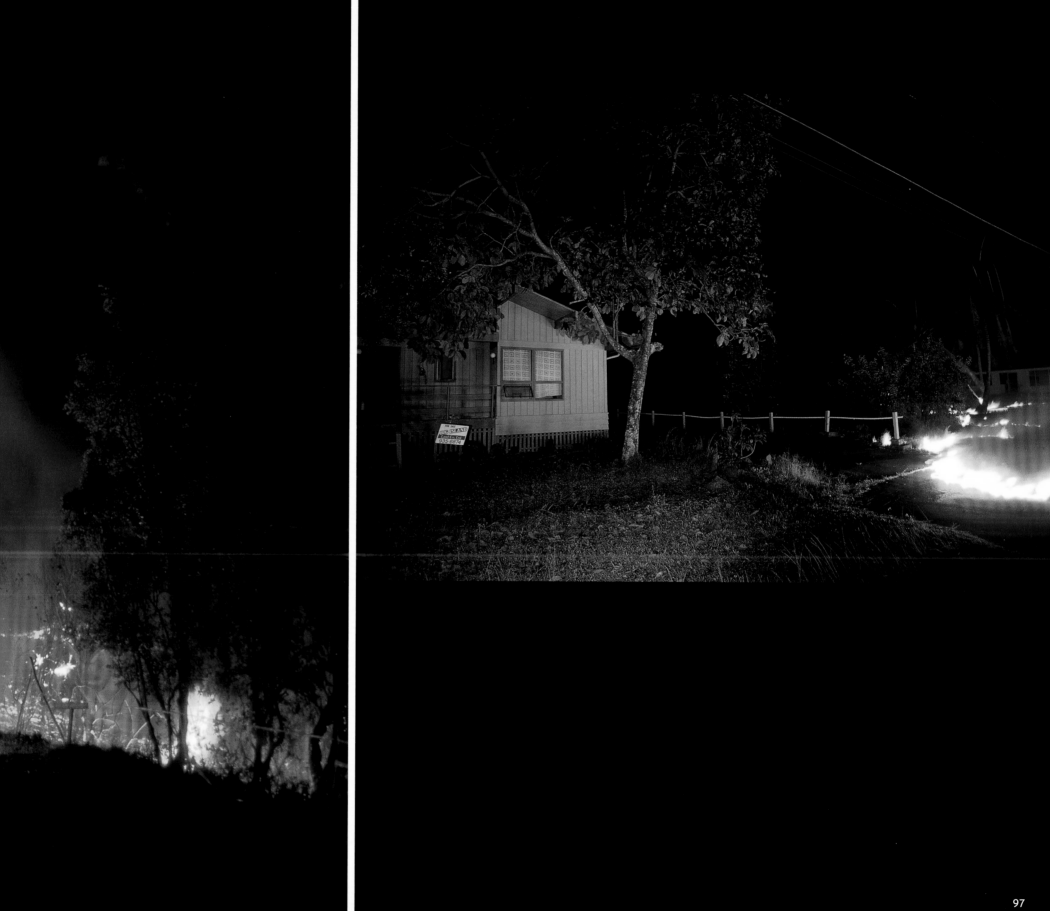

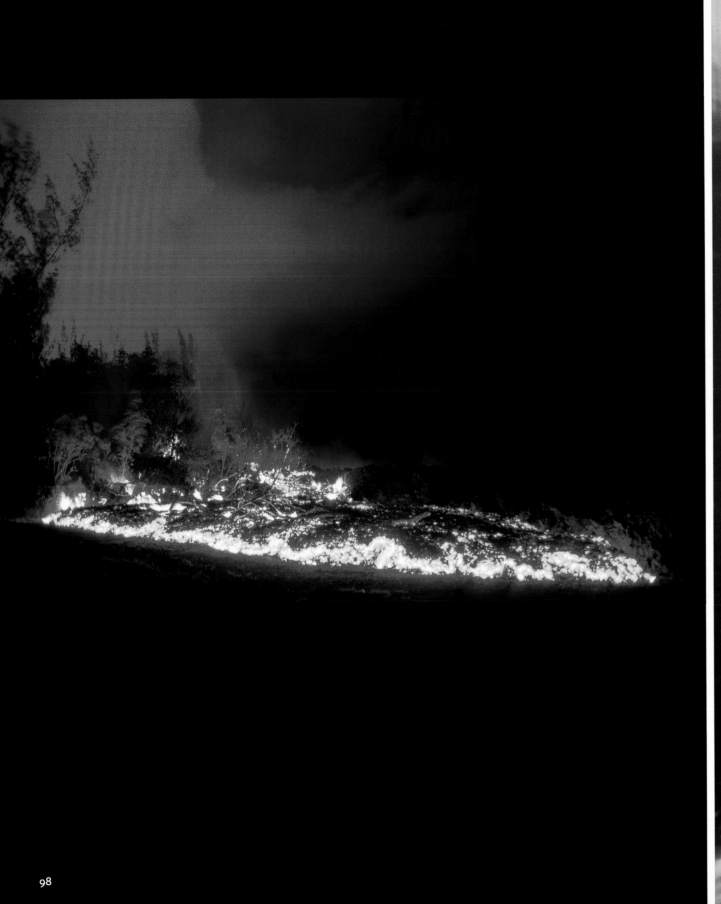

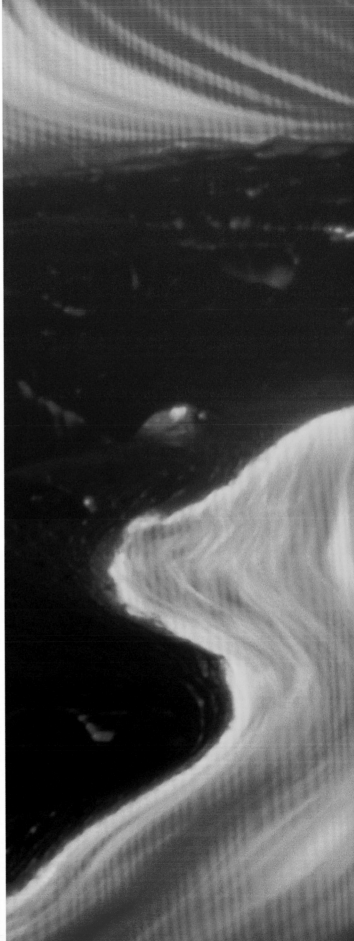

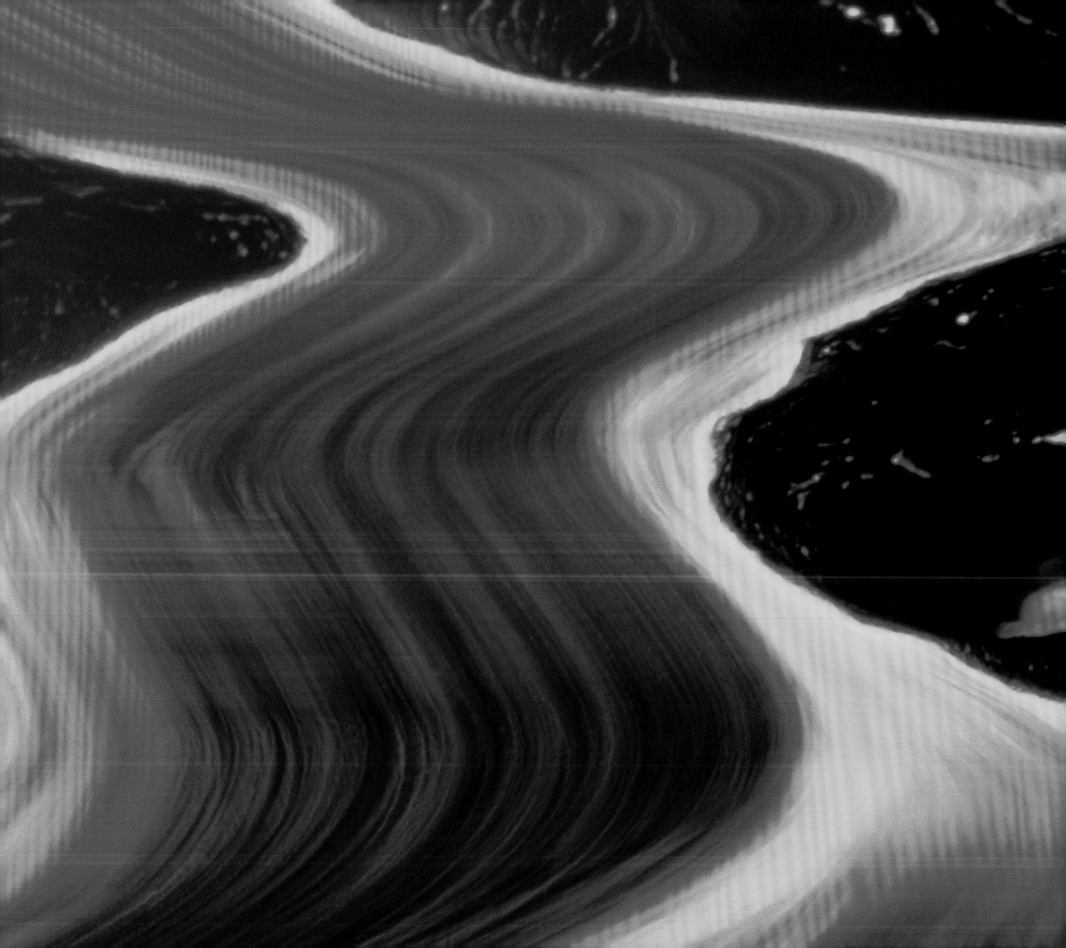

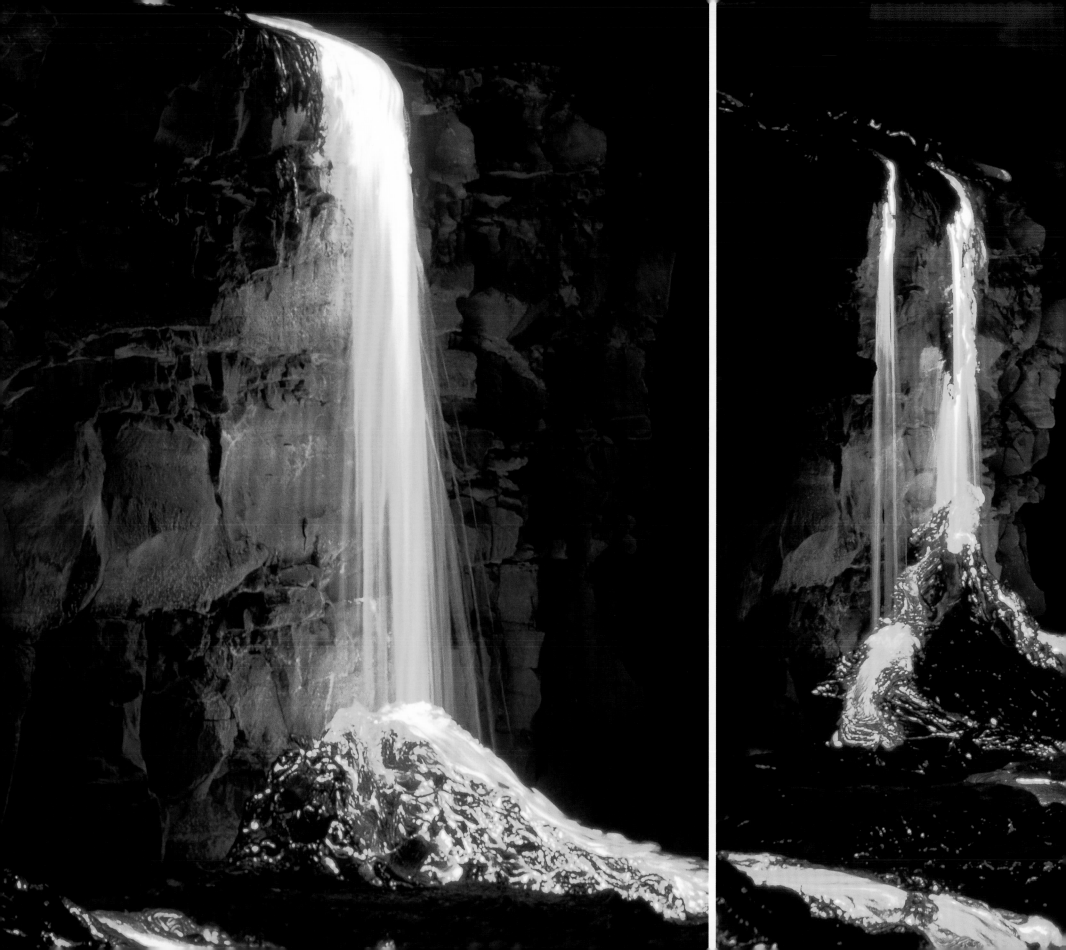

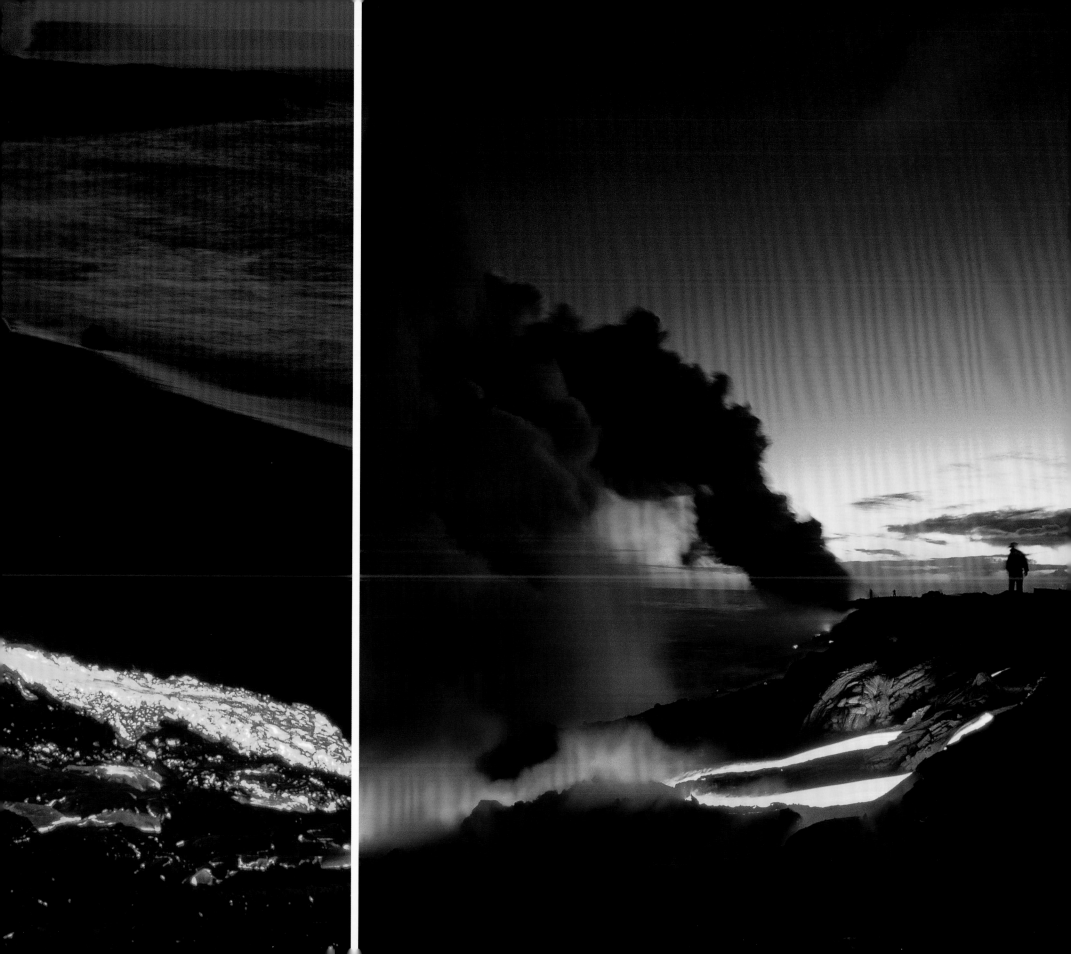

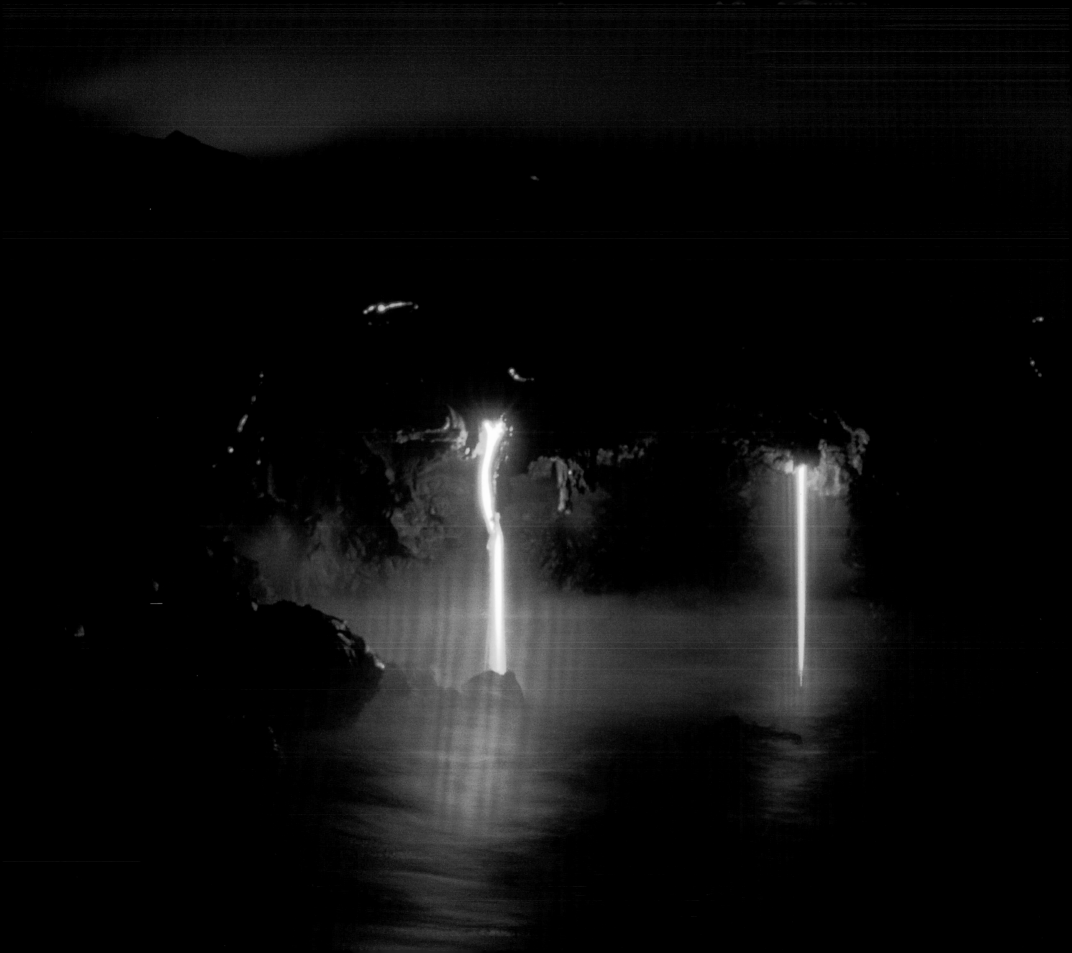

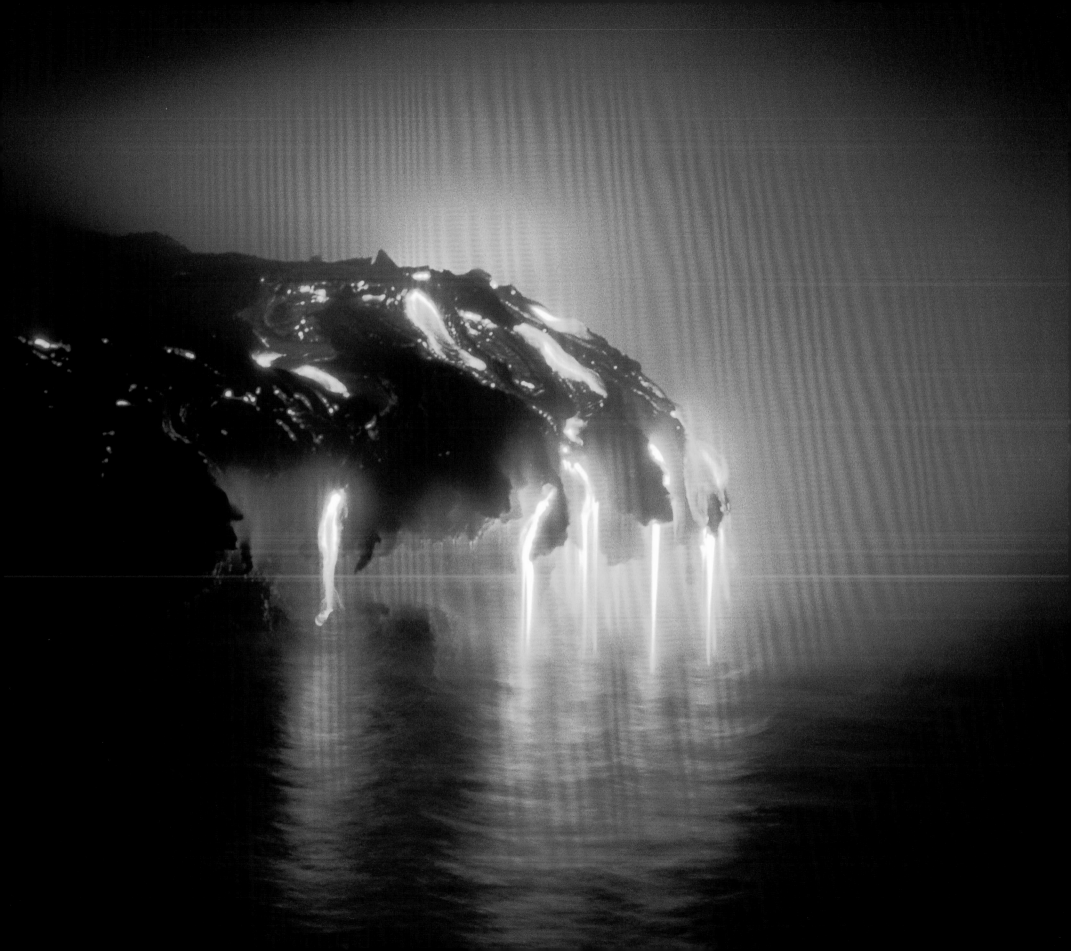

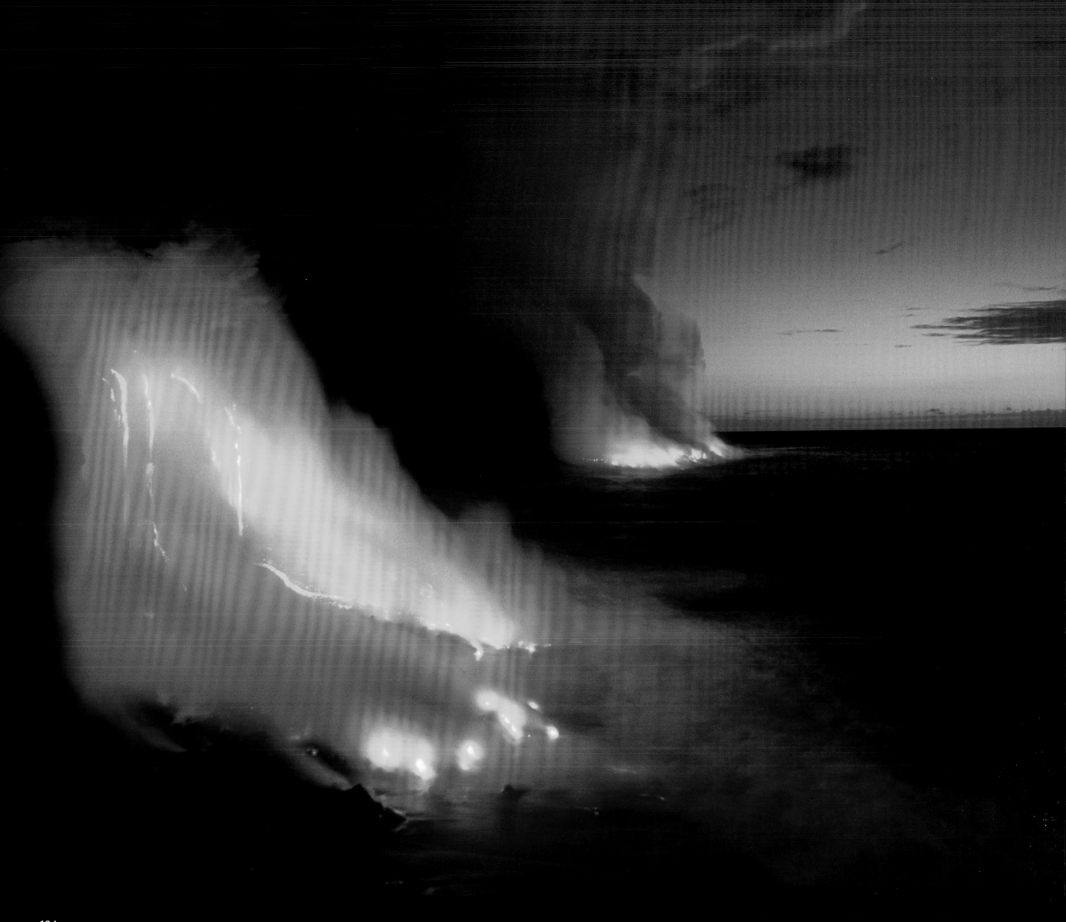

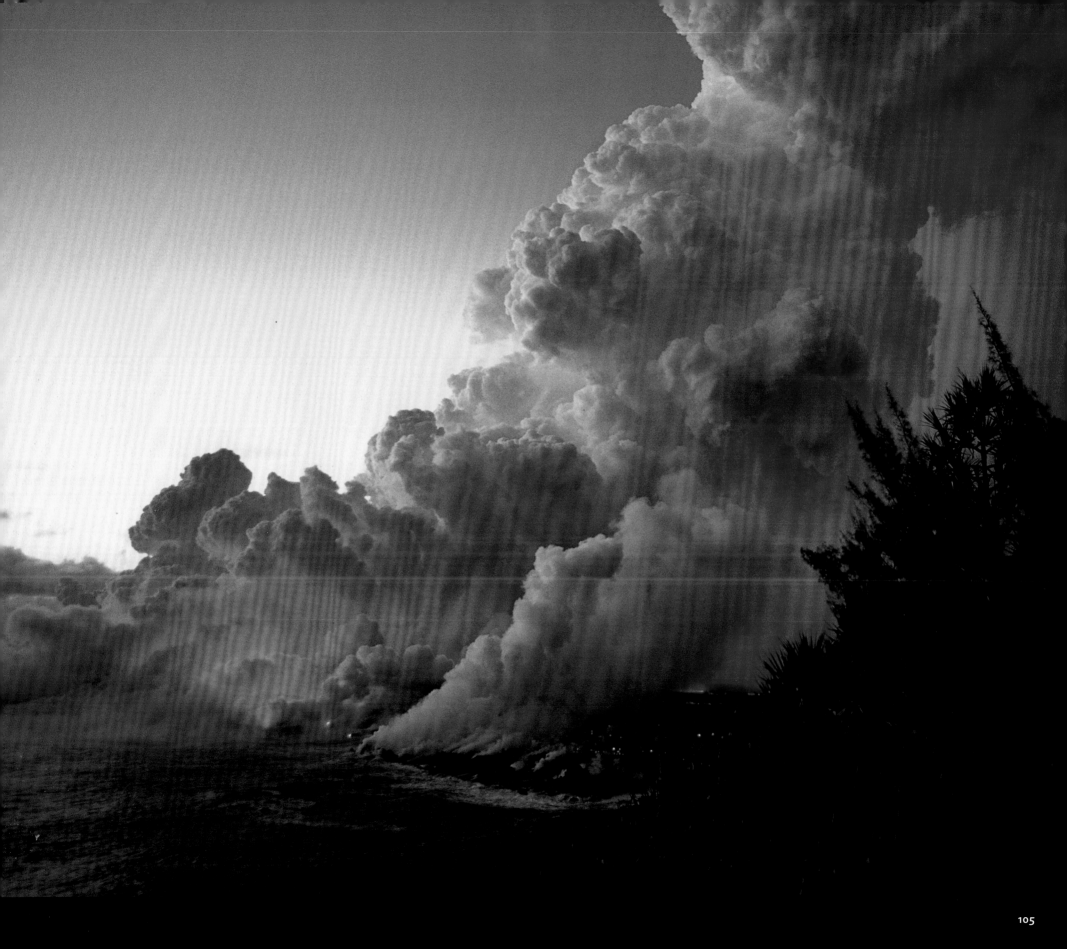

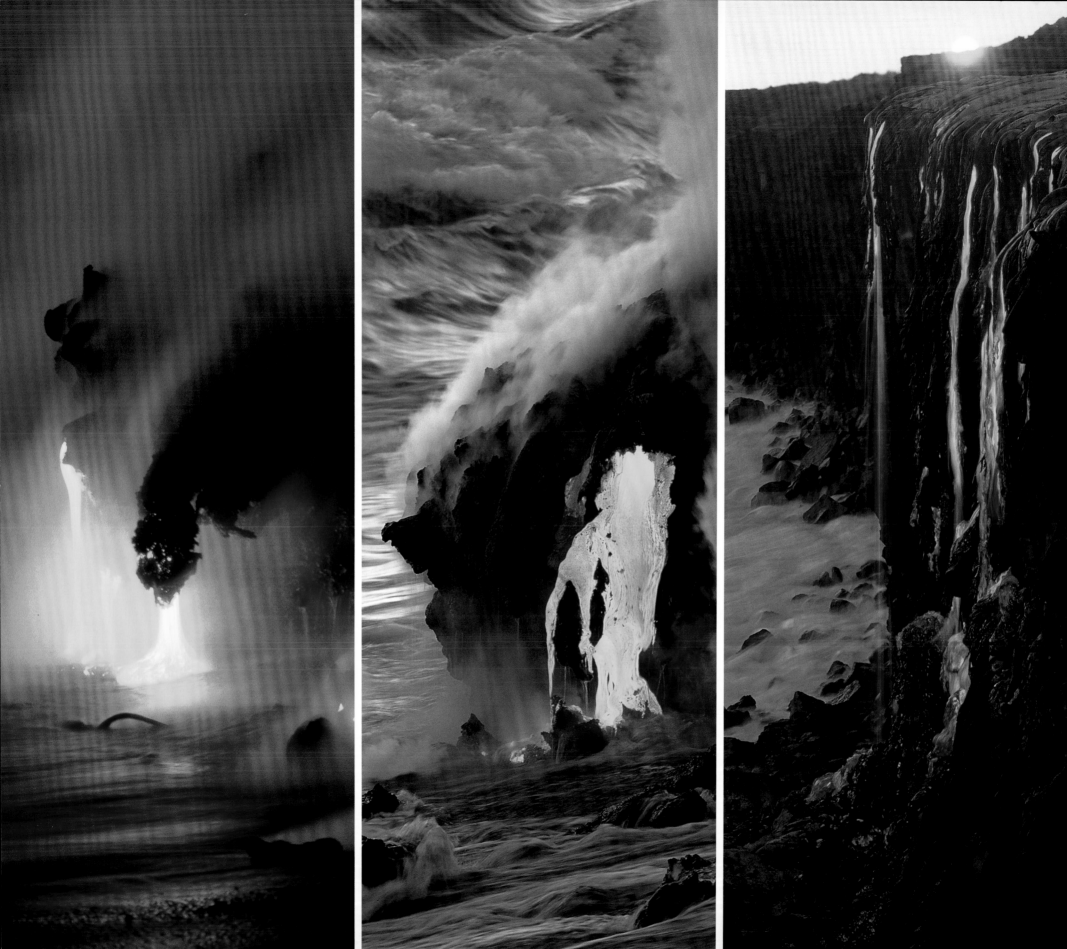

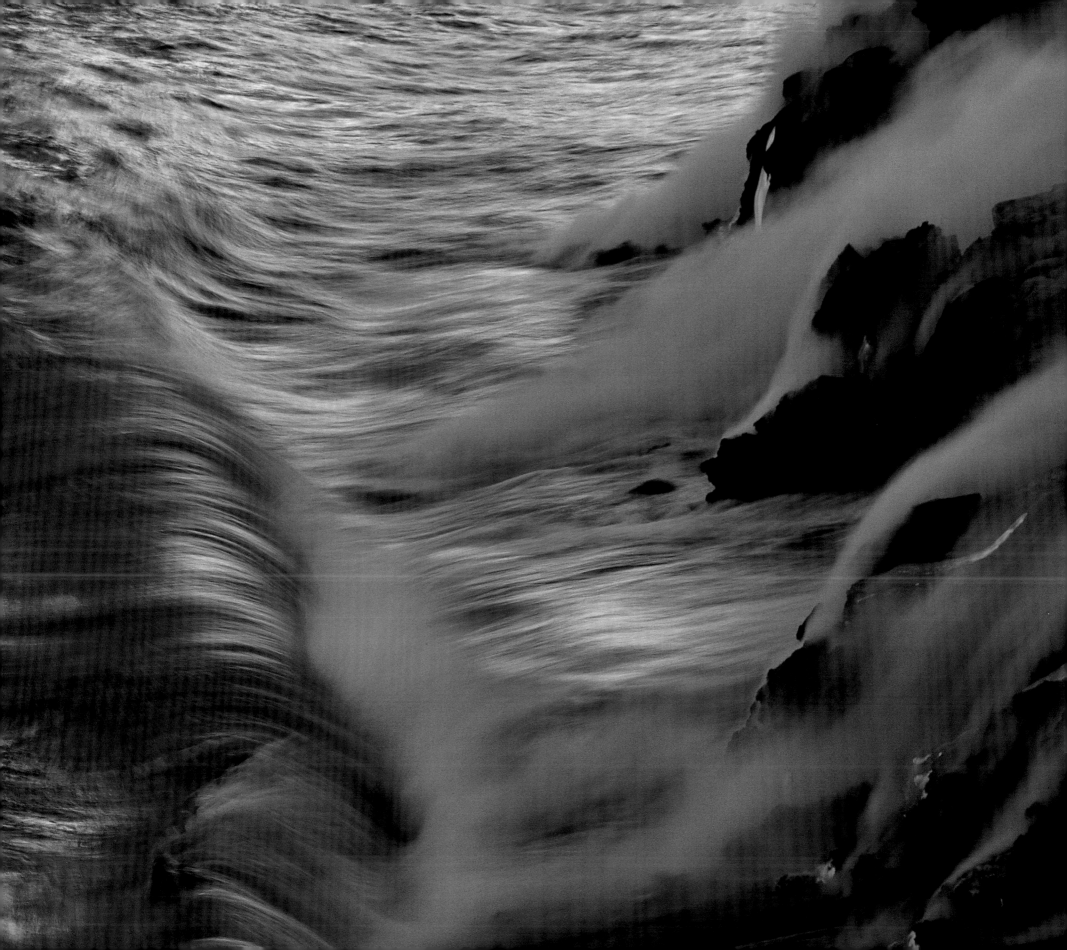

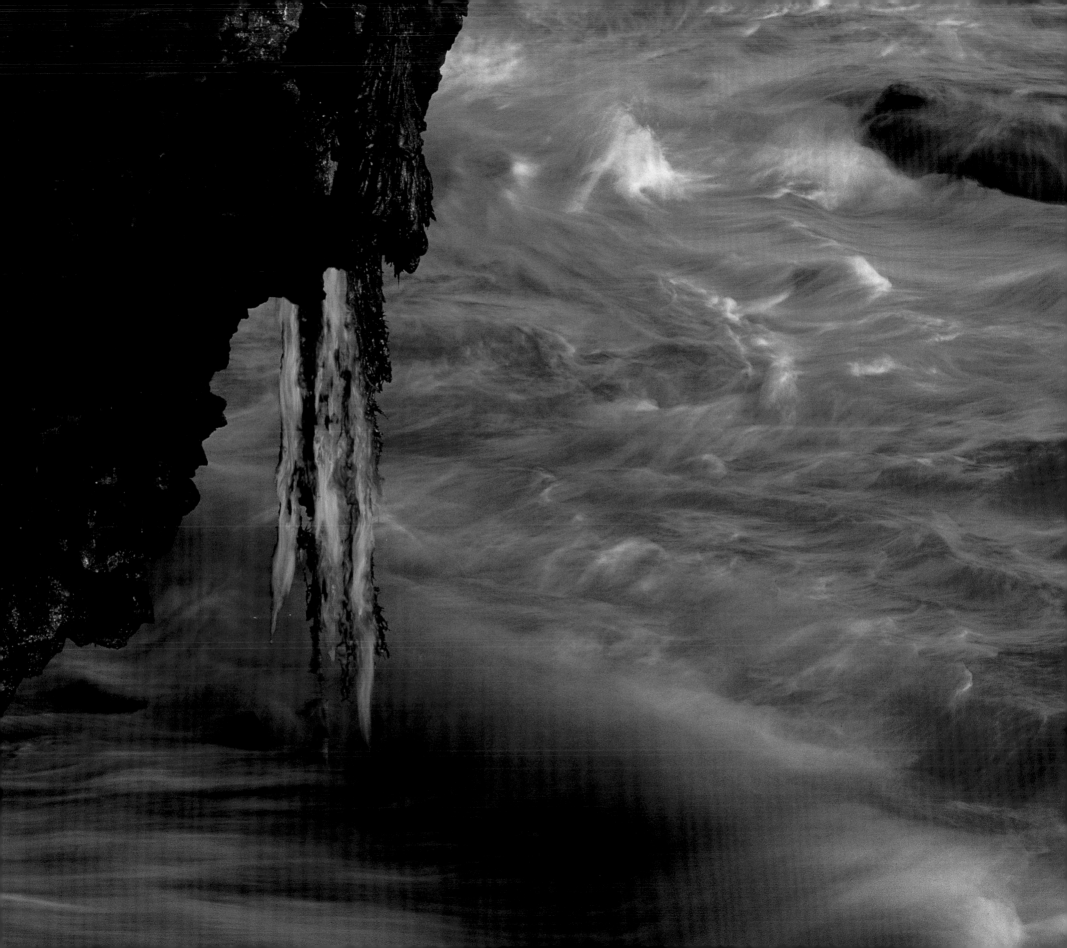

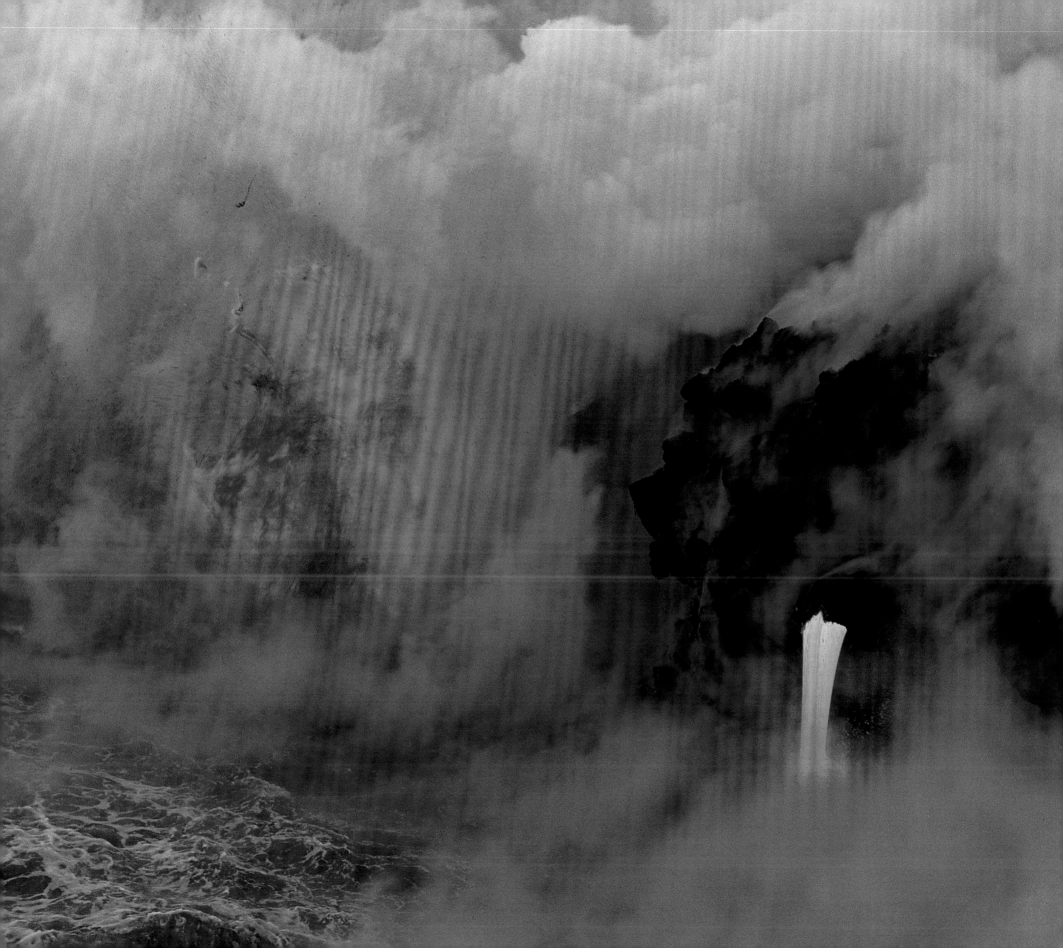

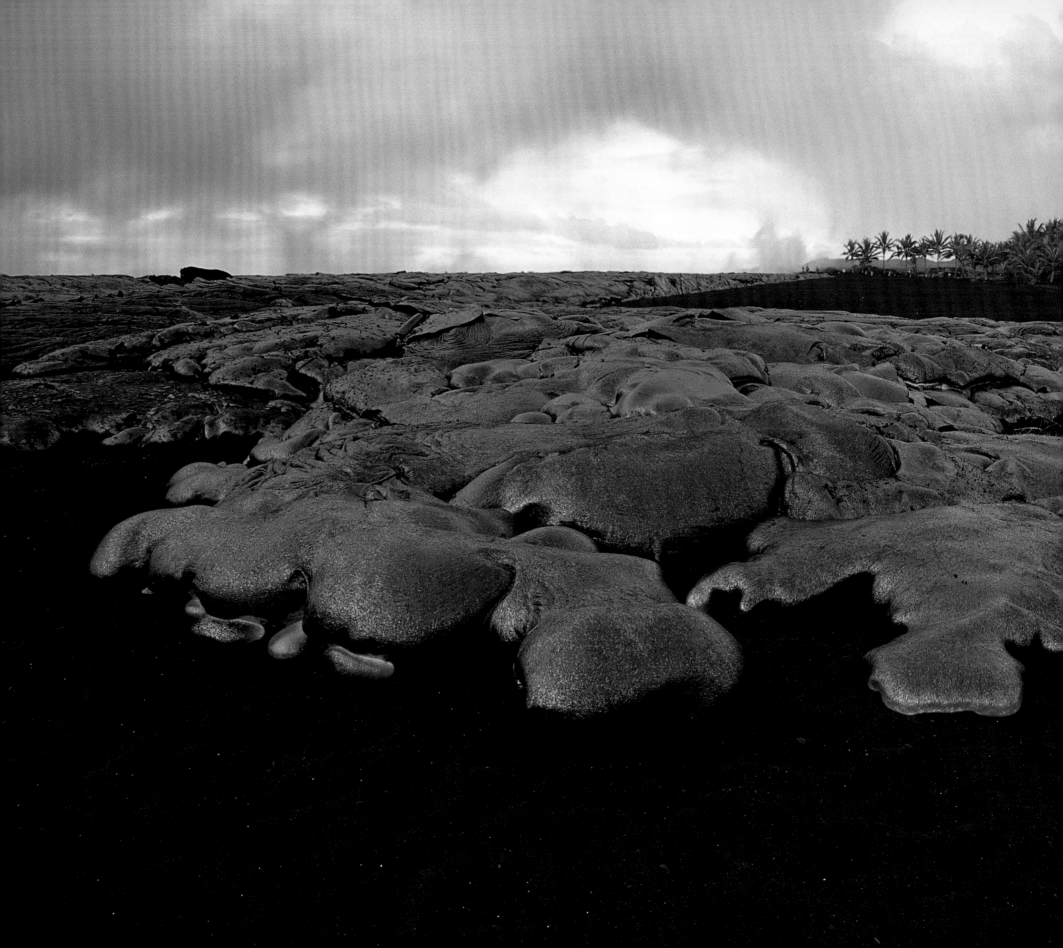

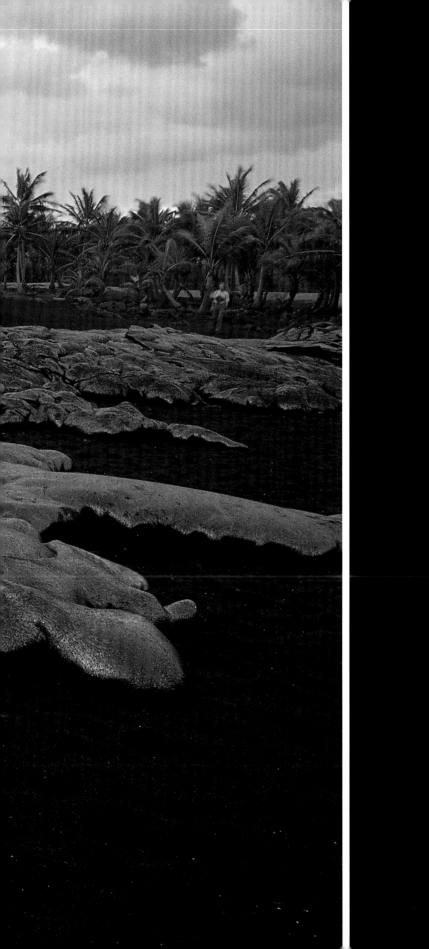

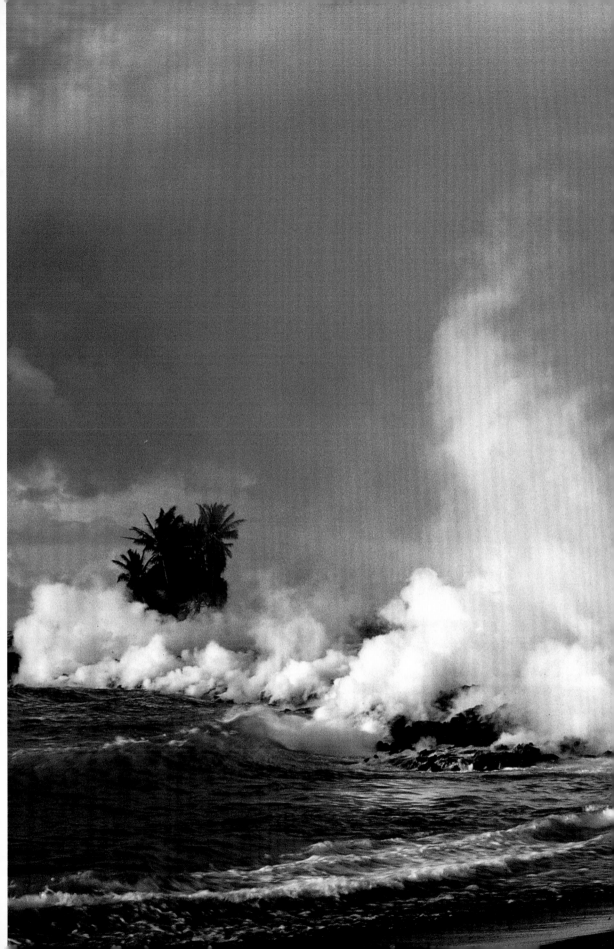

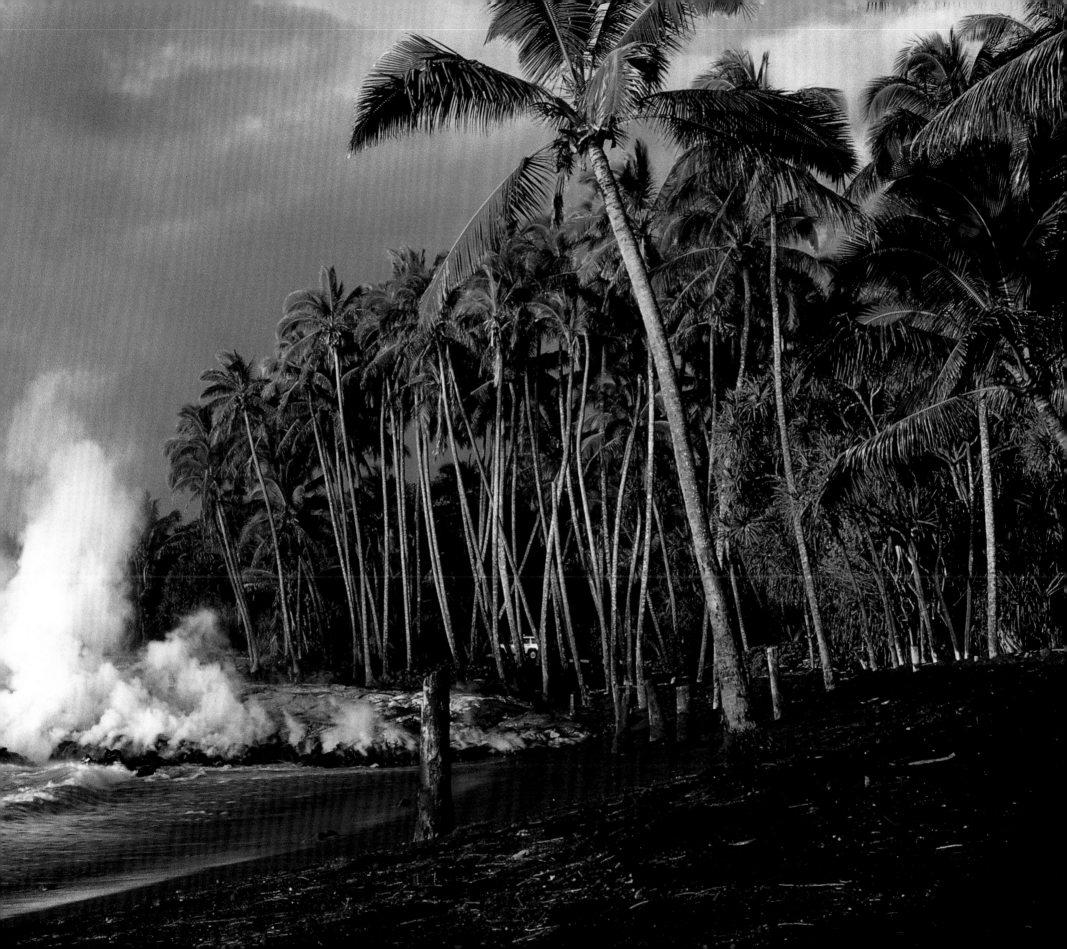

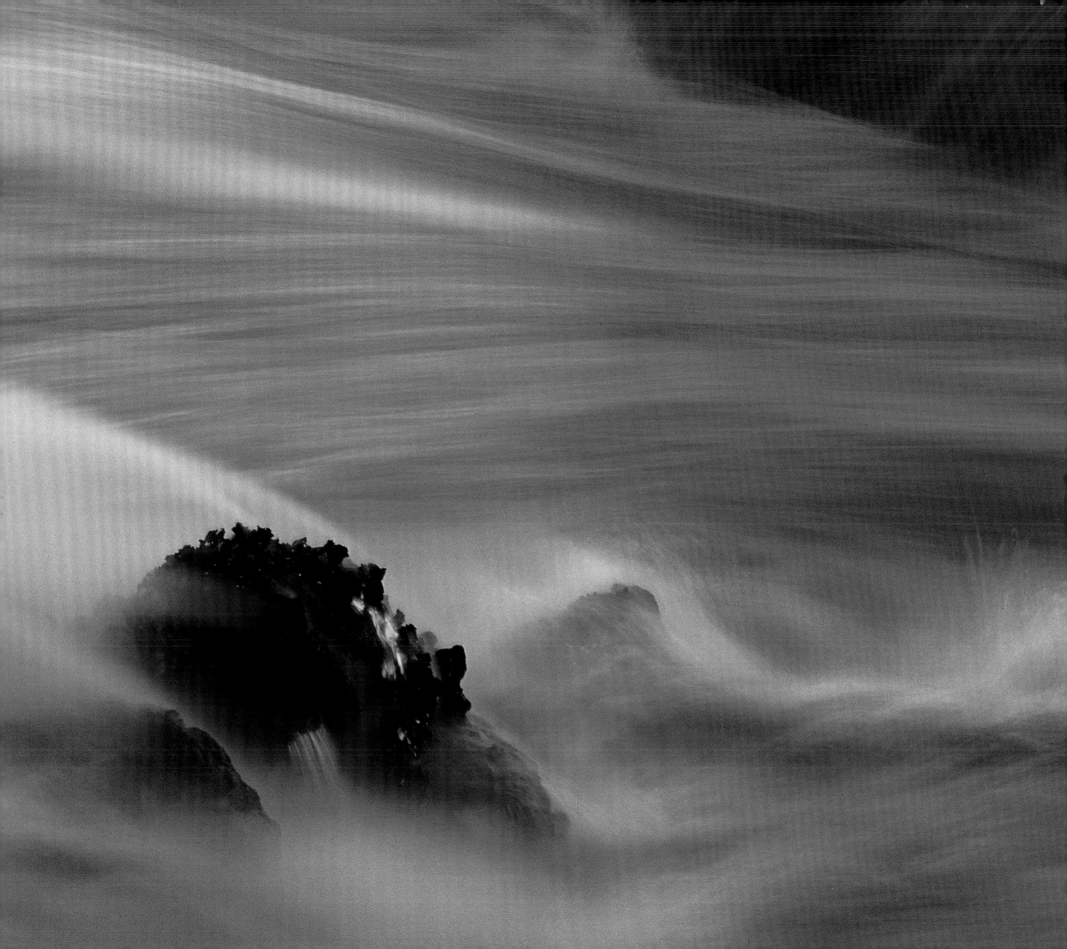

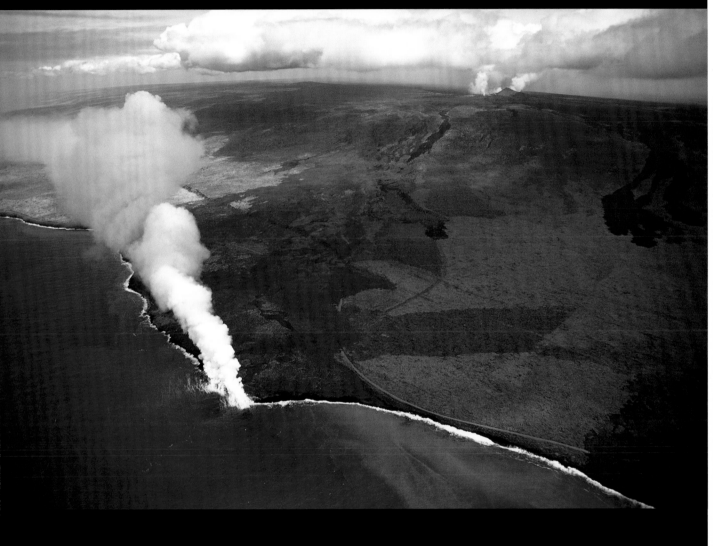
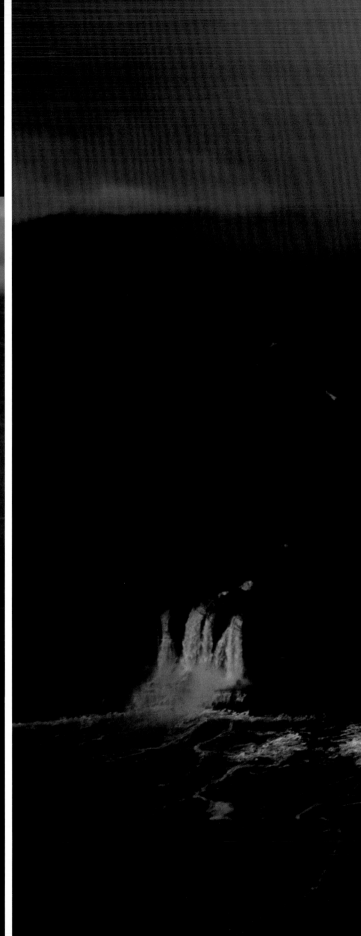

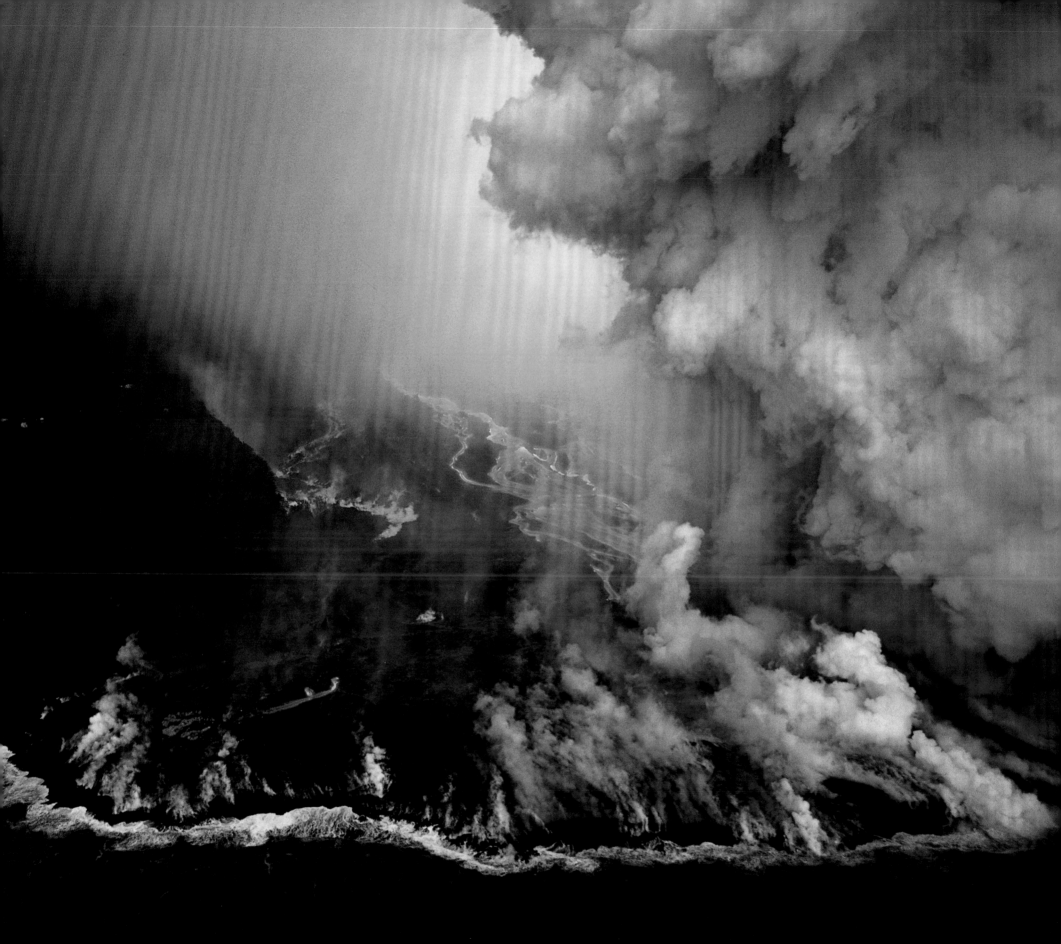

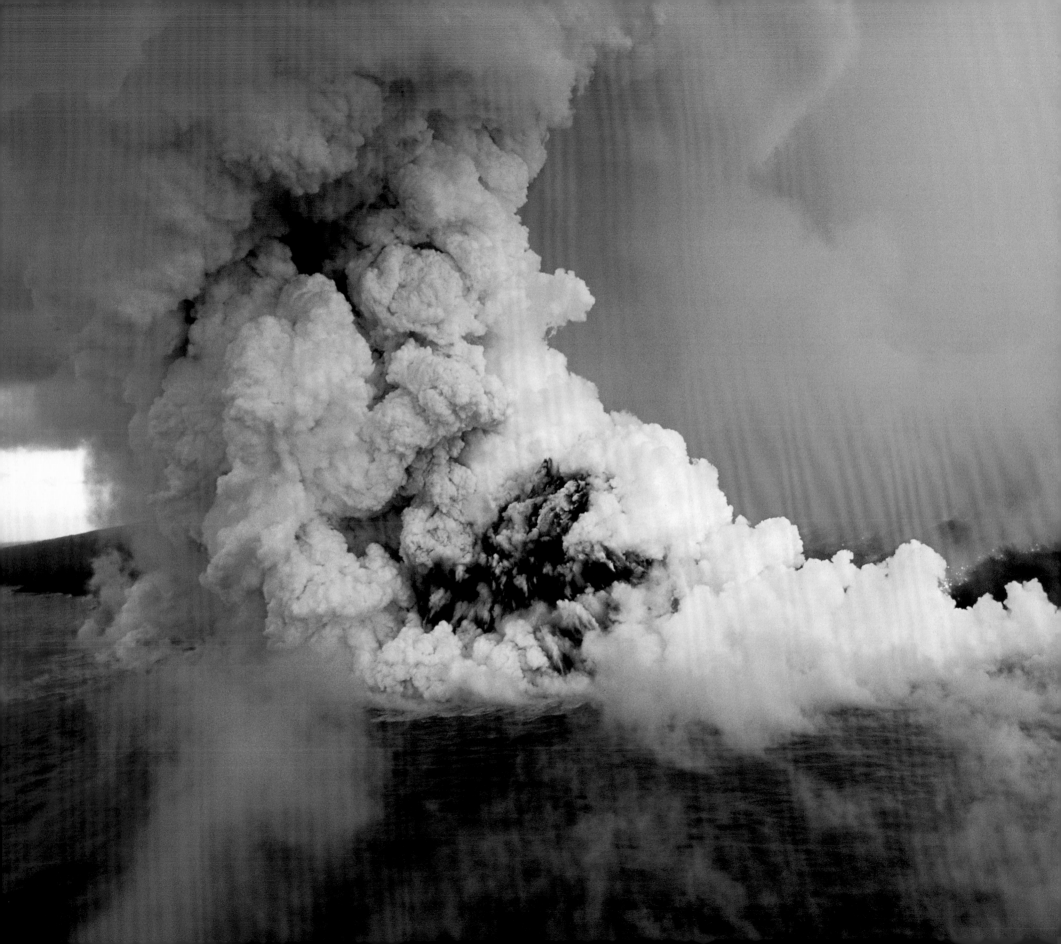

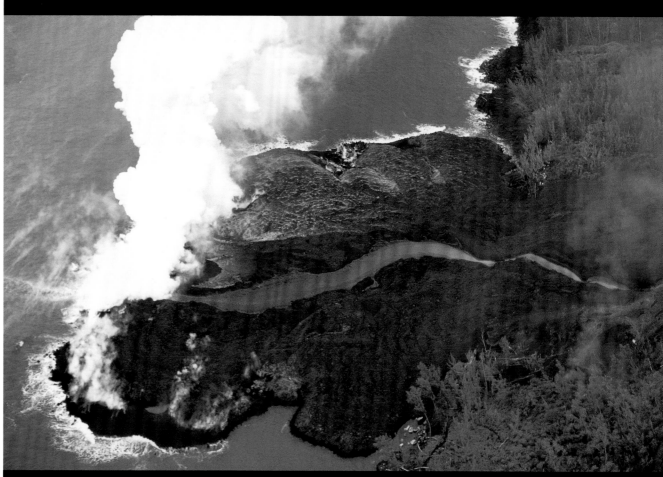

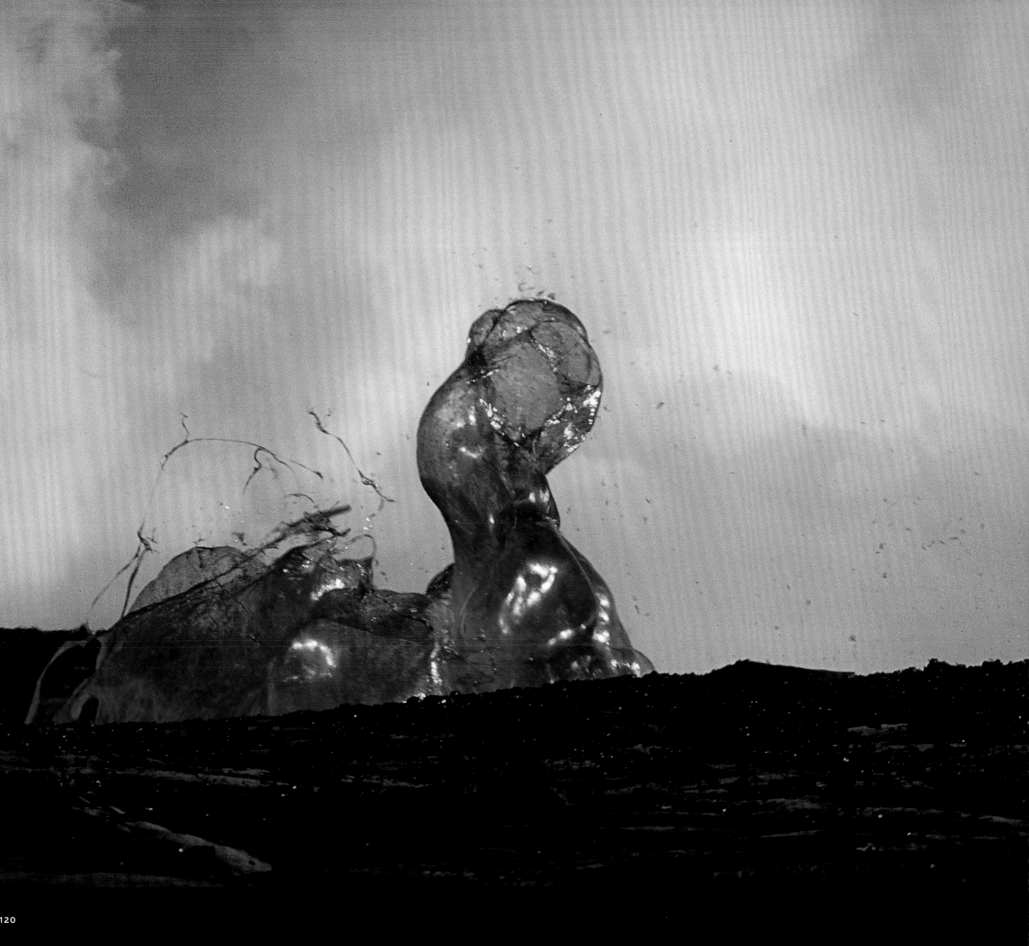

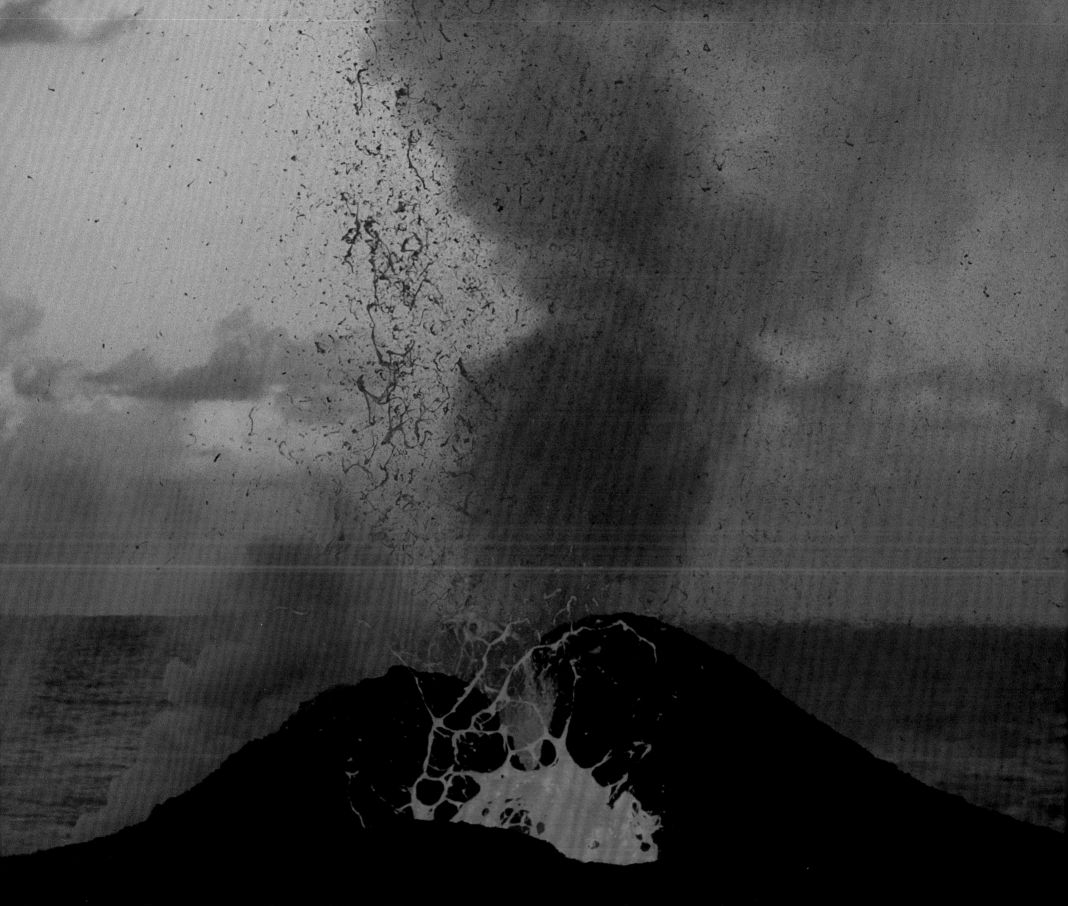

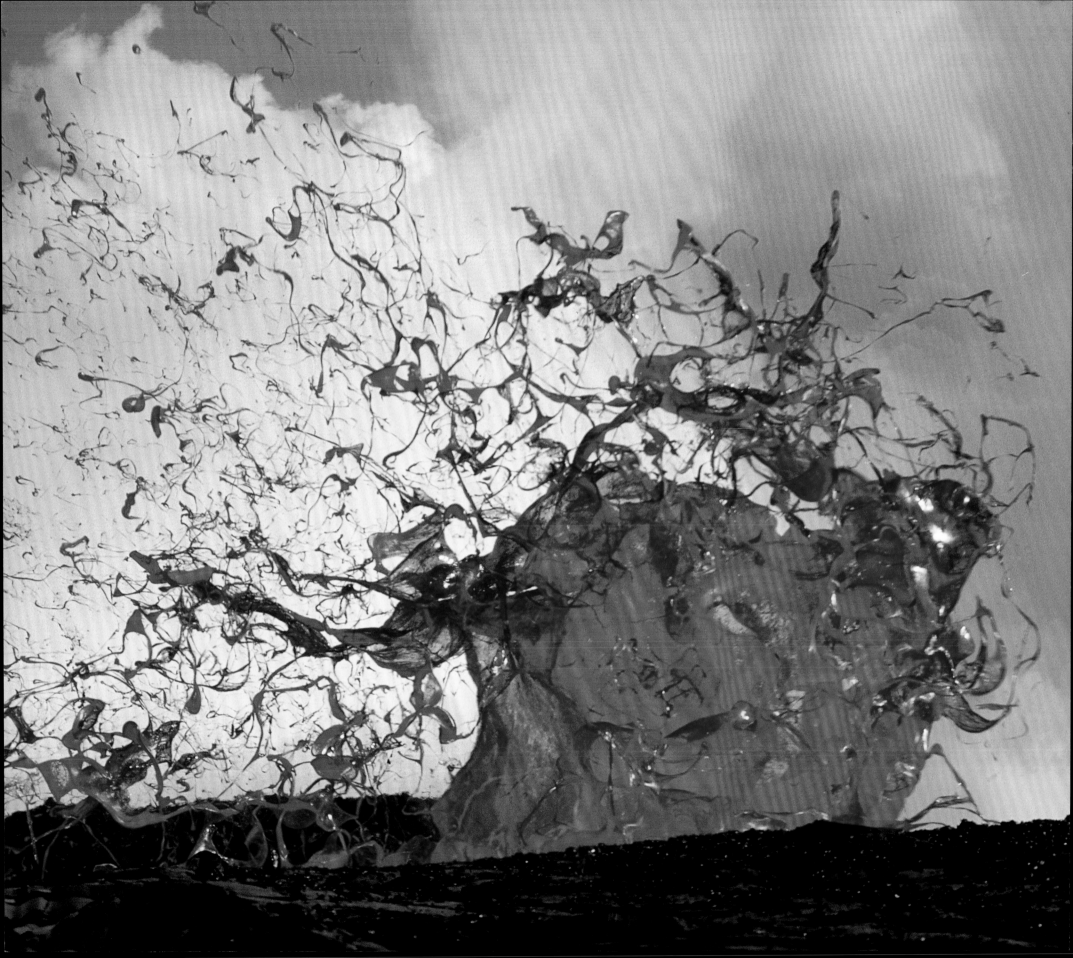

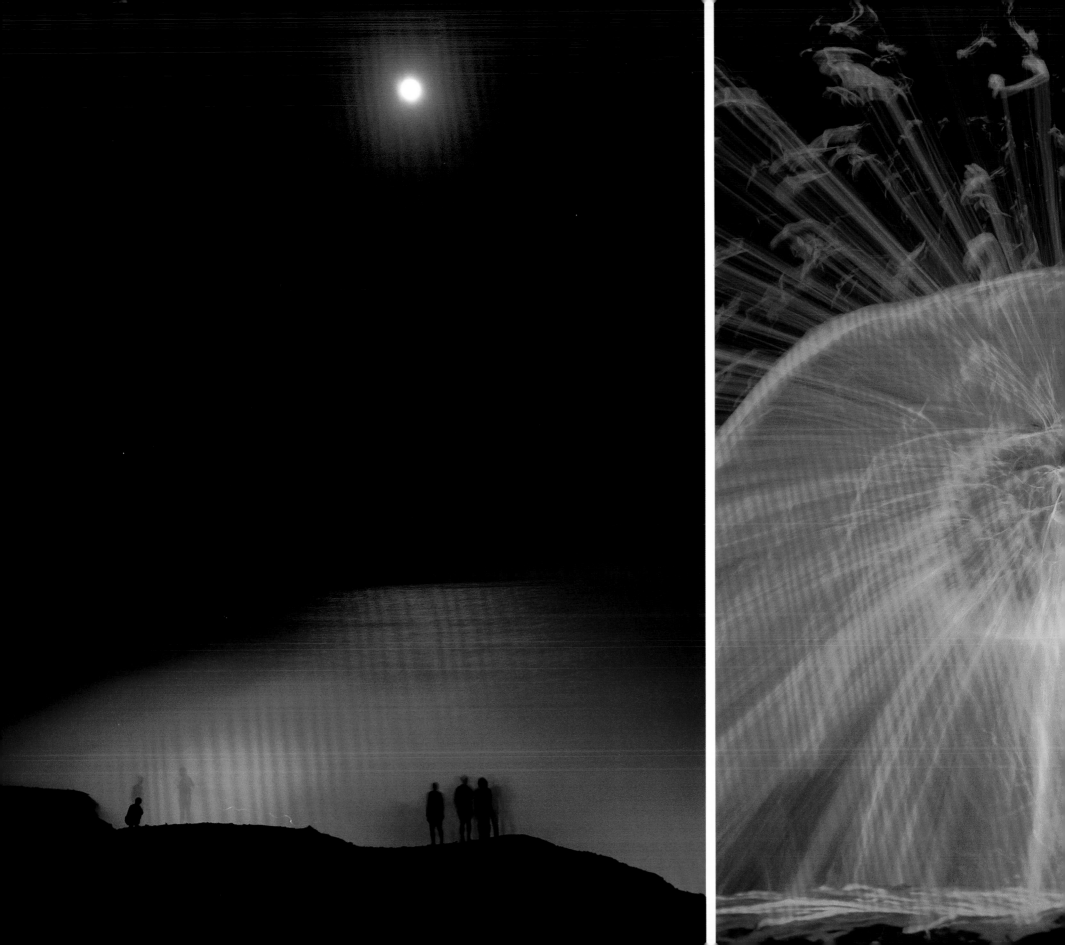

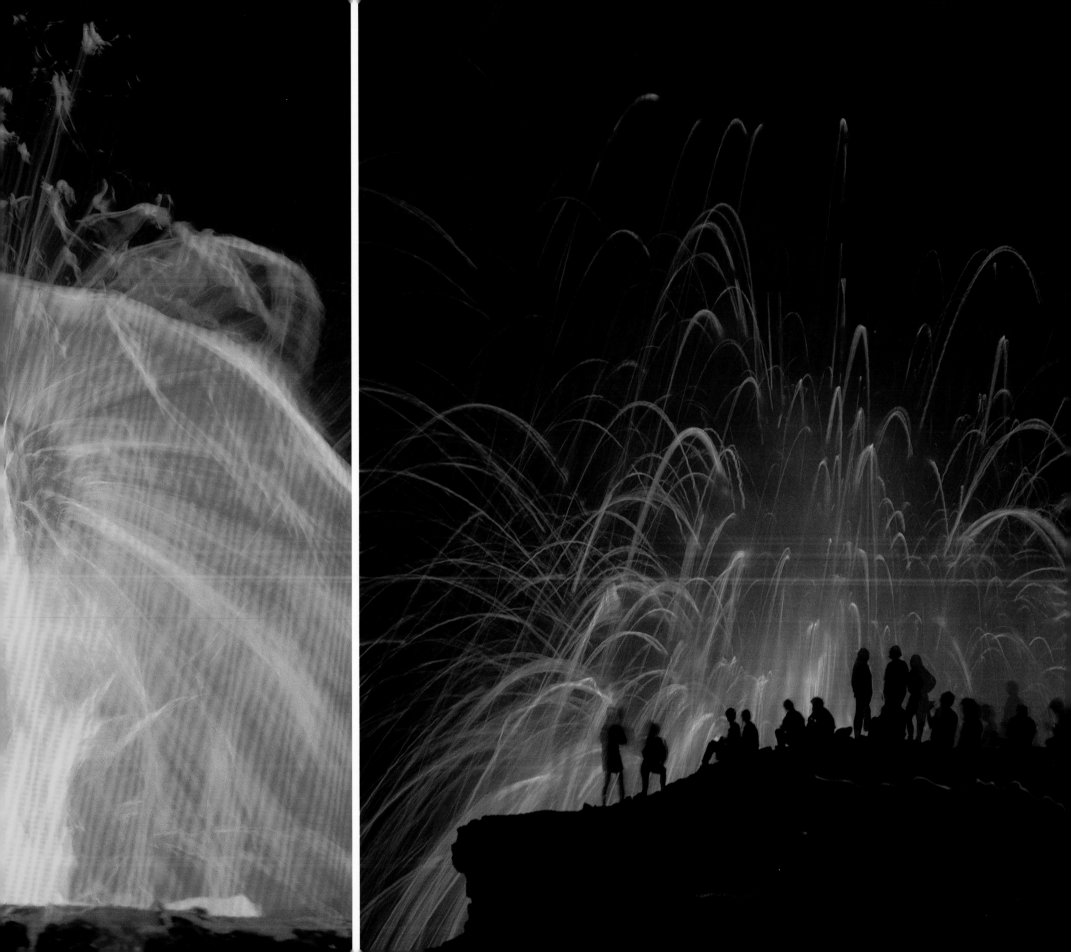

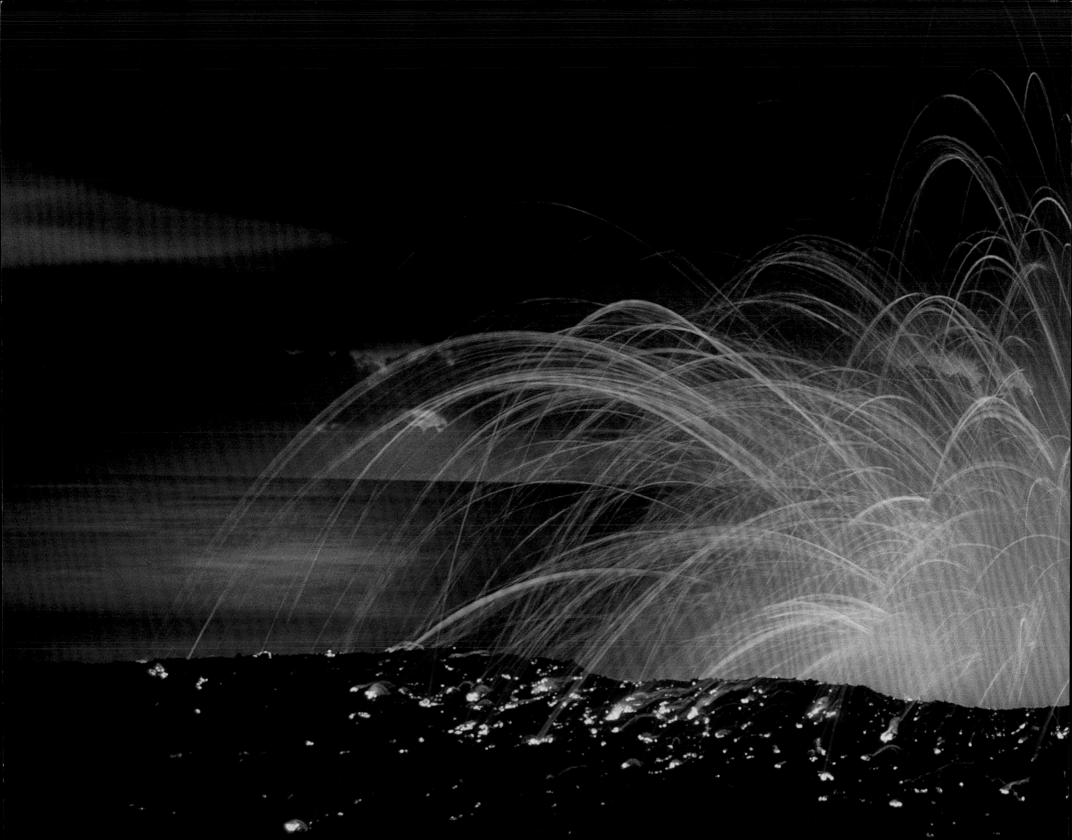

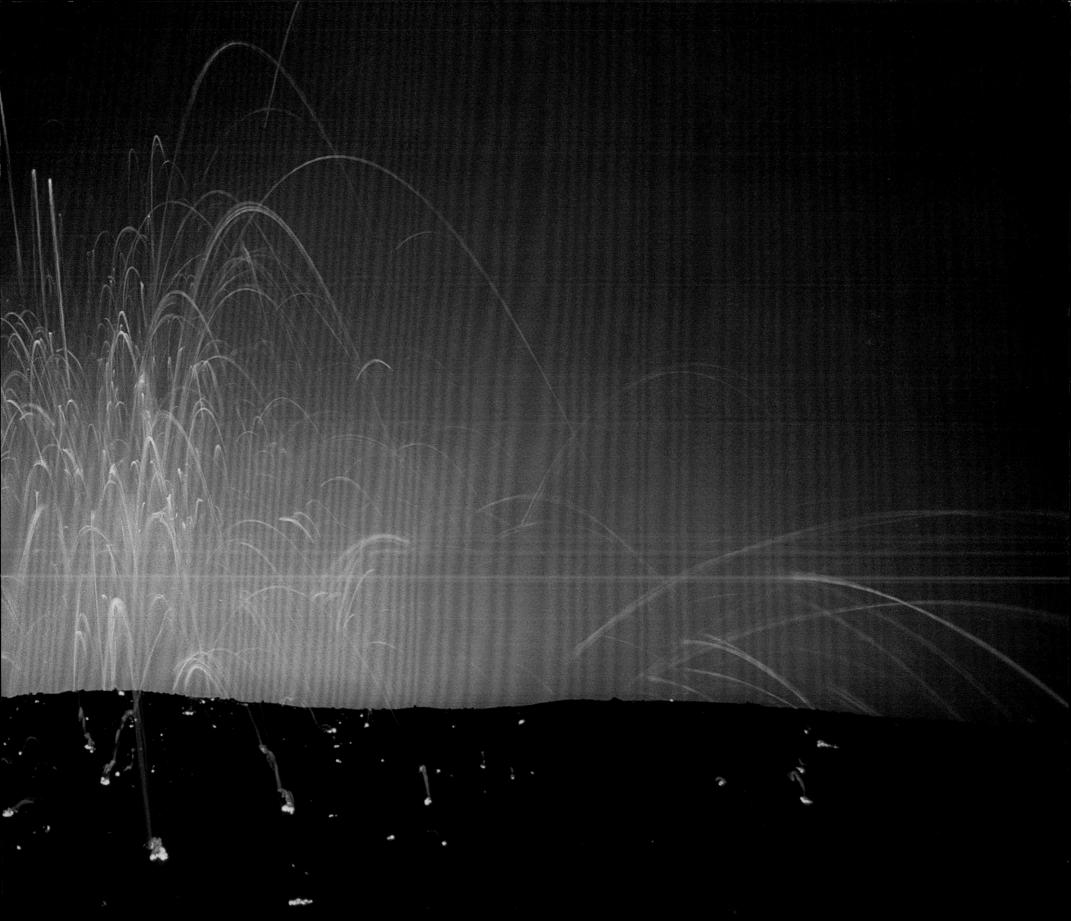

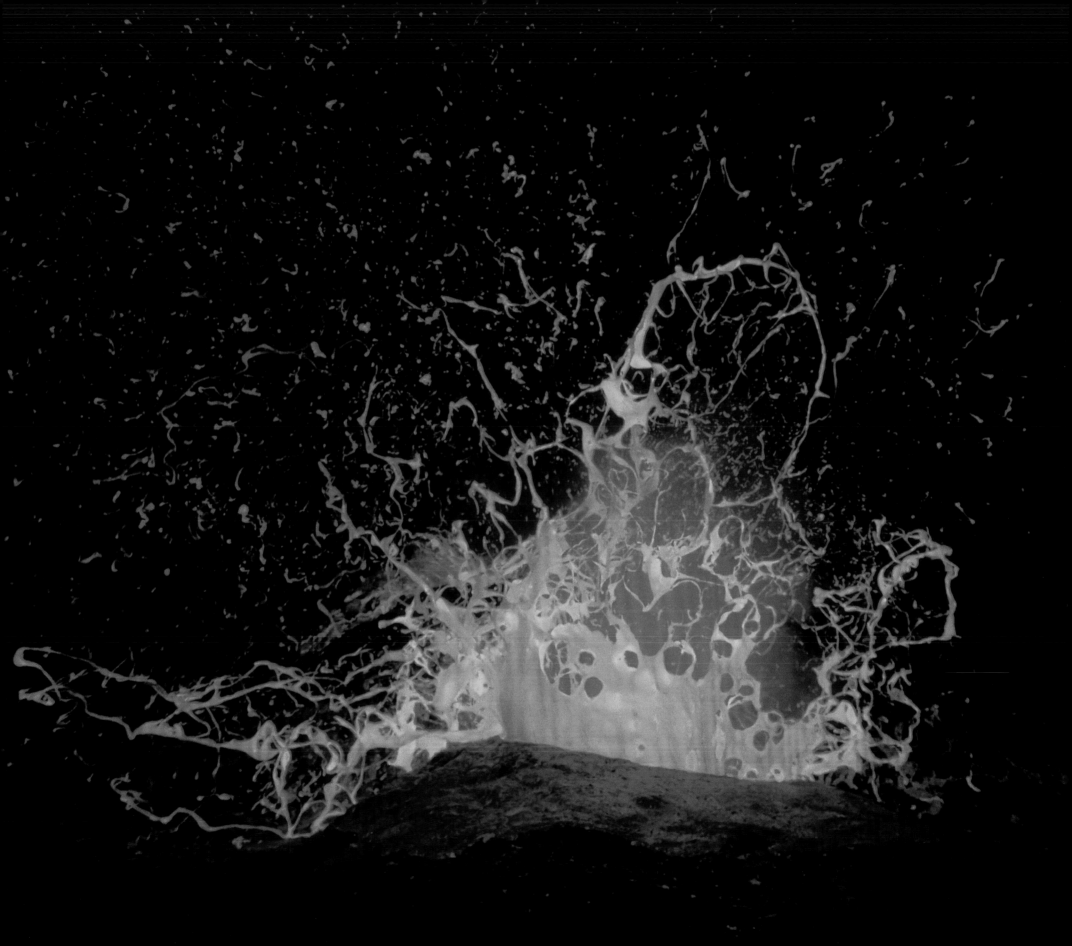

PAGE 1 RÉUNION

A lava tube on the Plaine des Osmondes. The surface of the flow cools off when in contact with the air and solidifies. Beneath the cooled surface, the temperature remains at over 1,100°C and the very fluid lava flows at over 30 k.p.h.

PAGE 8 HAWAII

Aerial view of massive lava flows on the southwest rift zone of Mauna Loa.

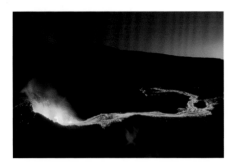

PAGES 2–3 RÉUNION

Eruption of Piton Kaf in the Dolomieu crater. Within 24 hours, a cone begins to form and lava pours out of it.

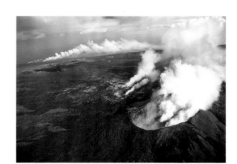

PAGE 10 HAWAII

Aerial view of the Pu'u O'o vent. The steam cloud from lava entering the ocean can be seen in the upper left corner.

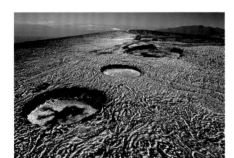

PAGES 4–5 HAWAII

The snowy summit of Mauna Loa volcano, showing several pit craters and Mokuaweoweo caldera.

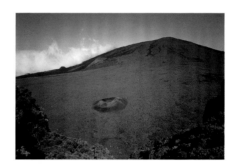

PAGE 13 RÉUNION

The Pas de Bellecombe, dominating the Enclos Fouqué, provides an excellent view of the summit cone.

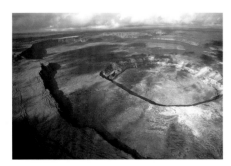

PAGE 6 HAWAII

Aerial view of Kilauea Caldera, with Halemaumau crater in the center.

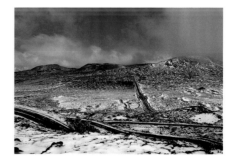

PAGE 15 RÉUNION

The Plaine des Sables, created by the eruption of Piton Chisny a thousand years ago (crater on the far right), was fully covered with snow in August 2003. This was the first time that this phenomenon had happened at this altitude in over a century.

PAGE 6 RÉUNION

In the mountainous region of Saint-Philippe, the first rays of sun illuminate one of the two Pitons de Fourche, created by an ancient eruption of unknown date.

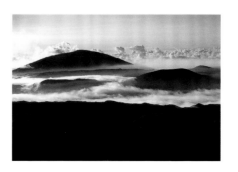

PAGES 16–17 RÉUNION

A plume of gas, caused by a volcanic eruption on the eastern flank of the summit cone, sweeps across the Enclos Fouqué and the Plaine des Sables, as well as a few inhabited areas, causing respiratory problems among the population.

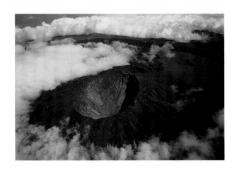

PAGE 18 RÉUNION

The Dolomieu summit crater is no longer the same after a huge collapse 300 meters deep, caused by the draining of lava from a shallow magma chamber.

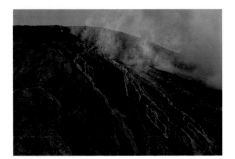

PAGES 18–19 RÉUNION

Piton de La Fournaise was born 500,000 years ago and has collapsed three times during its history, resulting in depressions called calderas. The most recent caldera is named Enclos Fouqué, where the summit cone rises to 2,632 meters, and is crowned by two craters, Bory and Dolomieu.

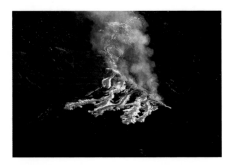

PAGES 20–21 RÉUNION

Fissure on the eastern flank of the Dolomieu crater, 1 kilometer long and at an average altitude of 2,200 meters.

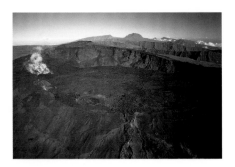

PAGE 21 RÉUNION

A small "curtain of fire" a few minutes after the start of activity. Pyroclasts of scorias rise no higher than 15 meters.

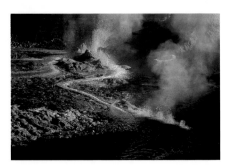

PAGE 22 RÉUNION

An eruption in the Dolomieu crater, only two hours after the start of activity.

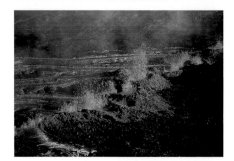

PAGE 23 RÉUNION

This eruptive fissure, 150 meters long, will be active for only a few hours.

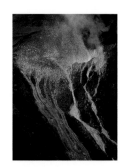

PAGE 24 RÉUNION

Pyroclasts feed the lava flows pouring into the Plaine des Osmondes.

PAGES 24–25 RÉUNION

Eruption of Piton Payankê. Projections of scorias spray from the collapsed crater, from which a very fluid lava flow emerges.

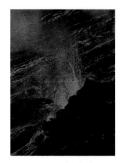

PAGE 25 RÉUNION

Eruptive fissures located less than 500 meters from Nez-Coupé de Sainte-Rose, at an altitude of 1,850 meters. The molten magma rises to 50 meters.

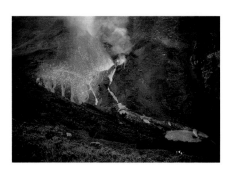

PAGE 26 RÉUNION

The presence of people shows the huge scale of the volcanic activity.

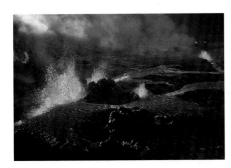

PAGE 27 RÉUNION

A fissure in the Dolomieu crater, a few hours after the start of the eruption.

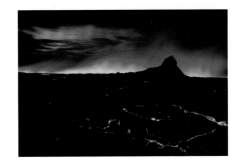

PAGES 32–33 HAWAII

A littoral cone is silhouetted by the glow of lava entering the ocean at dawn.

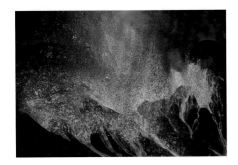

PAGES 28–29 RÉUNION

High-pressure lava fountains, 70 meters high, shoot out of the most active point.

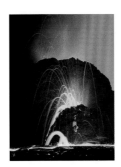

PAGE 34 RÉUNION

This eruption created four hornitos within the Dolomieu crater. In the foreground, a hornito is forming right before our eyes.

PAGE 29 RÉUNION

Piton de La Fournaise in the evening light. The lava flows, coming from the eruptive fissures, spread across the Dolomieu crater.

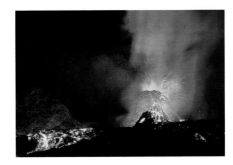

PAGES 34–35 RÉUNION

The eruption inside the Dolomieu crater illuminates the south rampart. Lava flows fill the bottom of the crater with 3 to 4 cubic meters of magma per second.

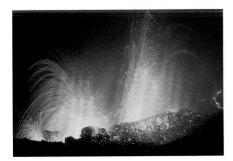

PAGES 30–31 RÉUNION

Eruption of Piton Payankê. Magma, about 1,200°C, is thrown into the air by high-pressure gases and sets the sky on fire.

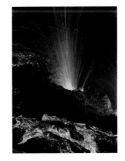

PAGE 35 RÉUNION

A kilometer-long fissure on the eastern slope of the summit cone. A long exposure turns the pyroclasts of magma into glowing threads.

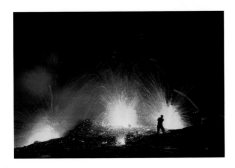

PAGE 32 HAWAII

A photographer silhouetted by lava on the beach, exploding before it enters the ocean.

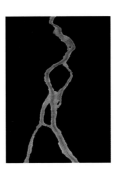

PAGE 36 RÉUNION

Lava flow in Grand-Brûlé.

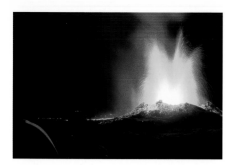

PAGES 36–37 RÉUNION

Our base camp, right next to the eruption. The gorgeous show increases in strength at night with lava fountains setting the sky on fire.

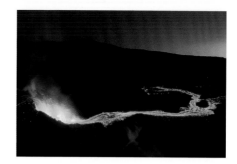

PAGES 42–43 RÉUNION

Eruption of Piton Kaf in the Dolomieu crater. Within 24 hours, a cone begins to form and lava pours out of it.

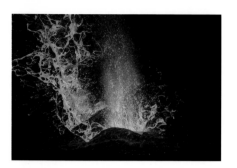

PAGE 38 RÉUNION

This image shows unusual projectiles called *limu*, a type of very thin leaf of lava. They are caused by the explosion of steam-filled lava bubbles, created by the intrusion of seawater inside tunnels where the magma flows. The interaction between magma and water forms two craters on the shore.

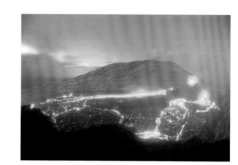

PAGES 44–45 HAWAII

A dawn scene in the Pu'u O'o vent. A spatter cone eruption has filled the lava lake.

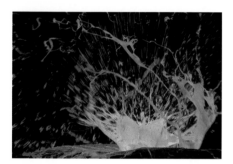

PAGE 39 HAWAII

Bubbles of lava are formed when seawater enters the lava tube near an ocean entry, often causing violent explosions.

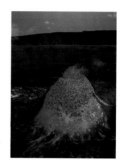

PAGE 46 RÉUNION

Eruption of Piton La Wouandzani and Piton Moinama inside the Dolomieu summit crater. The expansion of "gas pistons" causes a spectacular cascade of lava to overflow one of the cones, covering its flanks. Gas pistons are caused by the accumulation of gas beneath a column of lava, pushing up the overlying lava.

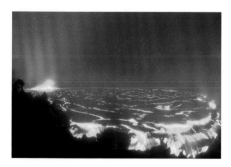

PAGES 40–41 HAWAII

Dawn scene at the Pu'u O'o lava lake. Moments after this image was taken, the lava lake breached the eastern spillway, and flowed out of the vent.

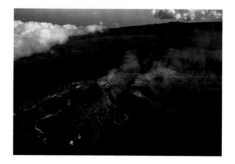

PAGES 46–47 RÉUNION

Eruption of Piton La Wouandzani and Piton Moinama inside the Dolomieu summit crater. Four cones were built up during a four-month eruption, changing the landscape of Dolomieu. Piton La Wouandzani stands on the left side beside the third and fourth cones, and Piton Moinama is on the right side.

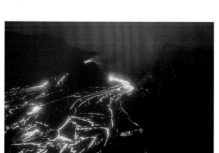

PAGE 41 HAWAII

A dawn scene looking into the Pu'u O'o vent, towards the West Gap. The vigorous flow from the spatter cone has formed a large lava lake.

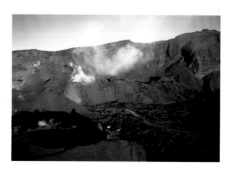

PAGES 48–49 RÉUNION

Eruption of Piton Kaf in the southwest of the Dolomieu crater, at the foot of the rampart. In the foreground, an older cone created by the eruption of December 29, 1985.

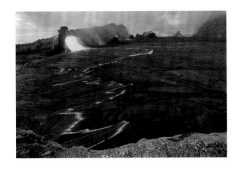

PAGE 49 HAWAII

A lava lake is created from a gushing spatter cone within the Pu'u O'o vent.

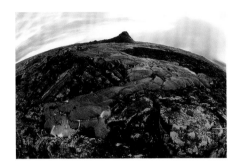

PAGE 50 HAWAII

Pahoehoe lava flows from a littoral cone.

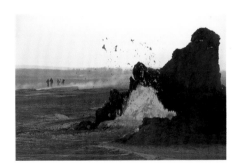

PAGES 50–51 HAWAII

An active spatter cone dwarfs scientists on the eastern edge of Pu'u O'o.

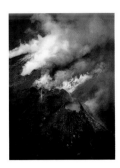

PAGE 52 RÉUNION

On the west slopes of the Plaine des Osmondes, between 1,500 and 1,700 meters high, a new fissure opens at the foot of the two cones, a week after the eruption started. Gases, ash plumes, and tiny projectiles shoot over a hundred meters into the air, creating an infernal noise that sounds like a jet plane taking off.

PAGES 52–53 HAWAII

Bubbles of lava are formed when seawater enters the lava tube near an ocean entry, often causing violent explosions.

PAGE 53 HAWAII

This spatter cone on the west side of Pu'u O'o is less than 24 hours old.

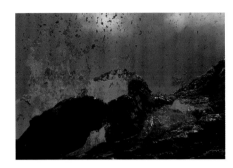

PAGES 54–55 RÉUNION

A hornito forming at one end of the fissure.

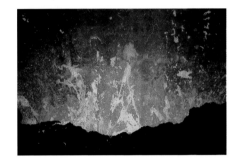

PAGE 55 RÉUNION

Inside the Dolomieu crater, a close-up of the forming cone, 15 meters high and throwing shredded lava into the air.

PAGE 56 HAWAII

A spatter cone on the outside of the Pu'u O'o vent, with the rainforest in the distance.

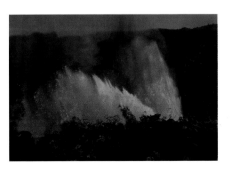

PAGES 56–57 RÉUNION

At an altitude of 600 meters, in the tropical forest, a crater is being built up. Two lava fountains 200 meters high are throwing up spectacular spreading jets of pyroclasts, which, along with the lava flows, burn vegetation all around. Only some islands of greenery remain.

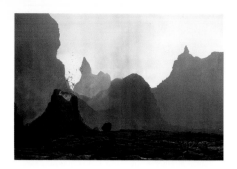

PAGES 58–59 HAWAII

Looking west into the Pu'u O'o vent, with various spatter cones and the jagged ridge of the east side.

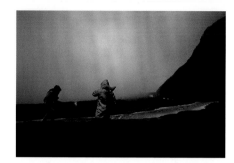

PAGES 62–63 RÉUNION

Thomas Staudacher, director of the Volcanological Observatory at Piton de La Fournaise, takes a lava sample in the Plaine des Osmondes.

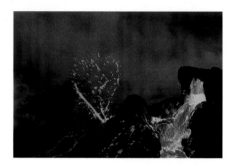

PAGE 59 HAWAII

Pele's heartbeat: a spatter cone on the west side of Pu'u O'o puts out a burst of lava in the shape of a heart.

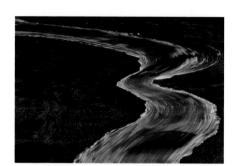

PAGE 63 HAWAII

A fast-moving river of lava flows from the MLK vent on the south flank of Pu'u O'o.

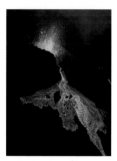

PAGE 60 RÉUNION

A breached crater, 1,500 meters up in the heights of the Plaine des Osmondes, releases a kilometer-long lava flow.

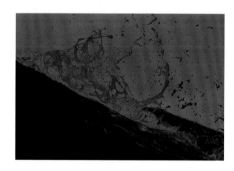

PAGE 64 RÉUNION

Helped by the strong gradient of the slope, about 35 degrees, the extremely fluid lava rushes down the Grandes Pentes towards the Plaine des Osmondes.

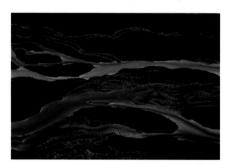

PAGES 60–61 RÉUNION

Extremely fluid pahoehoe lava flows move quickly across the Plaine des Osmondes.

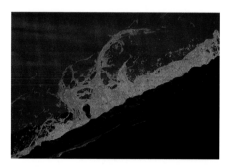

PAGE 65 RÉUNION

The magma runs down the Grandes Pentes at over 70 k.p.h.

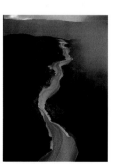

PAGE 61 RÉUNION

Channel of lava in the Grandes Pentes overhanging Grand-Brûlé.

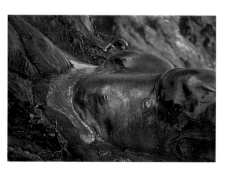

PAGES 66–67 RÉUNION

Smooth lava flow in the Grandes Pentes overhanging the Plaine des Osmondes.

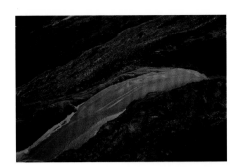

PAGE 67 RÉUNION

Lava flows produced by the eruption of Piton Guanyin in the Grandes Pentes of Enclos Fouqué.

PAGE 68 RÉUNION

Within a few hours, lava flows from a fissure on the eastern flank of the summit cone reach a length of 2 kilometers.

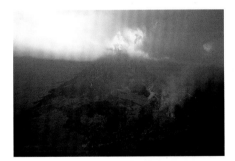

PAGES 68–69 RÉUNION

Eruption of Piton Guanyin. The lava flows move relentlessly across Grand-Brûlé, devastating the vegetation in their path.

PAGE 69 HAWAII

Aerial view of a river of lava flowing through a forest of ohia trees.

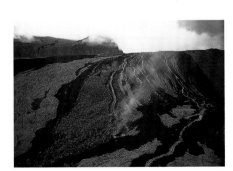

PAGE 70 RÉUNION

Lava flows run down the Cassé of the Plaine des Osmondes, swallowing the rainforest of Grand-Brûlé.

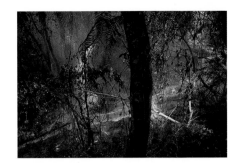

PAGES 70–71 RÉUNION

After crossing the main road, the lava continues its progress into the forest, along a dry gully.

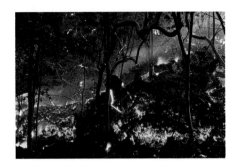

PAGE 72 HAWAII

A large a'a destroying a lowland forest.

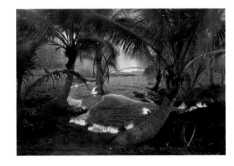

PAGE 73 HAWAII

A fast-moving lava flow takes out a coconut grove at Kamoamoa.

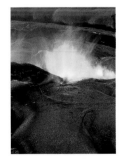

PAGE 74 HAWAII

An ohia log burning in a pahoehoe lava flow.

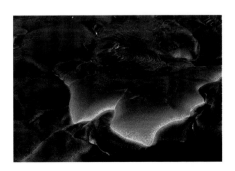

PAGES 74–75 HAWAII

Hot pahoehoe lava in dusk light.

PAGE 76 RÉUNION

A toe of pahoehoe lava heads toward the ocean.

PAGE 81 HAWAII

Detail of a pahoehoe lava flow.

PAGE 77 RÉUNION

Close-up of a rough and rocky lava flow known to volcanologists by the Hawaiian term "a'a."

PAGE 82 HAWAII

Detail of hot pahoehoe lava.

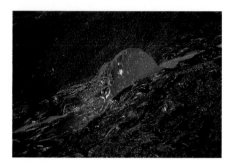

PAGE 78 RÉUNION

A spectacular bubble of lava. Very fluid magma runs down the slope at over 70 k.p.h.

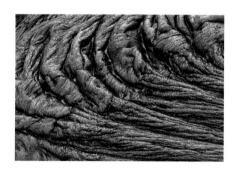

PAGES 82–83 HAWAII

Hot folds of pahoehoe lava.

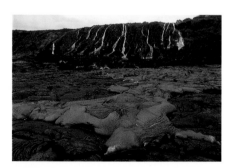

PAGES 78–79 HAWAII

A large surge of lava flows over a pali (cliff), onto the coastal plain.

PAGE 83 HAWAII

A river of pahoehoe lava flows over a small cliff.

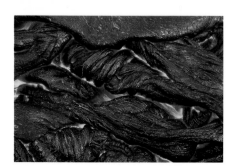

PAGES 80–81 HAWAII

Hot pahoehoe lava in dawn light.

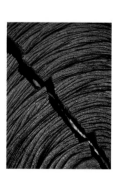

PAGE 84 HAWAII

Hot crack in pahoehoe lava.

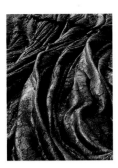

PAGES 84–85 HAWAII

Silky folds of cooled pahoehoe lava.

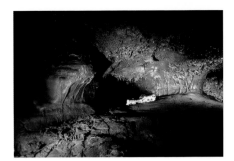

PAGES 88–89 RÉUNION

Within the center of the tube, the roof is supported by two pillars of lava, resembling modern architecture.

PAGE 85 HAWAII

Hot glowing folds of pahoehoe lava.

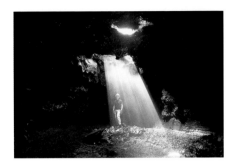

PAGES 90–91 RÉUNION

More than a kilometer long, this tube contains numerous galleries and rooms, some over 4 meters high.

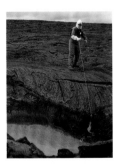

PAGE 86 HAWAII

Christina Heliker, of Hawaii Volcano Observatory, collects a lava sample.

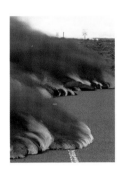

PAGE 92 HAWAII

Lava flowing over Chain of Craters road.

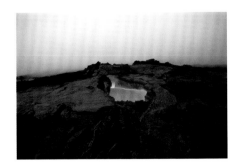

PAGES 86–87 RÉUNION

An opening in the roof of the lava tube is called a "skylight" by scientists and allows us to see inside. The lava inside is protected from cooling, so it remains very fluid and moves extremely fast. The roof is thick enough in some places to allow people to walk on it, while the magma flows quickly underfoot.

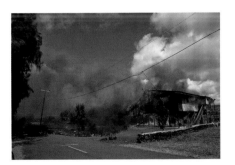

PAGES 92–93 HAWAII

A lava flow burning a house in Kalapana.

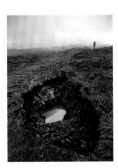

PAGE 87 HAWAII

A scientist standing near a lava tube.

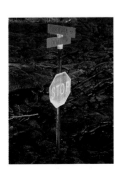

PAGE 93 HAWAII

Road sign in lava flow.

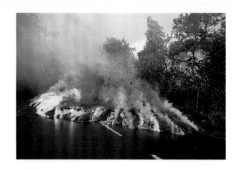

PAGE 94 RÉUNION

This roped lava flow, around a meter deep, cuts across the RN2, one of the island's main roads.

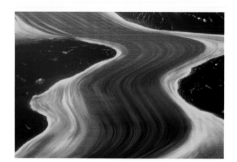

PAGES 98–99 HAWAII

Time exposure of lava river at night.

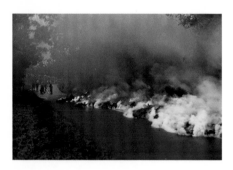

PAGES 94–95 RÉUNION

The lava flow crosses the asphalt in less than twenty minutes, watched by a crowd of fascinated spectators who have come to watch the show.

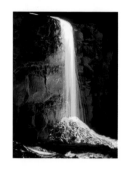

PAGE 100 HAWAII

A river of lava pours from a sea cliff onto a newly formed black-sand beach.

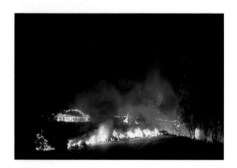

PAGES 96–97 RÉUNION

The lava engulfs the main road and swallows the craft store in the parking lot of the island's famous Vièrge au Parasol, a statue of the Virgin Mary that is reputed to have the power to hold back the lava.

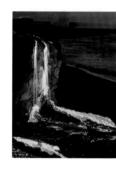

PAGES 100–101 HAWAII

Rivers of lava pour from a sea cliff onto a newly formed black-sand beach and into the ocean.

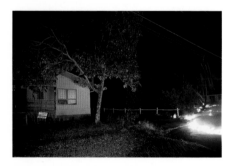

PAGE 97 HAWAII

A hot lava flow creeps up on a home in Kalapana.

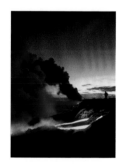

PAGE 101 HAWAII

A spectator looks on as rivers of lava enter the Pacific Ocean.

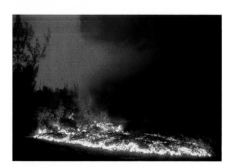

PAGE 98 RÉUNION

The front of the flow threatens to cross the main coastal road through Grand-Brûlé.

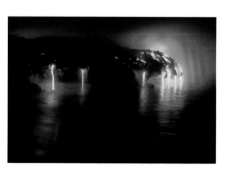

PAGES 102–103 HAWAII

A lava flow forms a small delta as it flows into the ocean.

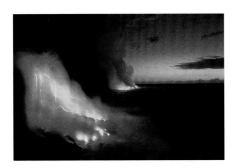

PAGE 104 RÉUNION

Lava flows reach the sea just before dawn. A few hundred meters apart, the two flows eventually join together to form a platform.

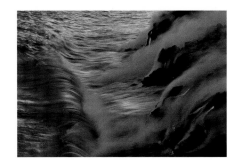

PAGE 107 HAWAII

Fingers of lava flowing into the Pacific Ocean.

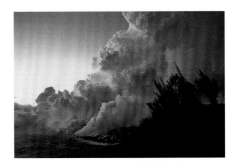

PAGE 105 RÉUNION

Lava flow reaching the sea at sunrise. A plume of glowing steam rises into the sky showing the fight between lava and seawater.

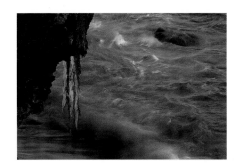

PAGE 108 HAWAII

Lava flowing over a sea cliff and into the Pacific.

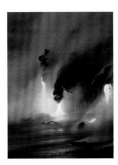

PAGE 106 HAWAII

Lava glows as it flows into the ocean off a newly formed black-sand beach.

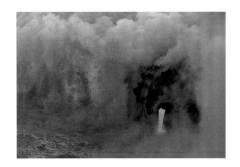

PAGE 109 HAWAII

Lava flows and explodes into the Pacific Ocean.

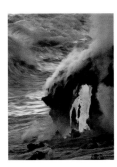

PAGE 106 HAWAII

A river of lava entering the Pacific Ocean.

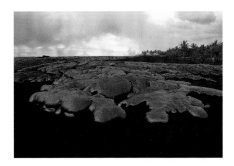

PAGES 110–111 HAWAII

A broad pahoehoe lava flow covers Kamoamoa black-sand beach.

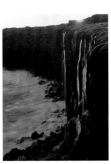

PAGE 106 HAWAII

A river of lava flows down a cliff and into the Pacific Ocean.

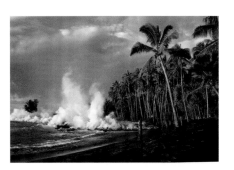

PAGES 112–113 HAWAII

A lava flow wraps around the once world-famous Kaimu black-sand beach in Kalapana.

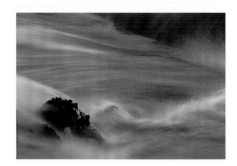

PAGES 114–115 HAWAII

Time exposure of lava flowing into the ocean.

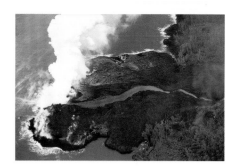

PAGE 119 RÉUNION

In less than 48 hours, the magma builds a shelf into the sea, expanding the island by several hectares.

PAGE 115 HAWAII

Lava explodes as it enters the ocean.

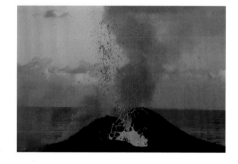

PAGE 120 HAWAII

A small bubble of lava about to explode near an ocean entry.

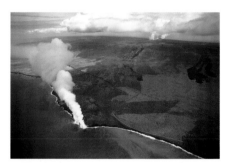

PAGE 116 HAWAII

Aerial view of Kilauea Volcano, from Pu'u O'o to the ocean entry.

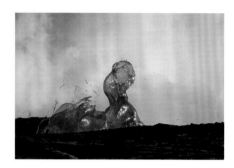

PAGE 121 RÉUNION

Seawater entering a lava tube causes powerful explosions to occur on the edge of the lava platform, later forming a new cone around 20 meters high.

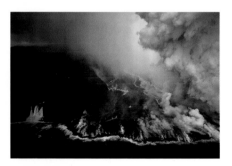

PAGES 116–117 RÉUNION

At the foot of Tremblet rampart, a bench of 15 hectares was formed by the sea. The inhabitants of Tremblet village and the vegetation both suffered from volcanic gases and acid rains carried by the plume.

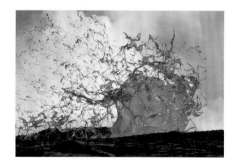

PAGE 122 HAWAII

A lava bubble explodes near an ocean entry.

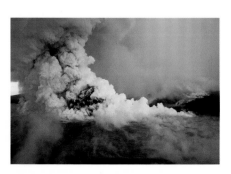

PAGES 118–119 RÉUNION

The plume of gas hundreds of meters high spreads across the sky of Réunion. The temperature of the seawater is close to 40°C, and volcanic gases are escaping out of its surface, caused by the lava moving beneath the ocean.

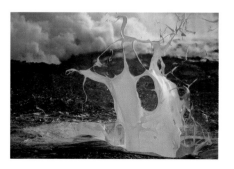

PAGE 123 HAWAII

Bubbles of lava are formed when seawater enters the lava tube near an ocean entry, often causing violent explosions.

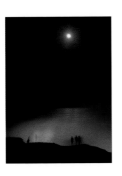

PAGE 124 HAWAII

Spectators watch lava flow into the Pacific Ocean.

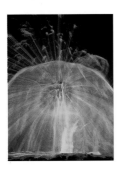

PAGES 124–125 HAWAII

A bubble of lava is formed by seawater and violently explodes.

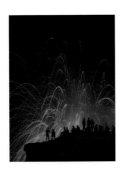

PAGE 125 HAWAII

A group of spectators are silhouetted by the glow of lava exploding into the ocean.

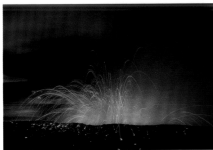
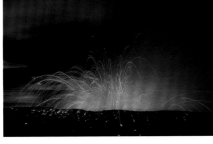

PAGES 126–127 HAWAII

The spectacular sight of lava entering the Pacific Ocean at dawn.

PAGE 128 RÉUNION

A lava explosion.

Ile de la Réunion

Piton des Neiges

Piton de
La Fournaise

INDIAN
OCEAN

0 50 km
0 30 miles

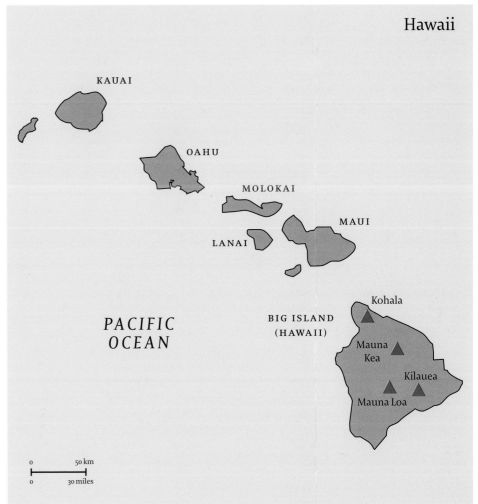

Hawaii

KAUAI

OAHU

MOLOKAI

MAUI

LANAI

PACIFIC
OCEAN

BIG ISLAND
(HAWAII)

Kohala

Mauna
Kea

Kilauea

Mauna Loa

0 50 km
0 30 miles

the national parks

Hawaii Volcanoes National Park was established on August 1, 1916, the 12th U.S. National Park in a system that now numbers 390 areas. It now welcomes nearly two million visitors a year.

The park extends over 134,763 hectares from sea level to 4,150 meters and encompasses the summits and rift zones of Kilauea and Mauna Loa, two of the world's most active volcanoes. Kilauea has been in near-continuous eruption since 1983; Mauna Loa last erupted in 1984. Park rangers mark trails and put up signs that enable visitors to get as close as safely possible to flowing lava. The park is also a refuge for rare and endangered species of plants, birds, bats, and sea turtles, and a spiritual reservoir for native Hawaiians.

In 2005, the park celebrated the reopening of the newly renovated Kilauea Visitor Center. There are exhibits on island formation, ecosystems from sea to summit, and the sights and sounds of the rainforest. Interwoven throughout are the *mana'o* (wisdom) and *mo'olelo* (stories) of Hawaii's first people.

For more information, visit: www.nps.gov/havo

Réunion National Park was established in 2007. The protected central area of the Park covers 105,500 hectares, some 42 percent of the island. Its purpose is to protect the exceptional ecosystems of Réunion, which encompass a wide variety of habitats and species, as well as the majestic natural landscapes created by volcanic activity and a cultural landscape of small, isolated villages, inhabited by some 200 families.

The spectacular active volcano Piton de La Fournaise and the fascinating landscapes of its older, inactive twin Piton des Neiges form a unique laboratory of the Earth, where the natural processes that shape the land can be studied at close quarters. Réunion's biodiversity also makes it a true theater of species evolution, with many plants and animals unique to the island. Life is regularly "reborn" on the lava flows of La Fournaise, and the threat from invading species is closely monitored.

For more information, visit: www.parc-national-reunion.prd.fr